Social Design in Museums

Social Design in Museums

The Psychology of Visitor Studies

Collected Essays Volume One

Stephen Bitgood

MUSEUMSETC | EDINBURGH

Contents

INTRODUCTION

1

Introduction to Social Design in Exhibition Centers

After reading Arthur Melton's (1935) seminal monograph, I took to heart his argument that "...there should be a branch of museum research which is wholly concerned with the psychological problems of museum architecture." (p. 267). However, psychology can be applied to more than the architecture of museums. The museum experience encompasses many areas of psychology including sensation, perception, cognition, learning, environmental, and social influence. Over the years, we have attempted to apply psychological principles and methodology to the study of visitors in a variety of ways.

Sommer's (1983) term, *social design*, which applies to several areas of psychology, seems to best express what we have been doing the last 25+ years within exhibition centers such as museums, zoos, science centers, parks, and other such informal educational exhibition centers. Social design examines the fit between the museum visitor and the environment of the exhibition center. As users, visitors have their own agendas, interests, knowledge base, physical and intellectual strengths and weaknesses. The heterogeneous nature of the audience is one of the greatest challenges to museums. How can enjoyable, meaningful experiences be designed for such a diverse audience? Can one size fit all? How can museums provide experiences that are both educational and satisfying to the visitor? The better we understand what the visitors bring to the museum, what impact the exhibition environment has on the visitors, and how the visitor and environment interact, the more effective we will be in

providing quality visitor experiences.

While many areas of psychology are able to study people in a stationary location such as a laboratory or a clinic office, visitor studies has the added problem of trying to understand moving targets – pedestrian movements or circulation through exhibition centers. What motivates visitors to move through museums they way they do? What are the most effective ways to capture and engage visitor attention as they move about? How do attention processes influence how visitors circulate through the museum? Given the complexity of the visitor-exhibition setting, how can we provide the most value to the visitor experience?

This book encompasses a 25-year journey of studying visitors in museums, zoos, science centers, and other types of exhibition centers. *Visitor studies* is the name commonly used to describe research and evaluation with visitors in museums and other exhibition centers. During the last quarter of a century the field of visitor studies has expanded considerably. Prior to 1986, I don't believe there was a publication devoted exclusively to visitor studies. For eleven years (from 1986 through 1996), I edited and published *Visitor Behavior*, a newsletter-journal. The Committee on Audience Research & Evaluation of the American Association of Museums began publishing *Current Trends in Audience Research and Evaluation* in 1987. (Many of the papers in the current volume come from *Visitor Behavior* and *Current Trends...*) From 1988 until 1992 Chan Screven published *ILVS Review: A Journal of Visitor Behavior*. There is now a professional association (The Visitor

Studies Association) which I founded in 1991 with the help of a number of colleagues. We have a yearly conference which I began organizing in 1988 and, since 1992, it has become a function of the Visitor Studies Association. *Visitor Studies Today*, a publication of the Visitor Studies Association, was published after *Visitor Behavior* ended in 1996. Now we have a journal, *Visitor Studies*, which is sponsored by the Visitor Studies Association and published by Routledge beginning in 2007. There are other journals that also frequently publish visitor-related material, among them are: *Curator, Journal of Interpretation Research*, and *Environment and Behavior*.

My career as a psychologist did not start with museum and zoo visitors. I received my PhD in experimental learning psychology, served as a post-doctoral research associate for two-years at McMaster University in Canada which included work with children. At Drake University, I was involved in clinical work as faculty supervisor in their child clinic. When I arrived at Jacksonville State University in 1974, I developed and co-directed a child clinic with a colleague. In 1980, I developed and co-directed a tutoring and enrichment center in which we conducted research to develop more effective tutoring methods for school children. Finally, in 1985, I began studying visitors. I believe these varied research experiences in psychology with different problems and populations provided me with an ideal background to conduct research with visitors in museums.

With my wife, Arlene Benefield, and colleague, Don Patterson, along with a group of enthusiastic students, we

began studying visitors at the Birmingham Zoo in 1985 and later at the Anniston Museum of Natural History. Our initial approach was very inductive. Our intention was to collect observational data at a variety of exhibits and see what empirical principles emerge (rather than starting with some theoretical bias). We targeted several animal exhibits that differed in animal size, popularity, etc. At each exhibit, we had two observers collecting simple data: whether a visitor stopped, total viewing time, other behaviors that may be relevant (such as group discussion, pointing), and weather and crowding conditions. Meanwhile, we read the works of Robinson, Melton, Screven, Shettel, Loomis, Koran, and any other visitor-related papers we could find. At the time, much of this material was difficult to find. The monographs of Robinson (1928) and Melton (1935) published by the American Association of Museums were particularly helpful and had a large influence on our thinking at the time. It was encouraging that our findings in the zoo and natural history museum settings were similar to those of Robinson and Melton in art and science museums.

We began presenting our findings of visitor studies at the annual American Association of Zoological Parks and Aquariums Conference (1985-88), several psychological conferences, and the American Association of Museums (1987). Since then we have published in a number of places including *Curator, Informal Education Review, Journal of Museum Education, Environment and Behavior, Journal of Interpretation Research*, a French journal, a German journal, as well as a chapter in the

Handbook of Environmental Psychology, and several papers in conference proceedings.

From the beginning we were searching for general empirical principles that applied to exhibition centers of all types. We started with minimal theoretical bias, and with a strong intention to follow Frances Bacon's cautions about allowing theoretical bias to influence our interpretation. During the first three years, I was told by a funding program officer with the National Science Foundation in the US that we would need a strong theoretical framework if we hoped to get research funding. However, we didn't feel we were ready (nor did we believe the field was ready) to jump into elaborate theory building before having a sound empirical literature. Only recently have I felt confident that we have enough solid research to formulate sound theories. The focus of our experiences has been on four areas:

1. visitor attention to exhibitions;
2. orientation and circulation in exhibits;
3. factors that influence the visitor experience such as simulated immersion or social influence;
4. methodology of research and evaluation with visitors.

These areas are represented as different sections of this book.

What is social design?

I consider social design a branch of environmental psychology. The major question of interest for social design: How can we design environments to best fit the users? Bob Sommer (1983)

seems to have coined the term (at least in this application). The approach uses the methodology of social science and analyzes behavior-environment relationships. Chapter 2 (*Studying Museums from a Social Design Perspective: An Update*) provides a more detailed description of this approach. Basically, social design is: user-oriented, multi-disciplined, theoretically eclectic, methodologically scientific, and politically democratic.

Organization of the book

The book is organized into several sections, topics of which reflect the areas of social design in exhibition centers. I believe that the various sections of this book represent a scientific, eclectic, user-oriented approach to the study of visitors. In reviewing and organizing these papers, I understood why George Washington in his later years, corrected many of his papers from early years to improve his grammar and writing. There are a few instances where I have either added updated comments to the papers or changed wording to improve the clarity of the meaning. I resisted making major changes to some of the papers that I thought could be improved.

Section 1: Introduction: The first section attempts to provide a background for social design in museums. In addition to this introductory chapter, it includes three additional papers, the first of which is a paper on social design written in 1989: *Studying Museums from a Social Design Perspective: An Update.* Updated notes (found in bold text) are included. The second paper is titled, *The Anatomy of an Exhibit*, and it attempts to

provide an analysis of the elements of an exhibit. Such an analysis provides a framework for examining the variables that are likely to be important in understanding the visitor-exhibition relationship. Chapter 4 (*Formal Versus Informal Education*) attempts to make clear some of the distinctions between formal and informal education in terms of the environment, the learners' behavior, and their interaction.

Section 2: Research and Evaluation Methodology: This section includes papers on the methodology of research and evaluation in visitor studies. The focus is on a systematic, scientific approach to the study of visitors. Chapter 5 (*Overview of the Methods of Visitor Studies*) includes considerations for applying social science methodology to the study of visitors. This discussion is especially important for those not familiar with concepts such as reliability and validity. A glossary of terms (Chapter 6) is provided to help clarify how we are defining concepts. Chapters 7 and 8 offer some guidance on designing exhibits and interpretive labels. Chapter 9 discusses evaluation of exhibitions and programs. Readability of text material is the subject of Chapter 10. How to sample a visitor survey is the topic of Chapter 11, and Chapter 12 is a discussion of cued versus non-cued methods in visitors studies.

Section 3: Attention and Value: The third section describes the theoretical approach we have taken in the social design of exhibition centers (see Bitgood, 2010). We argue that attention is the major concept in understanding the visitor experience. Managing visitor attention is fundamental to the design of any visitor experience. *Value* is the major motivational force that

gives direction to attention. These basic concepts, attention and value, are closely tied to observational events – the behavioral outcomes and the conditions that seem to influence them. A number of concepts are associated with attention: fatigue, satiation, competition, choice, distraction. Chapter 13 (*An Attention-Value Model of the Museum Experience*) describes the attention-value model that we have been developing in the last few years. Chapter 14 (*Decreases in Attention: Museum Fatigue and Related Phenomena*) deals with several phenomena that are associated with decreased visitor attention. Chapter 15 (*The Concept of Value and its Role in Attention*) provides further discussion on attention and value. The role of behavioral economics in attention is the topic of Chapter 16. Behavioral economic approaches, in one way or another, define value as a ratio of utility (satisfaction, benefit, etc.) divided by costs (time, effort, money, etc.). Chapter 17 describes a parametric study of text passage length, size of font, and proximity of text to the visitor's pathway. These variables are all assumed to be important in the capture, focus, and engagement of attention.

Section 4: Orientation and Circulation: Section four (Chapters 18 through 32) includes a number of short papers; some are reports of studies, others describe or discuss basic principles of orientation and circulation. In our work over the years, the importance of effective systems of orientation and circulation has become very apparent. Orientation includes conceptual and physical (wayfinding). Conceptual orientation provides information that allows visitors to know what the exhibition (or museum) is all about, how to plan a visit, and what there

is to see and do.

Wayfinding involves navigation through a facility. The ability of visitors to find their way depends upon a number of factors: the complexity of the pathway system, the number of intersections or choice points, the placement and clarity of direction signs, visual access to each choice alternative pathway.

Circulation describes how people move through spaces in a museum or other exhibition centers. Research suggests that movement patterns are predictable, especially when sound design principles are used and designers understand movement patterns.

Section 5: Exhibition Design Considerations: This section focuses on exhibition design principles. Chapter 33 (*Principles of Exhibit Design*) summarizes the empirical principles we identified early in our research. Chapter 34 provides guidelines for designing interactive exhibits and Chapter 35 gives a brief report on the evaluation of a hands-on exhibit (*Falling Feather*) contained in the Exploratorium Cookbook. Chapter 36 (*Deadly Sins Revisited...*) is a review of variables that influence interpretive label design. Chapter 37 (*Prompting Visitors with Signage*) examines the effectiveness of signs designed to prompt visitors to either look for animals in a simulated cave or to allow their eyes to dark adapt before entering the cave. Finally, Chapter 38 (*Formative Evaluation of a Pepper's Ghost Exhibit Device*) is an example of testing a hands-on exhibit device comparing the effectiveness of labels either inside or outside the device.

Section 6: Simulated Immersion: Six chapters on immersion are offered in this section. The first, Chapter 39 (*Immersion Experiences in Museums*) is an update on immersion and reviews some recent work by other researchers and evaluators. Chapter 40 (*The Role of Simulated Immersion in Exhibitions*) is a general discussion on the topic, and Chapters 41 through 43 provide some data on how exhibitions influence feelings of immersion. Finally, Chapter 45 discusses dioramas, the most common immersion-type of exhibition.

Section 7: Social Influences: There is little argument about the social nature of the museum visit. The vast majority of visitors are in groups and the social interaction among group members is a well-established pattern of visitor behavior. The family group has been the most commonly studied, but other types of groups should not be ignored. Chapters 45 through 48 include a discussion of social influence in the museum and some studies of how group composition and age play an important role in the museum experience.

Section 8: Social Design in Zoos: This section includes papers specifically related to zoo environments. It summarizes much of the data we have collected in the zoo setting over the years and offers specific design principles and guidelines based on these studies. Chapters 49 and 50 include our first publications in the zoo world. Chapters 51 through 53 are reports of studies completed at the Birmingham Zoo. Chapter 54 examines ways to decrease visitor littering at zoos. Chapter 55 is a paper suggesting design principles for zoo exhibits. Finally, Chapter 56 reports a study in which the behavior of both visitors and

a polar bear were examined with and without several types of animal enrichment present in the animal exhibit.

Section 9: Miscellaneous: The final section includes papers that didn't seem to fit into the previous sections. Chapter 57 is a review of factors that influence school field trips. Chapter 58 is a report of two years of evaluation of a Science Café sponsored by the NC State Museum of Natural Sciences in Raleigh, NC. Chapter 59 (*A Primer on Memory for Visitor Studies Professionals*) introduces readers to the psychology of memory as it applies to visitor studies. Chapter 60 discusses multicultural pluralism (racial and ethnic factors) in museum settings.

References

Bitgood, S. (2010). *An attention-value model of museum visitors.* Center for the Advancement of Informal Science Education. http://caise.insci.org/uploads/docs/VSA_Bitgood.pdf

Bruman, R. (1991). *Exploratorium Cookbook I: A Construction Manual.* San Francisco, CA: Exploratorium.

Melton, A. (1935). *Problems of installation in museums of art.* New Series No. 14. Washington, DC: American Association of Museums.

Robinson, E. (1928). *The behavior of the museum visitor.* New Series No. 5. Washington, DC: American Association of Museums.

Sommer, R. (1983). *Social design: Creating buildings with people in mind.* Englewood Cliffs, NJ: Prentice-Hall.

2

Studying Museums from a Social Perspective: An Update

Update: This paper, written In 1989, this paper attempted to introduce some ideas from environmental psychology into the visitor studies literature. After this paper, I rarely used the term, social design in our work, but even after more than 20 years, I think the term sums up accurately what we have been doing for 25 years. Bob Sommer's (1983) book introduced me to the concept of "social design" and I was attracted to it at once. It was the inspiration for a non-profit organization, The Center for Social Design, that we used for publishing, research, and evaluation projects.

The social design of museums

There has been a growing movement over the last 20 years in visitor settings such as museums and zoos that I would call *social design*, although those involved in the movement may never have heard the term. The concept of social design originates from the field of environmental psychology and the implications of this concept are very appropriately applied to the visitor studies movement. Robert Sommer (1983), one of the early environmental psychologists, stated that the "social design movement arose to correct misfits between people and the built environment." There is little doubt that such a misfit has occurred between visitors and museums. However, this misfit between people and environment in museums is rapidly being corrected by professionals with this social design perspective.

Social design will be defined as the scientific study of how environments can be designed or improved from the perspective of their users. Too often, built environments are designed more

for aesthetic appeal than for functional use. As stated by Philip Johnson, a leading architect: "The job of the architect is to create beautiful buildings. That's all." (cited by Sommer, 1983, p. 4). The social design movement emphasizes the creation of human environments based on the functional needs and desires of its users. This design approach can be applied to any type of environment. In museums, zoos, and other visitor-related organizations, social design evaluation has been conducted since the 1920s. The early works of Robinson (1928) and Melton (1935; 1972) represent the beginning of social design evaluation in museums. In the late 1960s and early 1970s the study of visitors became increasingly popular. In particular, the works of Harris Shettel (Shettel, 1967; 1968; Shettel, Butcher, Cotton, Northrop, & Slough, 1968) and Chan Screven (Screven, 1969; 1973; 1974a; 1974b; 1975; 1976) represented the dawning of a new age in the study of museum users. While Melton and Robinson emphasized the physical characteristics of museums (e.g., circulation patterns, position of labels and exhibit objects), Shettel and Screven focused on communicating educational messages by applying instructional technology to informal learning settings. More recently, many others have added significant contributions (See *ILVS Bibliography & Abstracts, 2nd Ed, 1988*).

The works of Robinson, Melton, Shettel, and Screven all came from outside the museum environment. All were psychologists employed by universities or, as in the case of Shettel, a research institute. During the 1970s evaluators began to appear on the permanent staffs of museums. Roger Miles and his colleagues at the Museum of Natural History (London)

have approached social design from an in-house perspective (e.g., Alt, 1980; Alt & Griggs, 1984; Alt & Shaw, 1984; Griggs, 1981; 1983; 1984; Miles, 1985; 1988; 1988b; Miles & Alt, 1979; Miles, Alt, Gosling, Lewis, & Tout, 1982; Miles & Tout, 1978; 1979).

There are many others who have made significant contributions during the last 10-15 years. John Koran and his colleagues at the University of Florida (Koran, Koran, & Freeman, 1976; Koran, Koran, & Baker, 1980; Koran & Koran, 1983) have approached museums from a science educational perspective. Marilyn Hood (1983; 1985; 1986) has emphasized "audience research" with a focus on marketing techniques. Ross Loomis (1973; 1987) at Colorado State University introduced the first useful textbook on visitor evaluation (other than the excellent manual by Miles, Alt, gosling, Lewis, & Tout, 1982; 1988). Bob Wolf (1980) created a following of researchers and evaluators who advocate qualitative methods of study. Many other could be cited for their contributions.

Update: Today we have a professional association (Visitor Studies Association) with a healthy membership, a journal (Visitor Studies), an annual conference, and many other resources available to professionals who wish to be part of the movement or learn more about it. The list of contributors to this movement has grown exponentially.

While their methods and emphasis have differed, all of the above researchers/evaluators have been concerned with how museums can be improved from the perspective of users and

thus all may be considered part of the social design movement within museum settings. A traditional design approach is more likely to place users in a secondary role. A traditional design administrator may be more concerned with how the museum is perceived by other museum professionals or major donors; or may assume he/she knows what is best for visitors and staff. Administrators who take the social design approach are more likely to be concerned with how effectively the museum does what it is supposed to do from both a visitor and staff perspective. Are exhibits achieving their objectives? Are visitors satisfied with their museum experiences? Can they easily find their way around the museum? Does the museum meet the comfort needs of visitors (i.e., restrooms, water fountains, seats, etc.). Are museum staff satisfied with their work setting? Is the museum designed to facilitate rather than impede their work?

The social design approach

At the heart of social design are five basic assumptions:

1. User-oriented (the focus of evaluation is on those who will use the environment).
2. Multi-disciplined (professionals from varied areas of expertise work together).
3. Theoretically eclectic (theory and methods are borrowed from whatever relevant).
4. Methodologically scientific (methods of social sciences are adapted to the evaluation of museum environments).

5. Politically democratic (input from all groups should affect decision making).

User-oriented focus: Visitors and staff must be considered the major user of a museum. While visitors may be the primary focus of design, staff and other members of the institution should not be ignored. How the design of the museum impacts on curators and other staff should be explicitly considered. Shettel-Neuber (1986) in a post-occupancy evaluation of the Whittier Southeast Asian Exhibits at the San Diego Zoo, in addition to visitor input, included interviews with various zoo officials and staff ranging from the President of the Board of Trustees at the Zoo to building and grounds maintenance employees.

Multi-discipined: In an ideal social design project, architects, administrators, educators, curators, other content experts, and evaluators all work together to design and evaluate museum projects. While this multi-disciplined ideal is not always accomplished in today's museum design, it is certainly becoming a more common occurrence.

Eclectic: Museum design has borrowed liberally from instructional technology, learning theory, cognitive theories, sensation and perception, environmental psychology, architecture, social sciences, and many other areas. In keeping with this tradition, social design evaluation is not associated with any particular theoretical viewpoint. It has applied whatever theories and concepts appear to fit.

Scientific methodology: Scientific measurement is applied to the evaluation process. Thus, we strive to obtain measures that

are objective, reliable, and valid. We attempt to make accurate conclusions in interpreting the results of our measurements.

Democratic: Social design encourages democratic decision making by ensuring that all users of a museum are considered. Empowering visitors has been, perhaps, the greatest accomplishment of the movement.

The goals of social design

Gifford (1987) provided a useful description of some of the goals of social research in the design process:

1. *Matching or good-of-fit (habitability)*: One of the primary goals is to create physical settings that match or fit the needs and activities of their users. Are museum exhibits designed to facilitate learning? Can visitors find their way through the museum? Are rest rooms available and easy to find? Are visitors distracted by too many exhibits jammed into a small exhibit area? If the museum design does not match the user objectives, what results is an absence of learning, visitor disorientation, physical discomfort, fatigue, boredom, dissatisfaction, and bad public relations.

2. *User satisfaction*: User satisfaction is always a goal of social design. If visitors enjoy themselves, they are likely to learn more, want to return, and communicate their experience to others.

3. *Behavior change*: The museum environment should be designed to accomplish behavior change in many ways. For example, it may be designed to: facilitate learning

in visitors, change attitudes toward conservation or some other socially relevant value, develop a greater appreciation of art; and discourage undesirable behaviors such as littering and crossing barriers.

4. *Personal control*: When users have options to control the amount of social contact or to go in one direction or another, they can make the setting suit their desires. The opportunity for choice is one design factor that increases personal control. Thus, flexible environments that allow for greater choice of responding are preferred. The entrance to the School of Nursing Building at our University illustrates a lack of choice. As you approach the entrance, you must walk up a long zigzagged ramp to enter the building. It would have been quite easy to have stairs placed on one side instead of ramps on both sides. If given a choice, non-handicapped users of this building would choose the steps rather than walking the extra 50 feet to negotiate the ramp. Other possible choices for visitors are: to sit when tired; to obtain food and drink when desired; and if outside in the summer, to escape the discomfort of heat when necessary.

5. *Social facilitation*: The museum experience is, for most visitors, a very social event. People tend to visit museums with family and friends and engage in social interaction during their visit. Some museum designs, however, do not foster social interaction. For example, the use of an audio tape tour with a portable tape recorder discourages social interaction.

Update: Today, it is common to use digital recorders in which the visitor can enter a number and listen to information about the exhibit display. This is much less disruptive to social interaction than the old, continuous tape player.

The benefits of social design

1. It is participatory – users participate in the design process by providing input. It fosters support at a grass roots level, it lets visitors know they are involved in decision making, and it reduces the friction of an adversarial relationship between visitor and museum staff.

2. It attempts to gather information in an objective, reliable, and valid manner. It allows you to determine if those who participate in gathering information and making recommendations really represent all of the users in terms of needs and desires.

3. Potential design problems are most likely to be identified and remedied early if social design evaluation is used effectively. If systematic input from all user groups has not been obtained, design flaws may go undetected until after the exhibit or program is being used. How many times have user groups said: "If only we had been consulted before the building was constructed!"

The evaluation process

As with any design approach, the social design process can be

divided into three major phases: planning, development, and post-installation or post-occupancy. From the social design perspective, evaluation can and should be part of each of these phases.

Planning (Programming)

The first step in a design project is to plan before any blueprints are drawn up. This requires a careful analysis of the resources, the users, and the setting. This phase of evaluation is often called "front-end analysis" (Miles, 1988; Screven, 1986; Shettel, 1989) when applied to visitor evaluation. An increasing number of Front-end evaluation studies are being reported (e.g., Loomis, Fusco, Edwards, & McDermott, 1988; Walker, 1988).

Update: Today, front-end evaluation is commonly practiced in museums. See Borun, 1995; Shettel, 1991.

Hayward (1989) called evaluation during this phase "concept planning research." *Market research, topic testing,* and *feasibility studies* are terms often used for these planning activities. Screven (1988) argued that pre-design planning should involve the largest portion of time with respect to evaluation efforts.

1. *Technical programming:* It is obvious that the technical and financial constraints of the project must be considered. This involves a study of possible spaces, costs, sources of outside funds, fire regulations, etc. This aspect of programming is rarely neglected. Since it is tangential to social design, it will not be discussed here.

2. *Social programming*: Gifford (1987) described three stages of social programming: (a) understanding users; (b) involving users; and (c) formulating design guidelines. In the discussion below, each of these three stages will be applied to museum design.

The first stage, *understanding users*, should include information about visitors and staff. Audience research or audience analysis (e.g., Hood, 1986; Loomis, 1987) is used to obtain information about potential visitors. An understanding of the visitor population aids planning efforts in many ways. For example, the visitor population may change from season to season requiring different seasonal programs designed for specific segments of visitors (Hood, 1988).

While visitors are being studied more and more, understanding staff as museum users has been a neglected area of study or has certainly lagged behind our understand of visitors. [See Shettel-Neuber (1986) for an example of obtaining input from users other than visitors.]

To understand users it is necessary to clarify the social rationale of the facility, that is, to specify the organization's goals. The mission statement of the museum should contain relevant statements of goals. Public education is a goal of all museums and should be part of every museum's mission statement. Of course, other goals may be unique to a particular museum. Whatever the institutional goals, they provide a foundation for any design project.

User needs assessment is the next step in understanding

users. Who will use the space? How many people? What activities will they be engaged in? How much space is requires for these activities? Shettel (1989) and others argue that for exhibitions, three questions are important: What do users already know about the subject matter? What, if any, misconceptions do they have? And What is most interesting to them? Borun (1988; 1989) found that a high proportion of visitors had misconceptions about gravity and air resistance. This knowledge allowed the Franklin Institute to design an exhibit that addressed and corrected these misconceptions.

Information gathering during all phases of evaluation should involve multiple methods. Self-report, direct observation, trace/decay (physical evidence such as littering or pathway wear on grass, etc.), archival records, and literature reviews are all appropriate methods. Relying on limited sources of information can result in misleading conclusions.

A literature review should be a required aspect of understanding users. A growing body of literature on visitors is available. For example, publications such as *Visitor Behavior*, technical reports from the Center for Social Design, *ILVS Review*, and the *ILVS Bibliography and Abstracts, 2nd Edition* are devoted exclusively to an understanding of visitors. Other publications such as *Curator*, and *Journal of Museum Education* often contain relevant articles.

Update: Many additional resources are now available. The Visitor Studies Association allows downloading of previous publications. Also: University of Pittsburgh, National Science Foundation, etc.

Involving users is the second stage of social programming. Users are often surveyed or interviewed to obtain input. Needs and preferences are obtained, but can be misleading on occasion. For example, if you ask visitors if they prefer longer exhibit labels, the answer is generally "yes," even though visitors are less likely to stop and read long labels (e.g., Borun & Miller, 1980).

The way information is collected and used in design can have an impact on results. One option is to collect information from the users and pass it on to the designer who then creates the design. Another option is to allow users to choose among completed designs. A third option is to allow users to arrange components provided by the designer. The first option gives visitors less choice with respect to the final design. The second option (allowing visitors to choose among completed designs) requires more time and expense to prepare. The third option generally requires elaborate mock-ups. The particular choice from these options will depend on many factors including time constraints and resources available.

The third aspect of social programming is the *formulation of design guidelines*. This requires applying information collected about visitors to the planning process. State another way, formulation design guidelines requires interpreting information about the characteristics and behavior patterns of visitors, actual or potential. Although design guidelines may be unique to each project, some generalities can be made. For example, the following list encompasses most of the general design guidelines for museum users:

· *Visitor learning.* How can the exhibits be designed to

maximize learning? Design guidelines for learning require a consideration of visitor comprehension of the material as well as attracting and holding visitor attention. Visitors will not learn if they don't pay attention to the interpretive devices.

- *User satisfaction.* The museum must be designed to produce enjoyable experiences for visitors as well as satisfying work experiences for staff.
- *Physical comfort and safety.* Can physical fatigue, temperature control, physical safety of visitors and staff be assured by the design?
- *Social contact.* Are the exhibits designed so that the visitor is free to engage in social interaction when he/she wishes? Is the visitor or staff member able to limit social interaction when it is desired?
- *Design flexibility.* It is desirable to design exhibit components that can be easily replaced or altered.
- *Cost-effectiveness.* Budgets are invariably limited and the cost effectiveness of the design has to be an important design factor.
- *Maintenance.* Particularly for interactive exhibits, repair and maintenance problems must be seriously considered. It is better not to have an interactive exhibit than to have one that is frequently broken down.

The above design guidelines obviously follow from the goals of social design. How these guidelines are stated is of

critical importance. Many evaluators (e.g., Screven, 1976; 1988) argue that these design guidelines should be stated as measurable objectives. Miles (1986), on the other hand, argues that behavioral objectives do not necessarily lead to good designs. Instead, he suggested that "teaching points" should be formulated. Whether they are called *objectives* or *teaching points*, it is important to make clear the aims or intentions of an exhibit project.

Develop (design and construction)

After design guidelines are established, they must be translated into specific plans. Gufford (1987) argued that "the social researcher's job is to advocate as many design considerations benefiting users as possible." Evaluation during the development phase can be thought of as a two-step process: first, a symbolic "walk through," and second, a trial test of design. A trial test is usually called "formative evaluation" or "mock-up" evaluation.

Symbolic walk-through of the plan or design (critical appraisal). Once the design concept is placed on paper, then it is possible to walk-through or visualize how the spaces might work from the perspective of its users. In doing so, design flaws are often revealed. All user groups can be involved in this walk-through exercise. Roger Miles' term, "critical appraisal" (Miles, 1986; 1988) is a fitting concept to use here, although I am not sure he would approve of how I am expanding the concept. Miles (1988) stated, "A critical appraisal is a report, prepared by a critic with no axe to grind, on the scientific, educational, and design

aspects of an exhibition in the light of the original aims of the design team." (p. 28). It is important that the walk-through or critical appraisal involve informed judgment – based on thorough knowledge of the visitor studies literature.

Trial test (prototype or mock-up test). In some cases an inexpensive prototype can be tested before the final installation of the project. Shettel, et al (1968) was apparently the first to conduct a mock-up study in museums. Since that time, many have advocated some type of trial test (e.g., Loomis, 1987; 1988; McNamara, 1988; Miles, 1988; Screven, 1988). Trial testing can take many forms. For example, Miles (1986; 1988) described the approach taken by the British Museum as "quick and dirty" or "rough and ready" formative evaluation. Loomis (1988) suggested several levels of formative evaluation: preliminary shakedown; consumer panel; and mock-up studies with visitors. Whatever the form, significant changes usually occur during the process creating a more effective exhibit in almost all cases. There are situations where mock-up evaluation may be difficult as in the development of audio-visual presentations (see Miles, 1989).

Update: The above discussion failed to discuss the iterative process of test-modify-test-modify that takes place during formative evaluation. In addition, it failed to recognize that mock-up boards can be, and are often, used in developing audio-visuals.

Post-installation or post-occupancy (use and adaption)
After completion of the exhibit or program, evaluation can

take the form of an actual walk-through by the evaluation team (post-installation critical appraisal) and, secondly, the collection of user reactions to the completed project (that is, how visitors actually use the space). Evaluation during this phase of a project has been called *post-occupancy evaluation* or *summative evaluation*. This process of fine tuning a completed project might take the following steps:

1. *Walk-through of completed facility before adjustments.* When the project is complete, an actual trip through the building or exhibition by an evaluator or evaluation team can help to identify additional problems. This "critical appraisal" would be similar to the one during the development phase except that, in this case, the physical space is already completed or the program is already implemented.

2. *User feedback.* Systematic data from users or potential users can provide valuable information upon which to consider design changes before final revisions.

3. *Adjustments.* Based on the walk-through and user feedback, changes can be made. Some projects put aside a percentage of the total budget for making minor changes after the project has been completed (e.g., Litwak, 1989).

After adjustments are made, another round of information gathering might occur with potential further adjustments in the future. This process, of course, is limited by the resources available and the severity of problems. It would not

be cost-effective to spend 90% of the resources making small improvements that may be barely noticeable.

Update: After this paper was published, a new type of visitor evaluation was proposed by Chan Screven (1990) called "remedial evaluation." Remedial is carried out during the post-installation stage, but is similar to formative evaluation in that it uses trial-testing of exhibit changes.

Emerging social design guidelines for museums

We have learned much in the last 60 years of social design research in museums. The following summary suggests some of the findings.

Visitor orientation and circulation

Visitor orientation and circulation is of great importance in museum settings. There are several useful overviews on this topic (Bitgood, 1988; Griggs, 1983; Loomis, 1987). Orientation and circulation can be divided into the various stages of a visit: pre-visit or off-site orientation; arrival orientation; orientation and circulation through exhibits; and exiting orientation.

Pre-visit orientation: Orientation problems begin long before visitors arrive at a museum. Loomis (1987) states: "Orientation begins with the images and messages that inform the public of the existence and location of a particular museum" (p. 165). Publicity and word-of-mouth are an important part of pre-visit orientation (Adams, 1983; 1988; Hayward & Brydon-Miller, 1984). Pre-visit problems are either psychological (based

on prior visitor experiences and expectations) or physical (obtaining directions to the facility and following directions).

Hayward and Brydon-Miller (1984) found that visitors often had misconceptions about what they would experience at a historical village in Massachusetts, even though many had been to a similar facility in the past. If visitor expectations are high and these expectations are not met, the museum visit is likely to be a less enjoyable experience. Obtaining information on visitor expectations can help to develop more effective publicity programs based on what visitors know or don't know (Adams, 1988).

Many travellers depend upon road signs to provide directions to a museum. Road signs, however, can be confusing if poorly designed. Road signs directing visitors to the Huntsville Space & Rocket Center sometimes say *Space Center*, other times, *Space Museum*, and these two sets of signs can be easily confused with other signs in Huntsville that say *Museum Tour* (Bitgood & Benefield, 1989).

Arrival orientation: Once the visitor has arrived at the museum, new problems emerge. Parking is a common problem for museum visitors. Difficulty in finding the entrance is another unnecessary problem. If the entrance is not visible from the parking area, directional signs should be provided. Perhaps the most important aspect of arrival orientation is entrance or lobby orientation. In a previous publication (Bitgood, 1988), I suggested that entrance orientation devices be designed so that they attract visitors, hold their attention, and can be easily understood. To meet these criteria orientation devices should:

- be easily accessible to visitors (preferably in the visitors' normal pathway);
- information should be concisely displayed (since visitors won't spend much time in an orientation area);
- involve multimedia (visitor seem to prefer a variety of devices including film, slides, posters);
- should not compete with exhibits (if exhibits are visible from the orientation area, visitors tend to bypass the orientation displays).

Orientation and circulation through exhibits: Several problems occur when visitors attempt to view exhibits. Thematic orientation devices attempt to communicate the overall theme of the exhibit. They tell visitors what an exhibit or museum is all about. Visitors often have difficulty in understanding abstract themes, and consequently, simple themes may be preferred. For example, Bitood & Patterson (1987) found that visitors at the Anniston Museum Natural History could not match exhibits with them titles because the theme titles (e.g., "Designs for Living") were not intuitively connected to the actual exhibits.

Another aspect of thematic orientation is pre-knowledge of things to do at a museum. At the Space & Rocket Center in Huntsville, AL, Bitgood & Benefield (1989) found that visitors were not aware of ticket options before they purchased their ticket. Even after purchasing their ticket they rarely knew how long it would take to see the Museum, ride the bus tour, and see the Omnimax movie.

Wayfinding devices direct visitors to where they want to go.

Within the museum, wayfinding devices include directional signs, hand-held maps, wall maps and other fixed maps, directories, and information booths. Several general principles appear to be important. For example, these devices should be placed where information is needed (e.g., at choice points). They should give as much information as possible without creating information overload. In addition, they should not compete with exhibits or other setting features. The use of landmarks as points of reference (Bitgood, 1988) make wayfinding devices more effective.

Visitor circulation devices determine how visitors travel through an exhibit and/or facility. Discrete pathways provide cues to visitors on which way to go. Melton (1935) demonstrated the influence of exit doors in visitor circulation. Visitors tend to walk along a direct path between the entrance and the first exit. After flirting with the notion that visitors should be encouraged to choose their own routes through an exhibit, Miles (1986) later concluded that the design should provide "firm guidance" through an exhibit to minimize bottlenecks, complex paths and confused circulation.

Exit orientation. Complex environments are sometimes more difficult to leave than to enter. I once found the x-ray room of a hospital with little difficulty by following directional signs. However, when I attempted to return to the parking lot, I couldn't retract my steps because all the directional signs were designed to getting there but not returning. It is important to make sure that orientation devices are provided that will direct users both into and out of the facility, especially if visual cues are absent.

In some settings finding your car once you leave a facility is a real challenge. Parking lots may be located on all sides of a facility. If parking lots are not marked by direction, number and sometimes color, there may be few other directional cues for visitors to locate their vehicle.

Exhibit evaluation from the visitor perspective

Several references provide rich sources of information on exhibit design (e.g., Loomis, 1987; Miles, 1986; 1988; Miles, Alt, Gosling, Lewis, & Tout, 1988; Patterson & Bitgood, 1988; Screven, 1986). The following discussion touches only a few of the relevant factors. The reader who is unfamiliar with the literature is encouraged to read the citations listed.

There are four general aspects of visitor-exhibit interaction that can be evaluated from a social design perspective:

- The meaning or message.
- Audience characteristics.
- Exhibit design variables.
- Architectural variables.

The *meaning or message* is usually communicated via labels or by some audio-visual device. Thus, a discussion of the message will be given in the next section on label design. Occasionally, it is argued that the exhibit object itself contains the message, particularly in fine arts exhibits. Discussion of this problem requires separate treatment and will not be discussed here. It is, however, important to realize that the exhibit objects and the exhibit label produce an interactive effect on visitor

behavior. Labels are designed to give meaning to objects. One way they can do this is to direct the visitors' attention to various aspects of the exhibit.

Audience characteristics: Patterson & Bitgood (1988) list several psychological factors related to visitors that must be considered in exhibit design. Exhibits that encourage visitor participation or involvement produce a more enjoyable experience and often more learning. Object satiation (Robinson, 1928) occur after viewing similar exhibit objects again and again. Cognitive factors (e.g., amount of invested mental energy) have been propose as another fruitful area of study (Koran, Koran, & Foster, 1989). Other visitor factors of interest include special interests, demographics, perception of objects, social facilitation, and comfort.

Exhibit design factors: Shettel et al (1968) identified a number of design factors that may be important in the success of exhibits. However, for purposes of review, the factors discussed by Patterson & Bitgood (1988) will be used, recognizing that many other variables are involved.

Other factors being equal, larger objects draw more visitor attention than smaller ones (Bitgood, Patterson, Benefield, 1988; Melton, 1935). In art museums, Melton observed that larger paintings received more visitor attention than smaller ones. And at zoos, Bitgood, et al (1988) found that the same generalization holds for animal size. Bitgood, Conroy, Pierce, Patterson, & Boyd (1989) found a similar correlation between viewing time and size of object for mounted animals in an exhibit of North American predators and prey.

Placement of exhibit objects appear to be an important factor. It includes a number of relational factors. One can consider the relation of an exhibit object with respect to: other exhibit objects, circulation flow, exits and entrances, other components of the same exhibit, etc. Melton (1935) showed that placement of paintings with respect to exits was one of the most powerful factors in determining visitor attention. In several studies, visitors tended to travel along only one wall of a gallery and exit at the first opportunity instead of circulating to the opposite wall.

Exhibits with movement attract more attention than those that are static. Melton (1935) reported that a moving machine in a science and industry museum increased the number of visitors who were attracted to the exhibit compared with the same exhibit when the machine was not in motion. Bitgood et al (1988) reported a high correlation between animal movement and visitor viewing time at zoos – active animals had an average of twice the viewing time than inactive ones.

Exhibits that impinge on more than the visual sense appear to attract more attention. Exhibits with interactive components (where an action causes a reaction from the exhibit such as pushing a button and causing a light to come one) hold attention better than those without interactive capabilities.

Other exhibit factors such as aesthetic qualities (shape, color, pattern) and novelty or rarity (the Hope Diamond, white tigers, pandas) are important for attracting visitor attention.

Architectural factors: There are many physical, non-exhibit

factors that influence visitor attention. Visibility (resulting from lighting effects, visual obstacles, and glare) will obviously affect exhibit viewing (Patterson & Bitgood, 1988). Proximity of the visitor to the object/animal (Bitgood, Paterson, & Benefield, 1988), naturalism/realism, and sensory competition are also important factors. Sensory competition usually come from visual or auditory stimuli. Two exhibit objects adjacent to one another will often compete for attention (e.g., Bitgood, Patterson, & Benefield, 1988; Melton, 1972).

Evaluating labels and graphics from a visitor perspective
The traditional visitor approach to the design of labels has placed the primary emphasis on the message (e.g., Screven, 1976; 1986; Shettel, 1973). Thus, the application of instructional technology has been one of the major focuses of visitor studies. The reader is referred to Screven's (1986) guidelines for the planning and development of labels and suggestions for motivating the reader of labels.

It is also common to find principles obtained from research on textbook typography and apply them to exhibit labels. Because of this, factors such as font style, number of characters per line, etc. may be given exaggerated importance. Few museum studies have analyzed the effects of typographic modifications on label text. Many of the factors discussed above for exhibit design affect visitors' attention to labels, i.e., placement with respect to exhibit objects, other labels, vertical height, visual line of sight, and visitor traffic flow. Based on our work and a review of the literature, we have concluded that

some of the most important factors (other than the content of the message) are: number of words per label, placement of labels with respect to line-of-sight, and size of letters.

Number of words per label: In several studies (Bitgood, Nichols, Patterson, Pierce, & Conroy, 1987; Thompson & Bitgood, 1988; Bitgood, Conroy, Pierce, & Patterson, 1989) we have found that labels with fewer words are read by more visitors. For example, in one study (Bitgood, et al, 1987) we divided a label of 150 words into three labels of 50 words each and obtained an increase from 11% to 26% reading.

Placement with respect to visitor line-of-sight: Line-of-sight can include several features: vertical height, peripheral vision, etc. Basically, line-of-sight refers to the range of visual attention as a visitor walks through the exhibit area. What features draw his/her attention? Those objects that can be easily seen without turning your head or body would fall into your lien-of-sight. Thus, placing labels behind an exhibit requires that a visitor turn around in order to read. Visitors are unlikely to do this!

Studies from several facilities illustrate the importance of line-of-sight placement. Bitgood, Benefield, & Patterson (1989) describe a study of prototype signs at the NC Zoo in which the position of exhibit labels was systematically placed in several positions at various exhibits. In almost every comparison, placement of labels on the railing in an angular position facing the visitors produced a higher percentage of readers than when placed either in a side or an overhead position. Since the rail placement is more obviously within the visitors' line of sight,

these results were interpreted as being consistent with the line-of-sight hypothesis.

Another factor is the proximity of the label to the exhibit object.

Size of letters (font size): It is obvious that letters must be of sufficient size to be read easily. It seems that increasing the size beyond what is sufficient make reading more likely. Increased size makes the or sign more salient. In a study reported above (Bitgood, et al, 1987), we assessed the effects of increasing the letter size of labels from 24- to 48-point font and found an increase in readers of about 15 percent.

Evaluation of museum programs

Of all the various types of museum programs, school field trips have received the greatest amount of attention from evaluators (Bitgood, 1989; Koran, 1989). Evaluations of field trips have been primarily summative in nature (assessment of the completed program with no changes built into the evaluation) rather than front-end (during planning stage) or formative (during the development stage). There is often a tendency to make field trip experiences similar to classroom experiences, thus not taking advantage of the unique qualities of the museum environment. Planning efforts should explicitly deal with the question of how the program can take advantage of the uniqueness of informal learning settings. In addition, prior knowledge, misconceptions, and interests of students are important to determine what should be taught (in addition to curriculum considerations).

Evaluation of pre-visit preparations has found that careful preparation of students results in greater learning (e.g., Balling & Falk, 1982; Falk, Martin, & Balling, 1978; Gennaro, 1981; Martin, Falk, & Balling, 1981; Melton, Feldman, & Mason, 1936). Preparing students for the instructional objectives is not enough. Studies by Falk and his colleagues (see above) demonstrate that students must be prepared for a novel environment or they will learn little about the instructional material.

On-site field trip activities have included a variety of experiences: lectures, demonstrations, guided and unguided tours of the museum, worksheets, and various kinds of audio-visual presentations. All of these experiences seem to have advantages and disadvantages. For example, students may learn more with structured tours, but they develop more positive attitudes with unstructured tours (Stronck, 1983).

Evaluators/researchers from the social design perspective have barely begun to understand the school field trip experience in museums. More research is needed during all phases – planning, development, and final implementation.

Evaluation from the staff perspective

Social design emphasizes input from all the users of a facility. Thus, museum staff must be considered as an important user group. Staff needs from both physical and social perspectives must be addressed including: Does the design of the museum facilitate work performance? Do staff members get positive feedback from visitors and administrators? Do staff members have the resources (equipment, supplies, time) to accomplish

their objectives? Are social needs of workers being addressed? Are performance expectations clear to staff?

In attempting to collect relevant information from staff, several difficulties arise. For example, the small number of staff in most museums makes it difficult to evaluate data in a scientific manner. In addition, there is always a power differential among staff members and the more powerful those in higher positions of power expect their input to be weighed more heavily than others. Third, there is frequently conflict between curatorial and visitor objectives. The curator/designer may be more concerned about the aesthetics of the exhibit, while the visitor may be more concerned about understanding the message. In addition to the aesthetics-meaning conflict, it is common (particularly in zoos) to encounter a naturalism-education conflict. Decision makers may be reluctant to spoil the naturalism of an exhibit by placing exhibit labels within the exhibit, preferring instead to have a separate interpretive area. When information is far from the animals/objects it describes, it is less likely to be read.

It is important to realize that staff usually benefit when a museum is well-designed from the visitor perspective. If visitors can find their way easily, fewer wayfinding questions are asked, leaving staff more time to carry out their work. Fewer visitor complaints should also result from careful social design.

Conclusions

The social design movement has made substantial inroads in museums, particularly since the late 1960s. It may be an

opportune time to assess where we are and where we need to go if this movement is to continue on track. While the social design perspective is alive and well, it is far from dominating decision making in the design of exhibits and programs in museums and related institutions. Key decision makers in museums must be persuaded to adapt the basic philosophy of social design. We have much work to do.

Originally published in Technical Report #89-20. Jacksonville, AL: Center for Social Design (1989).

References

Adams, G. D. (1983). *Museum public relations.* Nashville, TN: American Association for State & Local History.

Adams, G. D. (1988). Understanding and influencing word-of-mouth. In S. Bitgood, J. Roper, & A. Benefield (eds.), *Visitor Studies - 1988: Theory, research, and practice.* Jacksonville, AL: Center for Social Design.

Alt, M. (1980). Four years of visitor surveys at the British Museum (Natural History). *Museums Journal,* 80, 10-19.

Alt, M., & Griggs, S. (1984). Psychology and the museum visitor. In J. Thompson (ed.), *Manual of curatorship: A guide to museum practice.* London: Butterworths. Pp 386-393.

Alt, M., & Shaw, ?? (1984). Characteristics of the ideal museum exhibits. *British Journal of Psychology,* 75, 25-36.

Balling, J., & Falk, J. (1980). A perspective on field trips: Environmental effects on learning. *Curator,* 23(4), 229-240.

Bitgood, S. (1988). Problems in visitor orientation and circulation. In S. Bitgood, J. Roper, & A. Benefield (eds.), *Visitor studies - 1988: Theory, research, and practice.* Jacksonville, AL: Center for Social Design. Pp. ??

Bitgood, S. (1989). School field trips: An overview. *Visitor Behavior,* 4(2), 3-6.

Bitgood, S., & Benefield, A. (1989). *Visitor orientation at the Space & Rocket Center.* Jacksonville, AL: Center for Social Design.

Bitgood, S., Conroy, P., Pierce, M., Patterson, D., & Boyd, J. (1989). Evaluation of Attack & Defense at the Anniston Museum of Natural History. In *Current trends in audience*

research and evaluation. San Francisco, CA: American Association of Museums' Committee on Evaluation & Research.

Bitgood, S., Nichols, G., Patterson, D. Pierce, M., & Conroy, P. (1987). Designing exhibit labels from experimental research. In *Current trends in audience research and evaluation.* San Francisco, CA: American Association of Museums' Committee on Evaluation & Research.

Bitgood, S., & Patterson, D. (1987). Orienting and wayfinding in a small museum. *Visitor Behavior,* 1(4), 6.

Bitgood, S., Patterson, D., & Benefield, A. (1988). Exhibit design and visitor behavior: Empirical relationships. *Environment and Behavior,* 20(4), 474-491.

Bitgood, S., Pierce, M., Nichols, U., & Patterson, D. (1987). Formative evaluation of a cave exhibit. *Curator,* 311(I), 31-39.

Bitgood, S. Roper, J., & Benefield, A. (1988). *Visitor studies – 1988: Theory, research, and practice.* Jacksonville, AL: Center for Social Design.

Borun, M.(1989). Naive notions and the design of science museum exhibits. In S. Bitgood, A. Benefield, & D. Patterson (Eds.), *Visitor studies: Theory, research, and practice, Volume 2.* Jacksonville, AL: Center for Social design. (Pp. 158-162).

Boron, M., & Miller, M. (1980). *What's in a name?* Philadelphia, PA: Franklin Institute and Science Museum.

Falk, J., & Balling, J. (1980). The field trip milieu: Learning and behavior as a function of contextual events. *Journal of Educational Research,* 76(1), 10-13.

Gennaro, E. (1981). The effectiveness of using pre-visit instructional materials on learning for the museum field experience. *Journal of Research in Science Teaching*, 18, 275-279.

Gifford, R. (1987). *Environmental psychology: Principles and practice*. Boston: Allyn & Bacon.

Griggs, S. (1981). Formative evaluation of exhibits at the British Museum. *Curator*, 24(3), 189-202.

Griggs, S. (1983). Orienting visitors within a thematic display. *International Journal of Museum Management and Curatorship*, 2, 119-134.

Griggs, S. (1984). Evaluating exhibitions: In J. Thompson (Ed.), *Manual of curatorship: A guide to museum practice*. London: Butterworth's. Pp 412-422.

Hayward, J. (1989). Visitor research for exhibit development: An overview of options in "formative evaluation." *The Exhibitionist*, Spring, 5-7.

Hayward, J., & Bryden-Miller, M. L. (1984). Spatial and conceptual aspects of orientation: Visitor experiences at an outdoor history museum. *Journal of Environmental Education*, 13(4), 317-332.

Hood, M. (1983). Staying away. Why people choose not to visit museums. *Museum News*, 61(4), 50-57.

Hood, M. (1985). *Marketing to new audiences - Or, prospecting for trends in the year 2000*. AAZPA 1985 Annual Proceedings. Columbus, OH: American Association of Zoological Parks & Aquariums.

Hood, M. (1986). Getting started in audience research. *Museum*

News, 64(3), 24-31.

Hood, M. (1988). Arboretum visitor profiles as defined by the four seasons. In S. Bitgood, J. Roper, & A. Benefield (eds.), *Visitor studies - 1988: Theory, research, and practice.* Jacksonville, AL: Center for Social Design.

Koran, J.J., Jr., Koran, M. L., & Freeman, P. (1976). Acquisition of a concept: Effects of mode of instruction and length of exposure to biology examples. *AV Communications Review*, 24(4), 358-366.

Koran, J.J.,Jr., Koran, M. L., & Ellis, J. (1989). Evaluating the effectiveness of field experiences: 1939-1989. *Visitor Behavior*, 4(2), 21-26.

Loomis, R. (1973). Please! Not another visitor survey! *Museum News*, 52(2), 21-26.

Loomis, R. (1987). *Museum visitor evaluation: New tool for museum management.* Nashville, TN: American Association for State & Local History.

Loomis, R. (1988). The countenance of visitor studies in the 1980s. In S. Bitgood, J. Roper, & A. Benefield, (Eds.), *Visitor studies - 1988: Theory, research, and practice.* Jacksonville, AL: Center for Social Design.

Loomis, R., Fusco, M., Edwards, R., & McDermott, M. (1988). The visitor survey: Front-end evaluation or basic research? In S. Bitgood, J. Roper, & A. Benefield, (Eds.), *Visitor studies - 1988: Theory, research, and practice.* Jacksonville, AL: Center for Social Design.

Martin, W., Falk, J., & Balling, J. (1981). Environmental effects on learning: The outdoor field trip. *Science Education*, 65(3),

301-309.

Melton, A. (1935). *Problems of installation in museums of art*. New Series No. 14. Washington, DC: American Association of Museums.

Melton, A. (1972). Visitor behavior in museums: Some early research in environmental design. *Human Factors, 14*(5), 393-403.

Melton, A., Feldman, N., & Mason, C. (1936). *Experimental studies of the education of children in a museum of science*. New Series No. 15. Washington, DC: American Association of Museums.

Miles, R. (1986). Lessons in "Human Biology" – Testing a theory of exhibition design. *The International Journal of Museum Curatorship, 5*, 227-240.

Miles, R. (1988). Exhibit evaluation in the British Museum (Natural History). *ILVS Review, 1*(1) 24-33.

Miles, R., & Alt, M (1979). British Museum (Natural History): A new approach to the visiting public. *Museums Journal, 78*(4), 158-162.

Miles, R., Alt, M., Gosling, D., Lewis, B., & Tout, A. (1988). *The design of educational exhibits*, 2nd Edition. London: Allen & Unwin.

Miles, R., & Tout, A. (1978). Human biology and the new exhibition scheme in the British Museum (Natural History). *Curator, 21*(1), 36-50.

Robinson, E. (1928). *The behavior of the museum visitor*. New Series No. 5. Washington, DC: American Association of Museums..

Screven, C. (1969). The museum as a responsive learning environment. *Museum News, 47*(10), 7-10.

Screven, C. (1973). Public access learning: Experimental studies in a public museum. In R. Ulrich, T. SStachnik, & J. Mabry (Eds.), *The control of human behavior*, Vol. 3. Glenview, IL: Scott-Foresman, Pp 226-233.

Screven, C. (1974a). Learning and exhibits: Instructional design. *Museum News, 52*(2), 67-75.

Screven, C. (1974b). *The measurement and facilitation of learning in the museum environment: An experimental analysis.* Washington, DC: Smithsonian Press.

Screven, C. (1975). The effectiveness of guidance devices on visitor learning. *Curator, 18*(3), 219-243.

Screven, C. (1976). Exhibit evaluation: A goal-referenced approach. *Curator, 19*(4), 271-290.

Screven, C. (1986). Exhibition and information centers: Some principles and approaches. *Curator, 29*(2), 109-137.

Shettel, H. (1976). *Atoms in Action Demonstration Center impact studies: Dublin, Ireland, and Ankara, Turkey.* Report No. AIR-F58-11/67-FR. Washington, DC: American Institutes for Research.

Shettel, H. (1968). An evaluation of existing criteria for judging the quality of science exhibits, *Curator, 11*(2), 137-153.

Shettel, H. (1973). Exhibits: Art for or educational medium? *Museum News, 52*, 32-41.

Shettel, H. (1976). *An evaluation of visitor response to "Man in his Environment."* Report No. AIR-43200-7/76-FR. Washington,

DC: American Institutes for Research.

Shettel, H. (1978). A critical look at a critical look: A response to Alt's critique of Shettel's work. *Curator, 21*(4), 329-345.

Shettel, H. (1989). *Front-end evaluation.* AAZPA 1989 Proceedings. Pittsburgh, PA: American Association of Zoological Parks & Aquariums.

Shettel, H., Butcher, M., Cotton, T. S., Northrop, J., & Slought, D. (1968). *Strategies for determining exhibit effectiveness.* Report No. AIR E95-4/68-FR. Washington, DC: American Institutes for Research.

Shettel, H., & Shumacher, S. (1969). *Atoms in Action Demonstration Center impact studies: Caracas, Venezuala and Cordoba, Argentina.* Report No. AIR-F58-3/69-FR. Washington, DC: American Institutes for Research.

Shettel-Neuber, J. (1986). *The Whittier Southeast Asian exhibits: A post-occupancy evaluation and comparison with older exhibits.* Technical Report No. 86-80. Jacksonville, AL: Center for Social Design.

Sommer, R. (1983). *Social design: Creating buildings with people in mind.* Englewood Cliffs, NJ: Prentic-Hall.

Stronck, d. (1983). The comparative effects of different museum tours on childrens' attitudes and learning. *Journal of Research in Science Teaching, 20*(2), 283-290.

Walker, E. (1988). A front-end evaluation conducted to facilitate planning the Royal Ontario Museum's European Galleries. In S. Bitgood, J. Roper, & A. Benefield (Eds.), *Visitor studies – 1988: Theory, research and practice.* Jacksonville, AL: Center for Social Design.

3

The Anatomy of an Exhibit

Update: The following paper attempts to analyze the elements of an exhibit. A thorough analysis is important in order to identify variables that may influence visitor attention which can be used to guide research as well as design. The following analysis identifies both the components (objects, media, text) and the perceptual relationships among these components. Perceptual relationships include distance, size, color, movement, texture and shape. It is a contrast between these perceptual relationships that is dominant in visitor attention.

An educational exhibition center, whether it be a museum, zoo, aquarium, science-technology center, or some other type of informal educational facility, is an extremely complex environment. Unlike a formal classroom that is relatively barren of objects, most exhibition centers are packed with the sights and sounds of objects and media. Unlike the classroom where the learner remains seated and is exposed to one message at a time, the visitor to an exhibition center is free to wander through an environment rich in sensory stimulation, where attention to one object or message may compete with another. In addition, the motivation of learning differs. In a formal educational setting, people are expected to learn (enjoyment is not required); while in an exhibit center, one of the visitors' major goals is to enjoy themselves whether or not they learn anything. Given the complexity of the exhibit environment and the motivational goals of the audience, it is especially important to have an understanding of how these environmental components influence and are

processed by the visitor. This paper attempts to provide a detailed analysis of the exhibit environment – an important task if we are to understand how to design exhibits more effectively. Recognition must be given to the many previous researchers whose ideas have helped to shape the current analysis. In addition, many of the ideas presented in this article are the product of an ongoing collaborative project with Don Thompson (e.g., Bitgood & Thompson, 1992).

"Exhibit" defined

Before proceeding further, the problem of defining an exhibit will be addressed. There is often confusion when the word "exhibit" is used. It is sometimes used to mean a single display, sometimes applied to a series of displays dealing with the same, specific topic (e.g., "How airplanes fly"), and sometimes used to mean a large collection of displays with a common theme (e.g., "Electricity"). In this article, a distinction is made between an exhibit unit (the display), an exhibit group (two or more displays on the same topic), an exhibit area (a collection of displays with similar, general theme), and an exhibition (the entire collection of exhibit areas that make up a themed area).

In this article, the exhibit unit (display) is defined as a combination of two factors: exhibit components, and the configuration or relationships among these components. Fig. 1 illustrates these two factors comprising an exhibit unit.

The exhibit components

An exhibit unit is made up of one or more of the following

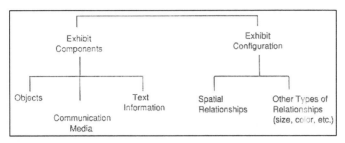

Figure 1: The exhibit unit.

three components: exhibit objects; communication (presentation) media; and text information to be communicated. Does an exhibit unit have to include all three of these components? Not necessarily. For example, a text panel alone would be an exhibit, although not necessarily a particularly effective one. Some exhibits include only media and text information (e.g., interactive computers).

Exhibit objects

Exhibit objects might include a painting, a sculpture, a piece of furniture, or a piece of china in an art museum; they might also include live animals in a zoo or mounted animals in a natural history museum. While science exhibit devices that attempt to illustrate a principle of science are not usually thought of as "exhibit objects," it can be argued that they are. For example, according to the viewpoint in this article, an electrical circuit which the visitor is required to connect to a battery is considered to be an "exhibit object." An exhibit object is defined as a visible or tangible thing that does not present text information.

Objects have varying degrees of importance in exhibits. Art museum exhibits place heavy emphasis on objects (paintings and sculpture) with media and text information often playing a secondary role (although visitors generally prefer more information if presented in a digestible manner). Other exhibits (e.g., an interactive computer) may contain a communication media device and information, but no exhibit objects.

While objects may convey meaning to visitors (e.g., "This is an important object because it is in the museum"), such meaning is not explicit and must be distinguished from the "text information" component of an exhibit which uses explicit language. It is also important to emphasize that the meaning that objects communicate to visitors may not be what is intended by the exhibit designers. In fact, it may be just the opposite!

To understand the impact of exhibits on people, we must understand which characteristics of objects have the strongest impact on visitors, and the qualitative nature of this impact. Fig. 2 provides a list of a few of the characteristics that are likely to have a significant impact on visitors.

The visitor literature includes many studies related to these characteristics. A few examples will illustrate:

- Larger objects attract and hold visitor attention better than smaller objects (Bitgood, Patterson, & Benefield, 1988)
- Objects in motion are more attention-getting than static objects (Bitgood, et al, 1988; Melton, 1972)

Characteristics of exhibit objects		
Size	Shape	Color
Sense modality	Motion	Dimension
Shape	Texture	Material

Figure 2: Characteristics of exhibit objects.

- Multi-sensory modalities (visual + sound) increase attention (Peart, 1984)
- Three-dimensional objects usually draw more attention than do two-dimensional (Peart, 1984)

These findings suggest that the major effect of exhibit objects is to capture visitor attention and to help sustain this attention. While objects convey meaning to visitors, that meaning is often personal, reflecting an interaction between visitor and exhibit object variables.

There are other characteristics from Fig.2 for which less data is available. For example, we do not know the effects of shape, color, and texture on visitor attention. To minimize confusion, an important distinction should be made here between object characteristics when the objects are in isolation versus objects in relationships in relation to other objects. (In the next section on the configuration of exhibit components, the relationship among objects and other components will be discussed.) Thus, an object that is relatively larger than other objects in a display may capture more attention because of its relational properties. These relational properties should be distinguished from

Examples of communication media		
Label panels	Flip or side panels	Museum guides
Diagram panels	Viseo/movie	Geographic maps
Computers	Audio guides	Exhibit guides

Figure 3: Examples of communication media.

the absolute characteristics. For example, a large object by itself will attract more attention than will a smaller object in isolation, all other things being equal.

Communication media

Almost every exhibit contains some type of device or vehicle for presenting text information. In fact, exhibits that do not provide text information are frequently misunderstood by visitors (e.g., Borun & Miller, 1980; Shettel, et al, 1968). Text information can be presented using many different types of communication devices or media. A medium may be as simple as a label panel or as complicated as an interactive computer with a random-access laserdisc. Fig. 3 provides a list of many of the commonly used communication media.

Communication media can be described in terms of their characteristics just as exhibit objects are in the discussion above. The list of the properties that make objects salient (e.g., size, motion, sense modalities as shown in Fig. 2) also apply to media. Thus, a large-screen audio-visual display will be given more initial attention by visitors than will a smaller screen display.

Miles, Alt, Gosling, Lewis, & Tout (1982) have classified

media into two major categories: static (those that do not change state) and dynamic (devices that change their state). Dynamic media include automaton (change in state is automatically programmed), operant (the change in state is determined by the visitor), and interactive (a "dialogue" between visitor and device can occur). Consistently, dynamic (and especially interactive) media have been more effective than static ones in terms of gaining visitor attention.

Several useful discussions of communication media can be found in the literature:

- Alt (1979) and Miles (1989) have reviewed studies of audio-visual devices developed at the Natural History Museum (London). These articles provide useful guidelines for the design of such devices.
- Screven (1986; 1992) and Bitgood (1990b) have reviewed findings and/or offered suggestions regarding the design of text information devices.
- Bitgood (1991c) reviewed the literature and suggested guidelines for developing interactive exhibits including media devices.
- Screven (1990a) and Serrell (1992) have specifically addressed the use of interactive computers as a medium of communication in exhibits.

Text information

Analysis of the text information component of an exhibit is more complex than of objects and communication media. Since the educational messages of an exhibit are presented

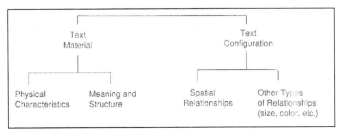

Figure 4: Analysis of text information.

in either written or auditory format, the use of language is a critical part of the exhibit's impact. The "text information" component deals with language, both in terms of how it is presented and its meaning. Fig. 4 provides an analysis of the text information component. (We use the word "text" to refer to both written and verbal information.) Text information can be analyzed into two components: text material and text configuration. Text material includes both physical characteristics and meaning/structure. Fig. 5 lists many of the possible physical characteristics of text. Some of these characteristics have been shown to be critical in getting visitors to attend to the information.

Findings on the physical characteristics of the text include:

- Small units of information are more likely to be read (Bitgood & Patterson, 1993).
- High contrast between print and background increase reading (Smith, 1991)
- Larger point size produces greater visitor attention (Bitgood & Patterson, 1993)
- Presenting the information in a manner that makes it easy to scan (numbering, bulleting, underlining)

Physical characteristics of text information		
Typeface	Point size	Numbering, lettering, or bulleting
Word length	Line length	Background contrast
Size of text unit	Sentence length	White space
Headings	Mapping	Size of background

Figure 5: Physical characteristics of text information.

usually results in more effective communication (Hall, 1988; Kool, 1984).

While the physical characteristics of text are important for attracting and hold visitor attention, the meaning and structure of text are critical for communicating the exhibit's message. The reader is referred to Rand (1985) and Screven (1992) for more on this important topic. Some of the factors included in the meaning and structure of text are listed in Fig. 6.

Findings concerning the physical characteristics of the text include:

- Small units of information are more likely to be read (Bitgood & Patterson, 1993).
- High contrast between print and background increase reading (Smith, 1991)
- Larger point size produces greater visitor attention (Bitgood & Patterson, 1993)
- Presenting the information in a manner that makes it easy to scan (numbering, bulleting, underlining) usually results in more effective communication (Hall, 1988; Kool, 1984).

Factors relating to the meaning and structure of text		
Vocabulary	Sentence complexity	Density of information
Style	Subject-matter content	Relevance of words
Relevance	Clarity of writing	Connection to objects

Figure 6: Factors relating to the meaning and structure of text.

Empirical studies with visitors on the meaning and structure of text are rare. However, a few are available in the literature. For example:

- Visitors learn just as much when key ideas are presented as they do when given traditional paragraphs of text (Hall, 1988; Kool, 1985).
- Visitors are more likely to read when questions are used as headers (Hirshi & Screven, 1988).
- Subject matter that connects to the visitor in a meaningful way is more likely to be read (Bitgood, et al, 1989).

In addition to the physical characteristics and the meaning and structure of text material, one must consider how the text material is configured. As shown in Fig. 4, spacial and other types of relationships among text material may be important. Some of the configural relationships that may be important include:

- The spatial relationship between the text and the visitor.
- The distance between one panel of text and another.
- The relative position of panels of text on a vertical plane. Do visitors interpret higher on the plane to mean more important?

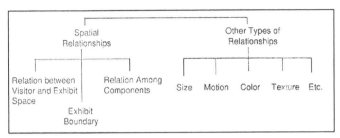

Figure 7: Exhibit configuration.

- The relative size of panels of text. Does larger mean more important?

Unfortunately, we have little empirical information on these possible configuration factors. There are some data available for the first factor (spatial relationship between the text and the visitor). Bitgood, Benefield, & Patterson (1990) found that visitors were most likely to read when the visitor is able to look at the exhibit objects and read at the same time.

Exhibit configuration

As described above and illustrated in Fig. 1, "exhibit components" (objects, media, text information passages) make up the first factor of an exhibit unit. The second major factor is how the exhibit components are configured (organized or arranged in relation to one another). We described configuration previously as it applies to text material; now we will consider the role of configuration for all of the exhibit components. Fig. 7 provides an analysis of exhibit configuration. In an effective exhibit, objects and

media must be organized by exhibit designers in a manner that facilitates rather than interferes with the communication of the educational messages. Of course, aesthetic factors must also play a role in the configuration of these elements. However, what is aesthetically pleasing/displeasing to the designer is not always what is pleasing/displeasing to the audience. For example, as many of us have learned during formative evaluation projects, designers are often unhappy with the unfinished look of temporary mock-up labels, while visitors do not seem to share this concern.

For purposes of discussion, relationships among exhibit unit components will be divided into "spatial relationships" and "other types of relationships." Each of these categories are described in more detail below.

Spatial relationships

Relationships between exhibit space and visitor space: Visitors and exhibit spaces are defined in the following way: visitor space is the area in which the visitor is allowed to move; exhibit space is the area which bounds the exhibit components. In many (if not most) exhibits, the visitor is denied access to the exhibit space by being prevented from either touching or walking into the exhibit. (Interactive devices, of course, are excepted.) The visitor is generally restricted to a path and often told not to touch objects. However, in some exhibits visitors and exhibit spaces may overlap. For example, in a walk-through exhibit, the visitor walks into the exhibit environment and is surrounded by exhibit components (such exhibits are often

immersion exhibits). In hands-on and interactive exhibits the visitor may be invited to touch and/or manipulate exhibit objects and the communication devices (e.g., computer). Exhibits that allow penetration of the exhibit space (either by walking into and/or by touching) seem to generate more prolonged attention (e.g., Bitgood, 1990a; Peers, 1991). Walk-through exhibits may be particularly effective in creating a feeling of "time and place" (Bitgood, 1990a). In addition, "hands-on" exhibits have proven particularly attractive to visitors (Gottfried, 1979; Koran, Koran, & Longino, 1986).

Relationships among exhibit objects: This includes the relation between primary and secondary (background) objects, the relation of one primary object to another, and the relation among secondary objects. A natural history museum diorama might contain a primary object (e.g., a mounted animal) surrounded by objects which make up the animal's natural habitat (e.g., trees, rocks, water). The goal of the exhibit may not be achieved if the secondary objects overpower the primary objects in some other way. The secondary objects in the case of a diorama may have two functions: (1) affective, i.e., they attempt to provide a more interesting context for the object (e.g., Thompson, 1993); and (2) cognitive, i.e., they try to provide some contextual information (e.g., what the animal's natural habitat is like).

The spatial relationships among primary objects is also important. Miles, et al. (1982) have described ways of manipulating spatial relations in order to give emphasis to a particular object. For example, placing one object in front of

others can isolate an object from others, or placing an object above others (on a higher plane) may help focus attention on the object.

In some cases, the spatial relationship among secondary objects could be important. For example, in a diorama, the spacing of vegetation might communicate the aridity of the habitat's climate.

Boundary of the exhibit unit: The exhibit unit's boundary defines the size of the exhibit space and marks a transition between one exhibit and another or an exhibit and some other type of space. The boundary can be defined by an exhibit case, or the visitor pathway, or some barrier, or the wall.

Other types of relationships

Other types of relationships among exhibit components in addition to space must be considered. The perceived relative size of one object with respect to other objects and media is important in getting visitor attention. Exhibit designers, when exhibiting a small object, usually scale down the size of the entire exhibit so that the primary object is not lost in its surroundings. The relative size of an object may also communicate what the designer thinks is important. So too with the visitor, a relatively large object may be perceived as being more important than smaller objects. (Data supporting or refuting this speculation could not be found when the visitor literature was reviewed).

Other comparative relationships among objects and media are likely to influence visitors. Miles, et al., (1982) suggest that

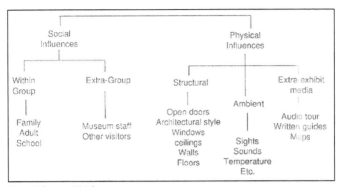

Figure 8: Extra-exhibit factors.

an object can be given emphasis by placing it with smaller objects, by placing it in front of a distinctive shape or texture for background, and by distinctive lighting of the object.

Extra-exhibit factors

Designing an effective exhibit is a juggling act. One must constantly balance the influence of the objects, the communication media, the text information, and the configuration of all of the components. In addition to the exhibit unit components and the configuration of these components, there is another set of variables that must be part of this juggling act – extra-exhibit factors. Fig. 8 summarizes the extra-exhibit factors. These factors include social and physical influences not specifically part of the exhibit unit.

Social influences

Both within-group and extra-group influences are important. Social influence within a visitor group will differ considerably depending upon the nature of the group (family, adult, school)

and the type of social interaction (asking questions, giving information, showing how to use an exhibit device, etc.). This point has been documented in many studies of family learning (Diamond, 1986; Hilke, 1988; Rosenfeld & Turkel, 1982).

Family group influences: There is considerable information from the literature about how family members influence one another. Some examples of the findings include:

- Children usually dictate where the group goes, while adults tend to help children focus their attention on the educational messages (Diamond, 1986)
- Children tend to touch and manipulate, adults are more likely to be readers (Diamond, 1986)
- Children and adults maintain a high level of attention to exhibits (Diamond, 1986)
- Children are more likely to model other visitors' behavior than are adults (Koran, et al, 1986).

Adult group influences: We know less about adult group interaction. Studies are needed that apply the methodology of family group research to adult-only groups in order to better understand the processes that operate on such groups. We also know relatively little about the difference between the single adult visitor and groups.

School field trips: Field trips make up one of the most frequent type of museum visitation. The school field trip, however, is often very different from the family visit. Research evidence from school groups suggests the following generalizations:

- Students learn more when pre-visit preparation is given (Bitgood, 1991)
- A structured tour results in more learning, but students enjoy an unstructured tour more (Stronck, 1983).
- In a novel setting, students tend to make fewer cognitive gains, but seem to learn a lot about the setting (Balling & Falk, 1982; Falk, Martin, & Balling, 1978).
- While classroom and museum cognitive outcomes often show little difference, differences in affective outcomes are usually large (Borun, Flexer, Casey, & Baum, 1983).

Extra-group influences: These include those from other visitors and facility staff. Other visitors can provide models for "hands-on" use of exhibits (Koran, Koran, Dierking, & Foster, 1988). Museum staff may facilitate an enjoyable visit by friendly greetings and assistance or may place a damper on the visit by rudeness. The presence of "explainers" are often more effective in communicating messages that the exhibit by itself may not do.

Physical influences

Physical influences can be of three types: structural (architectural), ambient, and extra-exhibit media.

Structural (architectural): These factors often create a mood by the style of the building, the effects of doors and windows, etc. Some of these influences include:

- When other forces are not operating, visitors spend more time viewing right-hand walls of exhibit galleries than left-hand walls (Melton, 1935)
- Exit attraction: an open door is an invitation to leave the gallery without viewing all the exhibit objects; visitors tend to leave by the first exit they encounter (Melton, 1972).
- Exit gradient: visitors often follow the straightest line between the entrance and a visible open door (Melton, 1935).

Ambient distractions: These include the signs and sounds from other exhibit units and other areas of the facility. Ambient factors may also include temperature and other causes of physical sensation. Research findings suggest:

- Exhibits on opposite sides of a visitor walk-way compete for attention with one another (Bitgood, et al, 1988)
- Distracting sounds often pull visitors away from an exhibit to which they have been attending. A train whistle may distract visitors from reading an exhibit label (Bitgood, 1986; Melton, 1935).
- Visitors spend less time viewing outdoor exhibits under aversive weather conditions such as extreme cold, extreme heat, and rain/snow (Bitgood, unpublished).

Extra-exhibit media: This includes museum guides and general orientation information. These media might include an audio

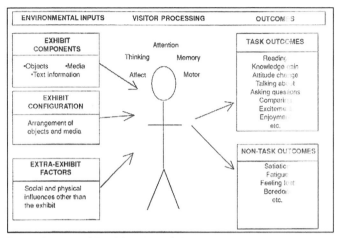

Figure 9: A summary of the exhibit-visitor analysis.

tour of the museum or a hand-carried audio guide. Such media are extra-exhibit if they are not associated with a specific exhibit. Unfortunately, only a handful of studies have been conducted on hand-carried communication media (Bitgood & Davis, 1991).

Where does the visitor fit in?

So far, very little has been said about the visitor. We are now ready to deal with the visitor who is, of course, the reason we are analyzing the anatomy of an exhibit. Fig. 9 illustrates what happens when the exhibit components (objects, media, text information), the exhibit configuration, and extra-exhibit factors (social and physical influences) are attended to and processed by the visitor. Visitors respond to these exhibit and extra-exhibit influences based on many factors including their prior knowledge, preconceptions, interests, attitudes, physical

abilities, etc. People arrive sometimes with little knowledge, sometimes with misconceptions, and sometimes with highly individualized ways of extracting information from an exhibit. Given the overwhelming range of ages, knowledge, cultural backgrounds, interests, attitudes, etc., it is not surprising that many professionals consider educationally effective exhibit design to be a difficult if not impossible endeavor.

Visitor variables can be divided into processing mechanisms (cognitive, affective, and motor) and outcome measures. Broadly conceived, cognitive processes include: attention, thinking, and memory. To a large extent, attention appears to be tied to the physical characteristics of things (e.g., larger or moving objects attract more attention. Various types of thinking (e.g., comparing, relating information to previous knowledge, making logical conclusions) are more closely tied to text information. While an object may stimulate thinking in the absence of text information, it is as likely to stimulate affective responses ("Isn't it pretty!"), or it may generate erroneous conclusions. Cognitive memory would include retrieval of facts, concepts, and other types of cognitive information.

Affective processing is more difficult to study. It is often difficult to separate cognitive and affective (attitudes have both cognitive and affective components). Obviously, people process their experiences emotionally based on past history. A visitor might dislike a science exhibit because it reminds him/her or something that a third grade teacher said. Cognitive understanding of topic influences affective

response (interest, feelings, etc.).

Motor processing is associated with the learning of motor skills. Examples include: using a microscope or telescope, operating a trackball on a computer, playing a Nintendo game, riding a bicycle, playing a musical instrument. Exhibits may fail because visitors do not know how to use a device correctly. Fro example, Alan Friedman (in Taylor, 1992) describe the formative evaluation of a telescope in an astronomy exhibit at the Lawrence Hall of Science. The evaluation found that visitors had less difficulty using an inexpensive, more familiar spyglass telescope than an expensive, complicated, high-quality one.

Outcome measures can be related or unrelated to the exhibit task. Task-related outcomes are those defined by the educational objectives of the exhibit – cognitive, affective, and motor reactions. Non-task-related outcomes are those independent of the exhibit's goals and objectives. For example, satiation, fatigue, and various types of off-task behaviors (reading a novel, managing children's behavior, etc.).

Visitor variables have received considerable attention in the literature (e.g., Falk & Dierking, 1992). But, there has been disagreement over the importance of various types of outcomes (cognitive, affective, motor). The selection of outcomes for measurement should depend, to a large extent, on the goals and objectives of the exhibit developers. Problems occur when goals and objectives are not explicitly stated. For a detailed discussion of the exhibit develop process from the visitor evaluation perspective, see Screven (1990b).

Applying the exhibit anatomy approach

The analysis of the anatomy of an exhibit in this article might be used in several ways. First, it is hoped that an analysis such as is provided here will make it easier for professionals to conceptualize all of the myriad of variables present in the exhibit environment. A logical analysis and orderly conception of the environment should make it easier to keep in mind all of the complexities inherent in the exhibit setting.

A second way this analysis may be useful is to identify needed areas of visitor research. The current analysis reveals many potentially important variables that have received very little study. For example, how differently do adult groups interact in an exhibit setting compared with family groups? It is hoped that identifying some of the neglected areas will stimulate readers to engage in needed research.

Another way to apply the analysis described in this article is to use it to develop a series of summary tables and checklists to be used in the design and/or remediation of exhibits. For example, when label text is being developed, one might refer to a series of tables such as Fig. 10.

Research questions

Shettel, et al. (1968), Koran & Koran (1986), and Falk & Dierking (1992) have been leaders in attempting to provide a framework for studying visitor learning from exhibits. Such a framework allows us to ask better research questions. Some of the questions raised by the current framework include:

· How do characteristics of objects and media interact

Characteristic	Guidelines
Typeface	Select typeface that is easily read (legible)
Word length	Keep the number of words to a minimum
Contrast between letters and background	Use high contrast color combination for text
Size of text unit	Keep size of text unit (number of words) at a minimum
Questions for headings	Use questions for headings to increase reading

Figure 10: Physical characteristics of text.

with the knowledge, interests, attitudes of visitors?

- How can exhibit media be used in the most effective way?
- What is the optimum way of designing text information?
- In what ways does a contextual background affect the visitors?
- Do the configurations of exhibit components influence visitors the way designers believe?
- How can family, adult, and school visits each be made more effective?
- How can exhibit design eliminate or minimize distracting influences?
- In what specific ways do exhibit components and extra-exhibit factors interact with visitor input variables?

These questions, although not unique to the current analysis, deserve careful study if we are to achieve our quest for a science of effective exhibition.

Conclusions

While there are many ways to conceptualize the exhibit environment, few have been attempted. The efforts of Shettel, et al (1968) and Koran & Koran (1986) to formulate a framework for studying visitor learning have generated limited systematic research. This is unfortunate because the anatomy of an exhibit interacts with the visitor variables. If exhibit designers are not aware of the myriad complex exhibit factors and how they interact with visitors, ineffective exhibits are likely to result. If visitor researchers are not aware of the many complex interactions between visitor and exhibit factors, they are not likely to misinterpret the findings of their visitor studies. It is hoped that the analysis of the exhibit environment suggested in this paper will stimulate more efforts to develop and test frameworks for visitor learning.

Originally published in Visitor Behavior, 1992, 7(4), 4-14.

References

Alt, M. (1979). Audio-visual presentations. *Curator*, 22(2), 85-95.

Balling, I., & Falk, 1. (1980). A perspective on field trips: Environmental effects on loaning. *Curator*, 23(4), 229-240.

Bitgood, S. (1990a). *The Role of simulated immersion in exhibition, Technical Report No. 90-20.* Jacksonville, AL: Center for Social Design

Bitgood, S. (1990b). The ABCs of label design. In S. Bitgood, A. Benefield, & D. Patterson, (Eds.), *Visitor studies: Theory, research and practice, vol. 3.* Jacksonville, AL: Center for Social Design. Pp.115-129

Bitgood, S. (1991c). What do we know about school field trips? *ASTC Newsletter*, Jan/Feb, 5-6,8. No. 14, What Research Says...

Bitgood, S. (1991a). Suggested guidelines for designing interactive exhibits. *Visitor Behavior*, 6(4), 4-11.

Bitgood, S., Benefteld, A., & Patterson, D.. (1989). The importance of label placement: A neglected factor in exhibit design. In *Current trends in audience research, vol. 3.* Washington, DC: AAM Visitor Research and Evaluation Committee. (Pp. 49-52).

Bitgood, S., Conroy, P., Pierce, M., Patterson, D., & Boyd, J. (1989). Evaluation or "Attack & Defense" at the Anniston Museum of Natural History. In *Current trends in audience research, vol. 3.* Washington, DC: AAM Visitor Research and Evaluation Committee, Pp. 1-4.

Bitgood, S., & Davis, J. (1991). Self-guided handouts in museums and zoos: An annotated bibliography. *Visitor*

Behavior, 6(3), 7-10.

Bitgood, S., & Patterson, D. (1993). The effects of gallery changes on visitor behavior. *Environment and Behavior, 25*(6), 761-781..

Bitgood, S., Patterson, D., & Benefield, A. (1988). Exhibit design and visitor behavior: Empirical relationships. *Environment and Behavior,* 20(4), 474-491.

Borun, M., Flexer, B., Casey, A., Baum, L. (1983). *Planets and pulleys: Studies of class visits to a science museum.* Washington, DC: Association of Science Technology Centers.

Boron, M., & Miller, M. (1980). *What's in a name?* Philadelphia, PA: Franklin Institute and Science Museum.

Diamond, J. (1986). The behavior of family groups in science museums. *Curator,* 29(2), 139-154.

Diamond, J. (1991). Prototyping interactive exhibits on rocks and minerals. *Curator,* 34(1), 5-17.

Falk, J., & Dierking, L. (1992). *The museum experience.* Washington, DC: Whalesback Books.

Falk, J., Martin, W., & Balling, J. (1978). The novel field trip phenomena: Adjustment to novel settings interferes with task learning. *Journal of Research in Science Teaching,* 15, 127-134.

Gottfried, J. (1980). Do children learn on school field trips? *Curator,* 23(3), 165-174.

Hilke, D.D. (1988). Strategies for family learning. In S. Bitgood, J. Roper, & A. Benefield (Eds.), *Visitor studies - 1988: Theory, research and practice.* Jacksonville, AL: Center for Social Design. (Pp. 120-134).

Hirschi, K., & Screven, C. (1988). Effects of questions on visitor reading behavior. *ILVS Review*, 1(1), 50-61.

Kool. P.. (1985). *Behavioral or cognitive effectiveness: Which will it be? Musee et education: Modeles didactique d'utilization des musees.* Montreal, Quebec: University of Quebec.

Koran, J., & Koran, M. L. (1986). A proposed framework for exploring museum education research. *Journal of Museum Education: Roundtable Reports*, 11(1), 12-16.

Koran, J., Koran, M. L., & Foster, J. (1989). The (potential) contributions of cognitive psychology to visitor studies. In S. Bitgood, A. Benefield, & o. Patterson (Eds.), *Visitor studies: Theory, research, and practice, vol. 2.* Jacksonville, AL: Center for Social Design. (Pp. 72-79).

Koran, J., Koran, M.L., Foster, J., & Dierking, L. (1988). Using modeling to direct attention. *Curator*, 3 1(1), 36-42.

Koran, J., Koran, M. L., & Longino, S. (1986). The relationship of age, sex, attention, and holding power with two types of science exhibits. *Curator*, 29(3), 227-235.

Melton, A. (1935). *Problems of installation in museums of art.* New Series No. 14. Washington, DC: American Association of Museums.

Melton, A. (1972). Visitor behavior in museums: Some early research in environmental design. *Human Factors*, 14(5), 393-403.

Miles, H. (1989). Audiovisuals, a suitable case br treatment. In S. Bitgood, A. Benefield, & I). Patterson (eds.), *Visitor studies: Theory, research, and practice. volume 2.* Jacksonville, AL: Center for Social Design. Pp. 245-251.

Miles, R., Alt, M., Gosling, D., Lewis, B.,& Tout, A. (1988). *The design of educational exhibits* (2nd ed.). London: Allen & Unwin.

Peart, R. (1984). Impact of exhibit type on knowledge gain, attitudes and behavior. *Curator, 27*, 220-227.

Rand, J. (1990). *Fish stories that hook readers:Interpretive graphics at the Monterey Bay Aquarium.* Technical Report No. 90-30. Jacksonville, AL: Center for Social Design.

Robinson, E. (1928). *The behavior of the museum visitor.* New Series No. 5. Washington, DC: American Association of Museums

Rosenfeld, S., & Turkel, A. (1982). A naturalistic study of visitors at an interpretive mini-zoo. *Curator, 25*(3), 187-212.

Screven, C. G. (1986). Exhibitions and information centers: Some principles and approaches. *Curator, 29*(2), 109-137.

Screven, C. G. (l990b). Uses of evaluation before, during, and after exhibit design. *ILVS Review: A Journal of Visitor Behavior, 1*(2), 36-66.

Screven, C. G. (1992). Motivating visitors to read labels. *ILVS Review, 2*(2), 183-211.

Serrell, B. (1992). Computers on the exhibit floor. *Curator, 35*(3), 181-189.

Shettel, H., Butcher, M., Cotton, T., Northrup, J., & Slough, D. (1968). *Strategies for determining exhibit effectiveness.* Report No. AIR E-95-4/68-FR. Washington, DC: American Institutes for Research.

Stronck, D. (1983). The comparative effects of different museum tours on children's attitudes and learning.

Journal of Research in Science Teaching, 20(4), 283-290).

Taylor, S. (Ed.) (1992). *Trying it.* Washington, DC: Association of Science-Technology Centers.

Thompson, D. (1993). *Considering the museum visitor: An interactive approach to environmental design.* Ph.D. Dissertation. University of Wisconsin-Milwaukee.

4

A Comparison of Formal and Informal Learning

Update: There are many forms of informal learning and several terms that are used to label it (e.g., non-formal, free-choice, self-directed, etc.). Informal learning in museums shares many characteristics with other forms of informal learning. However, it is unique when applied to museums, primarily because of the educational device used – the exhibition. Exhibitions are designed by museum professionals to provide learning experiences to visitors that could not be obtained from other places. An exhibition can be didactic, provocative, interactive, immersive, reminiscent, etc. Whatever the focus, there is little doubt that exhibitions can provide an appealing experience. There is no shortage of writings that attempt to describe, analyze, and identify the importance and implications of the museum experience. The following paper deals with informal learning in museums. Many of the points made are not likely to apply to other types of informal learning.

It is a common belief that informal learning institutions (e.g., aquariums, botanic gardens, museums, nature centers, parks, and zoos) do not teach effectively since many researchers have found that visitors learn (in the traditional academic sense) relatively little compared with school learning. However, as many have suggested, it is unrealistic to expect that the same amount and type of learning will occur in these informal learning settings as occurs in formal learning institutions. A number of museum evaluators have noted differences between formal and informal education (e.g., Beers, 1987; Brown, 1979; Koran, Shafer, & dierking, 1983; Sakoffs, 1984; Screven, 1986).

Dimension	Formal learning	Informal learning
Instructional	Verbal (lecture format)	Visual (exhibits and labels)
Stimuli	Visual (textbook) Sustained exposure to material Exposure explicitly controlled Symbolic exposure to objects	Short exposure to material Exposure controlled by visitor Direct contact with objects
Environment	Learning in one environment Highly structured setting Emphasis on educational stimuli	Learner constantly changing place Highly varied setting Focus on physical setting
Responses	Teacher-paced behaviors Strictly prescribed behaviors Closely monitored learning	Learner-paced behaviors Behavior is non-prescribed Attendance monitored more than learning
Social contact	Highly structured teacher-learner interactions Lack of family social interaction Peer contact discouraged Learning is a non-social event	Little if any contact between designer and visitor High degree of family social interaction Peer contact encouraged Learning mostly in a social context
Consequences	Often coercive (pressure to learn)	Few coercive pressures to learn
Objectives	Quantity & quality of learning emphasized	Quality of experience emphasized
Audience	Restricted by age and academic achievement	Unrestricted; heterogeneous

Figure 1: Comparison of formal and informal learning environments

This paper attempts to look more closely at these differences and to explore their possible implications. Although both types of educational institutions have been extensively studied, there has not been a detailed comparison between these two types of learning institutions. The two institutions are, of course, not completely independent of one another, since they often interface when school groups take field trips to museums and zoos.

Formal vs informal learning

Formal and informal learning institutions share certain characteristics. For example, both attempt to specify educational objectives. Both are likely to use lectures, computer tutorials, films, slide presentations, demonstrations, and several other instructional techniques to achieve their objectives. In addition, the subject matter for the two settings is often similar, including areas such as art, biology, and science.

Notwithstanding the above similarities between formal and informal learning, there are important differences. Such differences have implications for how and what educational objectives are accomplished. Fig. 1 provides an overview comparison between the two types of environments. Differences can be categorized into at least seven areas: instructional stimuli; characteristics of the environment; responses elicited; social interactions; consequences of learning (or not learning); instructional objectives; and target audience.

Instructional stimuli

In formal education, the instructional stimuli are usually verbal (from lecture) or written (from textbooks). Informal educational settings, on the other hand, rely primarily on visual stimuli (exhibits and interpretive labels). While there is sustained exposure to the learning material in formal education, quite the opposite occurs in informal education. That is, exposure to instructional material is brief, sometimes only a few seconds. While students in formal education may repeatedly study the same information until the criterion level is achieved, visitors to informal educational settings rarely study an exhibit more than once unless they repeat their visit. In formal education, the exposure is explicitly control by the teacher, in informal education, exposure is control by the visitor. There is also a difference in how learners are exposed to the objects of learning. Formal education usually provides only symbolic or abstract exposure to the instructional material in the form of reading about objects and things or being told by the teacher. Informal education, on the other hand, provides direct contact or concrete experiences with the object under study. While formal education may be more effective in teaching abstract thinking, students usually acquire knowledge more effectively if they first have concrete experiences with objects under study. Visitor to the Air & Space Museum can see the Wright Brothers' airplane or the space capsule that travelled to the moon. This direct experience with such objects can provide a foundation for later acquiring abstract information about the history of human flight.

These differences in the instructional stimuli have several other important implications. In formal education, instructional material can cover a large volume of information or complex chains of behavior since students are a captive audience of long-standing duration. Informal education, however, cannot attempt to teach long sequences of information since their audiences are only briefly exposed to the instructional material and the explore time is rarely controlled by the institution. Visitors rarely read all of the interpretive labels in an exhibit. If the instruction objectives require reading each label in a long series, the message is likely to be lost on all but a few visitors. Obviously, science museums could not attempt to teach a course in Algebra with unguided visitors. Or for that matter, museums and zoos cannot delve into any specific topic with attention to detail.

It is true that museums/zoos and other such exhibition type centers occasionally control exposure time to the instructional material. However, when they do, this control is usually designed to reduce exposure because of crowding conditions rather than increase exposure to meet instructional objectives. The practical problem of too many learners eagerly viewing instructional material is one not usually shared by formal educational institutions.

Another implication of the differences between formal and informal instructions stimuli relates to the variety of material used. Informal educational institutions present a much greater variety of material than do formal educational settings. This variety may be both a blessing and a curse. Such

variety may help to keep visitors interested in learning due to constantly changing stimuli. On the other hand, the visitor is often bombarded by too much information. This may lead to information overload, satiation, and/or fatigue.

The type of exposure to the world also has important implications. Symbolic or abstract exposure provided by lectures and textbooks seems less likely to have a meaningful impact on the learner. It would seem more meaningful to the learner when he/she can actually see what an exotic animal looks like in person rather than reading about it or being told about it. The myths associated with the dangerousness of gorillas can be more easily dispelled by observing how gentle these giants actually are.

The instructional environment

The environments for formal and informal learning are markedly different. In formal education, classrooms tend to provide little distracting stimulation – bare walls, a lack of auditory stimuli, etc. It is an environment that is designed, at least hopefully, so that the learner's focus is exclusively on the instructional stimuli (e.g., lecture and reading textbooks). In addition, the learner stays in the same or similar environments (the classroom) throughout the day and day-after-day. Classroom chairs are designed and arranged so that social interaction with peers is generally discouraged (although certainly not eliminated). By contrast, informal learning environments are rich with stimuli. The instructional message is part of the environment. Quite often the salience of the

exhibit's characteristics overpowers the written messages. For example, in zoo exhibition, visitors often focus on the playful antics of animals and miss entirely the written message of conserving endangered species. The visitor to an informal learning setting is constantly moving from one environment to another or from one exhibit to another. While exposure to such changes in stimuli may keep interest level high, it is unrealistic to expect that visitors will learn much about any one thing in such an environment. Informal learning environments usually overstimulate the potential learner. It is difficult to focus your attention on one aspect of the environment when you are being bombarded with more stimuli than your brain can possibly process at one time. Informal learning settings may be better off decreasing the amount of stimulation by isolating exhibits so that visitors can focus on one exhibit at a time. Bitgood, Patterson, and Benefield (1988) reported data showing that a larger percentage of visitors will stop to view an exhibit when there is not another exhibit visually competing for the visitors' attention (e.g., on the opposite side of a pathway).

Learner responses

The notion of "situation specificity" is useful when comparing the responses that are elicited in formal versus information educational environments. "Situation specificity" suggests that behavior, to a large extent, is determined by an individual's immediate surroundings. In formal educational settings responses are teacher paced – the teacher tells the student when assignments are due, when an exam is scheduled, etc.

Behavior patterns are strictly and explicitly prescribed by the system. The student is expected to sit quietly at his/her desk, listen to the teacher lecture, complete text assignments, take examinations, etc. The acquisition of knowledge is carefully monitored and close attention is given to performance measures (particularly exam performance). When learning responses are not under stimulus control, it is usually because students fail to study at home. Students know where the instructional material is and they usually have the skills (e.g., reading and studying) to learn the material; the problem is to find ways to ensure that teacher assignments are carried out.

Analysis of informal learning environments reveal a very different pattern of behaviors and a different set of behavior problems. Rather than teacher paced, behavior is visitor paced – visitors decide when they will attend, how long they will stay, what they will do, etc. Behavior is considerably more variable since there is a much wider range of acceptable behaviors in this setting. Typically, however, visitors leisurely walk from exhibit to exhibit – sometimes stopping, something walking by with merely a glance. Visitors look, talk with one another, often touch (particularly children), occasionally read labels, stand, squat, learn, and sit. Informal learning systems place little emphasis on performance; rarely is knowledge acquisition measured. Unlike formal educational institutions, problems are more likely to be associated with getting the visitor to pay attention to the instructional material. Unlike textbooks, exhibit labels must be designed so that they are noticed and there is visitor motivation to read. Limiting the number of

words on each label, making letters large, and placing the labels in the visitors' line-of-sight are methods that increase visitors' reading of labels (Bitgood, Nichols, Patterson, Pierce, & Conroy, 1986). These design factors are irrelevant in formal educational settings since students can be easily required to read the instructional material.

In most cases, learning in informal learning environments takes place while the visitor is on his/her feet rather than seated. Given these characteristics of informal learning settings, it is not surprising that responses associated with the acquisition of instructional stimuli are of very brief duration, usually limited to 20-30 seconds per exhibit label.

From this analysis it is obvious that different types of responses are elicited in each of the settings. Because students in a formal learning setting are intimately familiar with the environment, problems such as wayfinding and control of path-taking are minimal (except maybe the first day of class!). On the other hand, informal learning centers must spend a considerable amount of time and effort ensuring that visitors can find their way and circulate through the facility in a manner that gives them exposure to the instructional stimuli.

Social interactions

In formal education, student-teacher interactions tend to be highly structured. The teacher lectures, gives assignments and examinations, asks questions, etc. These interactions tend to be strongly related to the instructional objectives. Peers interactions in the classroom are intentionally infrequent

and, when they do occur, may interfere with accomplishing instructional objectives. For example, peers may pressure other students not to perform as well as they are capable; talking among students is disruptive to the teacher's lectures; and students engaged in peer social interaction may not pay attention to instructions by the teacher. Family interactions are not part of social interactions in schools since other family members are not only absent in the classroom but usually are prevented from participating in such learning activities. In formal education, learning tends to be a solitary event. When families do become involved in the formal educational process, it often involves unpleasant social interactions. For example, parents supervising or helping with their children's homework, more often than not, is unpleasant for both parent and child. Learning is rarely considered a fun activity under such circumstances.

Social interactions in informal learning environments are quite different. Visitors usually come with family members and/or friends. Learning is usually a social event where visitors exchange information (or sometimes misinformation) with one another. The social group is generally as much the focus of attention as the instructional material. Social interactions with family and friends can, and often do, detract from learning as well as enhance learning. If a child is hungry, tired, or needs to use the rest room, the entire group is likely to focus more on the child's desires and needs than on the instructional objectives. Peer interactions are less common in informal learning settings (at least for unguided visitors).

Social interactions may be an unexplored factor in formal education. In informal settings, parents frequently pass on information to their children in a socially reinforcement environment. Perhaps formal education could take better advantage of the possible benefits of parent-child interactions as a learning aide.

Consequences of learning

Formal educational setting tend to use coercive consequences, both positive and negative. The immediate and long-term consequences of academic success or failure can be extremely powerful. In the short run, successful performance produces good grades, teacher and parental attention, privileges, etc. Failure results in poor grades, disapproval by parents and teachers, and privileges take away. In the long run, success or failure determines whether or not the student is accepted to a competitive university and obtains desirable employment.

It is noteworthy that in formal learning settings, students know they will be tested. In museums/zoos, visitors learn more if they know they will be tested. Since knowing that one is going to be test influences the amount of learning, why not take advantage of this phenomenon by designing this expectation into the exhibition? In fact, this strategy has been taken by the TVS's Energy Museum in Chattanooga where visitors receive a test card that they carry through the Museum and place in computer control grading machines at several stations throughout the Museum. If visitors complete the quizzes in all of the stations, they receive a small prize from

the gift shop counter.

The consequences of learning in informal learning environments are very non-coercive. There are no obvious consequences if the visitor fails to learn form exhibits. There is no permanent record of success or failure associated with learning in museums, zoos, etc. In fact, informal learning centers rarely measure how much visitors learn from an exhibition. These centers appear to be more concerned with other criteria of success. Shettel (1988) suggests that factors such as the workmanship and the quality of the materials use during the construction of the exhibit and whether other curators and museum personnel view the exhibit favorably count more than how much visitors learn from the exhibits.

There is also a difference in the characteristics of rewards in the two settings. Formal learning uses contrived rewards (grades, etc.); informal learning uses natural, intrinsic rewards (satisfying curiosity, engaging in a fun or interesting activity). Unfortunately, in public schools, too few students are learning without the contrived incentives of grades and degrees or the threat of unpleasant consequences.

Informal learning centers are not without their aversive consequences, although they tend to be less explicit and demanding. Visitors are likely to become bored after observing numerous examples of similar exhibit objects. If the exhibit labels are written in too technical a fashion, then the visitor is likely to feel stupid. After walking on hard floors for a couple of hours, and bending over to read poorly placed labels, visitors are likely to become fatigued. These sources of

aversive consequences in informal educational settings can be minimized, if the facility is carefully designed. Unfortunately, preventing these consequences is often not a high priority for informal education administrators.

Objectives

In formal educational settings learning objectives usually emphasize quantity of learning, convergent thinking, and expressive, verbal, verbal/analytical responses (left hemisphere activity). In addition, there is a traditional body of knowledge included as part of the instructional objectives. Textbook materials for a given subject area are highly standardized at all levels of education. I recently served on a textbook selection committee for an introductory psychology text and was amazed at the similarity of the content from book to book.

When evaluation is undertaken, informal learning environments are more likely to emphasize the quality of the experience. That is, did the visitor find the experience to be rewarding other than did he/she learn everything he/she was supported to learn? Learning in museums and zoos is more attitudinal and receptive (right hemisphere activity). A study by Borun, Flexer, Casey, & Baum (1983) illustrates at least one of the differences between formal and informal learning. The study compared 5th and 6th grade students who visited a mechanics exhibit in the Franklin Institute with a similar group who were given a classroom lesson on the identical information. While the classroom lesson group scored higher on test performance than the museum-visit group,

the museum-visit group rated the learning activity as more enjoyable.

Perhaps informal learning centers should not select the same type of instructional objectives as schools. On the other hand, perhaps schools should consider the importance of enjoyment as an objective of learning. During a faculty meeting with my academic colleagues, I suggested that we should try to make learning more enjoyable to our students. My colleagues were appalled! School learning is not supposed to be fun! Yet, perhaps that is why students are not more internally motivated in our academic systems.

Audience characteristics

Formal educational environments centers restrict the audience according to age and academic achievement. Presumably, this allows greater homogeneity of instructional material since learners are all on approximately the same level of achievement. While the ideal of a homogeneous learning audience is rarely achieved in formal education, instruction proceeds as if that were the case. Despite students' varied rate of learning the material, most informal educational settings have few accommodations for self-pacing. Students are also expected to learn in large groups. A school class typically varies between 20 and 50 students.

The audience of informal educational settings, however, are a mixture of ages and levels of knowledge. Such institutions are faced with the dilemma: "At what audience level do we design our educational material?" Should exhibit labels

be written at the sixth grade level, 10th grade level, college graduate level? Some centers attempt to write labels for the lowest common denominator. Others take a snobbish attitude and let the uneducated visitor be damned. Some museums assume that parents will read the labels to the children and therefore one does not have to write labels for children. Other museums attempt to provide a combination of labels, some written for children, others for educated adults. Personally, I favor the lowest common denominator approach. I have not encountered any highly educated visitors who were insulted by labels written in a simple style! Group size in informal learning is generally two to four persons. Few people visit alone, and few come in large groups (except for group events such as school and church groups).

Clearly, we need to recognize the heterogeneity of our audiences, both in formal and informal learning settings. Instruction in both schools and exhibition centers often fail to design the learning environments for this heterogeneity.

Strengths and limitations of informal education

Informal educational centers will never substitute for formal education. It is important that educators realize the strengths and limitations of both formal and informal education. The characteristics of the type of institution determine the advantages and limitations of learning. Large quantities of information on a single topic cannot be effectively presented to visitors in museums and zoos. Since visitors to informal learning centers stay only a matter of hours, a large amount of

knowledge acquisition is unlikely to occur. Exhibit labels with volumes of information are avoided by visitors. Such exposure is likely to be less meaningful. Visitors get tired standing on their feet (sometimes bending over) for long periods of time while reading. Such factors provide limitations to traditional learning. However, this does not mean that informal educational institutions are less valuable. It is difficult to provide concrete, direct experience with important objects in formal educational setting where students must rely on second-hand information. Museums and zoos are able to show the objects under study, often allowing the learner to touch or otherwise interact with the objects. Since these centers are usually rewarding or "fun" to the visitor, they are likely to have an impact beyond a single visitor by increasing the probability of a return visit where more learning can occur. Or, perhaps the museum visit elicits a trip to another exhibition-type center where new experiences and information are available. It is difficult to measure long-term impact of these informal educational institutions on learning. This thought is a challenging idea: if you compare hour-for-hour between formal and informal educational institutions, which type of institution has great impact on our lives? For example, Falk (1988) found that museum recollections of visitors were still vivid after years had passed since their experience. Since the visit lasted only a couple of hours, the experience appeared to have a profound impact.

We would not suggest that informal learning centers can replace formal learning. That would be a silly argument.

Rather, it is our belief that informal learning centers should be used to complement (rather than substitute for) formal learning settings. Most visitors enjoy learning, while students often do not. Perhaps formal education should look at better ways to make learning an enjoyable, rewarding experience. On the other hand, informal learning settings should borrow from the practices of formal learning in terms of monitoring the learner's behavior and increasing the chances of accomplishing instructional objectives.

Acknowledgement

The author wishes to acknowledge the contributions of C. G. Screven for his suggestions on an early draft of this paper.

Updated from Technical Report #88-10. Jacksonville, AL: Center for Social Design

References

Beer, V. (1987). Do museums have curriculum? *Journal of Museum Education*. 12(3), 10-13.

Bitgood, S., Nichols, G., Patterson, D., Pierce, M., & Conroy, P. (1986). *Effects of label characteristics on visitor behavior*. Technical Report No. 86-55. Jacksonville, AL: Psychology Institute of Jacksonville State University.

Bitgood, S., Pierce, M., Nichols, G., & Patterson, D. (1987). Formative evaluation of a cave exhibit. Curator, 30(1), 31-39.

Bitgood, S., Patterson, D. & Benefield, A. (1988). Exhibit design and visitor behavior: Empirical relationships. *Environment & Behavior*.

Borun, M., Flexer, B., Casey, A., & Baum, L. (1983). *Planets and pulleys: Studies of class visits to science museums*. Philadelphia, PA: Franklin Institute.

Brown, W. S. (1979). The design of the informal learning environment. *The Gazettte*, 4-10.

Koran, J., Jr., Morrison, L., Lehman, J. R., Koran, M. L., & Gandara, L. (1984). Attention and curiosity in museums. *Journal of Research in Science Teaching*, 21(4), 357-363.

Melton, A. W. (1935). *Problems of installation in museums of art*. New Series No. 14. Washington, DC: American Association of Museums.

Robinson, E. S. (1928). *The behavior of the museum visitor*. New Series No. 5. Washington, DC: American Association of Museums.

Sakofs, M. S. (1984). Optimizing the educational impact of a museum visit. *Curator*, 27(2), 135-140.

Screven, C. G. (1973). Public access learning: Experimental studies in a public museum. In R. Ulrich, T. Stachnik, & J. Mabry (eds.), *The control of human behavior*, Vol. 3. Pp. 226-233.

Screven, C. G. (1986). Exhibitions and information centers: Principles and approaches. *Curator*, 29(2), 109-137.

Shettel, H., Butcher, M., Cotton, T. S., Northrop, J., & Slough, D. S. (1968). *Strategies for determining exhibit effectiveness*. Report No. AIR E95-4/68-FR. Washington, DC: American Institutes for Research.

Shettel, H. (1988). Do we really, really need to do visitor studies? In S. Bitgood, (ed.), *Visitor studies - 1988: Theory, research, and practice*. Jacksonville, AL: Psychology Institute, Jacksonville State University.

METHODOLOGY

5

An Overview of the Methodology
of Visitor Studies

If we are to make important decisions from our research/
evaluation results, our measurements must meet the standards
of science. The two most important standards, *reliability* and
validity, will be discussed here.

Reliability
The term reliability refers to the consistency or stability of
measurements. If two observers are observing the same visitor,
we expect the same measurements to be reported by both
observers (referred to as "interobserver reliability").

Reliable measurement depends upon two things. First,
it requires objectivity (not allowing personal feelings or
expectations to influence the measures). If behaviors to be
measured are precisely defined, there should be less room for
subjective measurement. Reliable measurement also depends
upon standardization. Each person using the measuring
system should use it in the same way. Non-standardized
practices can make interpretation of results difficult. For
example, in a survey, if a question is asked in different ways,
the answers might vary depending upon the particular
wording of the question.

Validity
Validity is a complicated concept that includes several sub-
concepts. Not everyone agrees on all of these terms, but
each does focus on an important aspect of validity. A brief
description of some of the sub-concepts is below:

Assessment Validity: refers to the accuracy of conclusions

about your measurements including the following:

Content validity: Is your sample of visitor behavior representative of the population of behaviors you wish to test?

Predictive validity: Can you use a sample of behavior to predict the visitor's behavior to other exhibits? In other museums?

Construct validity: Are your measurements really measuring the concepts you think they are? If visitors are able to answer multiple-choice questions correctly, does it mean that they learned this information from the exhibit?

Recording validity: Does your measurement system distort the actual behavior of visitors? For example, when visitors are asked to estimate time they spend at an exhibit or in a museum/zoo, they often overestimate time (e.g., Bitgood & Richardson, 1986).

Convergent validity: Degree to which a measurement device correlates with similar measures of the same concept.

Discriminant validity: Degree to which a device produces results different from other measurement devices when it should differ.

Ecological validity: Degree to which simulated environments, slides, or verbal representations of environments are related to the real environment through behavioral measures. Do these measurement devices relate to how people behave in the real environment?

Experimental validity

Internal validity: Are the results due to the factors that you

think? If visitors read one exhibit label more than another, can you conclude that it was the content that produced the difference rather than the number of words, size of letters, position of the label, etc.?

External validity: Do your results generalize or extend to other settings with other visitors?

Types of visitor research

There are several types of research used in visitor studies. These types differ primarily in terms of the control they exert over the variables being studied and, consequently, in terms of what kinds of questions they answer.

Experimental research

An experiment attempts to determine how isolated variables influence visitor behavior. For example, let us assume that we wish to determine how number of words on an exhibit label influences visitor reading. In an experiment we might present labels of varying numbers of words to different groups of individuals and measure whether or not they read and how long they read each label. If we conduct this experiment, we would probably find that the shorter the label, the more likely that visitors will read. If factors such as the characteristics of the visitors (age, gender, education, group size) and characteristics of label (content, letter size, distance from visitor) are the same from group to group, we expect that any differences in reading between one label length and another is due to the number of words rather than other, uncontrolled factors. Other variables

(time of day, crowding, climate control, etc.) must also be considered and held constant.

An experiment attempts to establish cause-and-effect relations by showing that variables we manipulate influence behavior when other factors are held constant. Subjects are chosen carefully according to acceptable, scientific selection procedures. Those chosen must be representative of the total population of individuals about which we wish to draw conclusions. For example, a sample of weekday visitors may be quite different than weekend visitors since families are more likely to be represented on weekends while family members are likely to be in school or work during the weekdays.

Laboratory experiments: This type of experiment is conducted in a very carefully controlled environment. A laboratory setting allows much greater control over events than is possible in the real world. Thus, unexpected interruptions and intrusions can be carefully controlled and interpretation of results becomes more straightforward. However, the subjects in a laboratory experiment may realize that the situation is not realistic and may behave differently than in the real world. Thus, laboratory experiments may have less "experiential realism" than other types of research.

Field experiments: A field experiment is conducted in a real world situation. It is difficult to conduct such experiments since it is often impossible to exert enough control. For example, it is usually difficult to assign subjects to groups in an acceptable manner for experimentation.

Simulations: If the research cannot be conducted in an

appropriate field setting for one reason or another, researchers may attempt to simulate the real world by creating important aspects of the setting. Museums have been simulated with slides and videos.

Quasi-experimental studies: When the assignment of subjects to groups cannot be controlled by the experimenter, it may be possible to use "quasi-experimental designs" (Cook & Campbell, 1979). These designs attempt to create controls as close as possible to regular experiments. Many visitor studies articles fit into this type (e.g., Bitgood, Pierce, Nichols, & Patterson, 1987).

Correlational research

This type of research examines the relationships between visitor behavior and variations found in the setting. For example, Bitgood, Patterson, & Benefield (1988) measured visitors' behavior in zoo exhibits of similar species across 13 zoos throughout the U.S. They found that factors such as the size of the species, movement, and presence of infant were correlated with longer viewing times no matter where zoo visitors were observed. While correlational research does not allow the researcher to make strong conclusions about causal effects, the results may be suggestive of factors influencing behavior. For example, while no one may be able to prove conclusively that cigarettes cause cancer, the correlation between smoking and cancer is strongly suggestive.

Descriptive/observational research

Descriptive or observational research gives us information

about how visitors respond (either through direct observation or self-report) but this method does not allow us to make conclusions about how specific factors influence the behavior of visitors. This method merely describes how visitors behave, often in a qualitative rather than quantitative manner.

Methods of measuring visitor behaviour

Direct observation: Recording what visitors actually do is a common way to measure visitor behavior. Usually this involves exhibit-related behaviors, but this is not always the case (see Falk, Koran, Dierking, & Dreblow, 1985). Falk et al. (1985) examined visitor attention to exhibit content, exhibit setting, and social group.

Recording can be obtrusive or unobtrusive. In unobtrusive recording, visitors do not know they are being observed. In many situations, people behave differently when they know they are being watched. Thus, studies using obtrusive recording may be more difficult to interpret. For example, Bechtel (1967) found that visitors spent longer in an exhibit area when they knew they were being observed.

Below is a list of some of the behaviors measured by direct observation:

- Visual attention to the exhibit and/or label (looking at or glancing at exhibit).
- Stopping and visually attending to the exhibit or label.
- Viewing time.
- Time in exhibit area.
- Pointing to some aspect of the exhibit.

- Touching or manipulating some aspect of the exhibit.
- Social interaction between or among visitors.
- Circulation path through an exhibit or facility.

The above behaviors can be monitored throughout the museum or exhibit area (tracking procedure) or at a specific exhibit area (focused observation procedure). In the tracking procedure visitors are followed and their pathway and other aspects of their behavior are carefully recorded. In the focused recording procedure visitor behavior is recorded at isolated exhibits.

Behavior mapping: Behaviors are marked on a drawn-to-scale map. This method allows one to determine which specific behaviors occur and whether or not they are associated with features of the setting (e.g., Ittelson, Rivlin, & Proshansky, 1970).

Other methods: Indirect measures (erosion techniques like worn pathways in the grass; leftover techniques such as pieces of litter) are occasionally used. In addition, photos and video/audio recording are often used.

Self-report methods

Self-report methods include such techniques as questionnaires, interviews, focus group methods, and rating scales. Self-report methods by their very nature are "reactive" since the visitor knows he/she is being treated in a special way. Visitors may try to be "helpful" by exaggerating the pleasure of their experience or telling the interviewer what he/she thinks is

expected. Any good textbook on research methodology in the social sciences will describe the pros and cons of self-report (e.g., see Marans, 1975). Also, see Loomis' (1987) chapter on the use of visitor surveys and Hood's (1986) paper.

Questionnaires: These are paper-and-pencil devices used to assess factual information and/or attitudes.

Interviews: Visitors are asked questions and their answers carefully recorded.

Focus groups: This technique uses a directed interview with small groups who are carefully chosen to represent some segment of a population of potential or actual users. Rating scales. This method attempts to force respondents to rate the strength of cognitive or affective reactions to some aspect of the environment (e.g., physical feature, staff friendliness).

Originally published in Visitor Behavior (1988) 3(3), 4-6.

References

Bechtel, R. (1967). Hodometer Research in Museums. *Museum News*, 45(7), 23-25.

Bitgood, S., Pierce, M., Nichols, G., & Patterson, D. (1987). Formative Evaluation of a Case Exhibit. *Curator*, 30(1), 31-39.

Bitgood, S., Patterson, D. & Benefield, A. (1988). Exhibit Design and Visitor Behavior Empirical Relationships. *Environment and Behavior*. 20(4), 474- 491.

Bitgood, S. & Richardson, K. (1987). Wayfmding at the Birmingham Zoo. *Visitor Behavior*, 1(4), 9.

Cook, T. D. & Campbell, D. T. (1979). *Quasi-Experimentation*. Chicago: Rand McNally.

Falk, J., Koran, J., Dierking, L., & Dreblow, L. (1985). Predicting Visitor Behavior. *Curator*, 28(4), 249-257.

Hood, M. (1986). Getting Started in Audience Research. *Museum News*, 64(3), 24-31.

Ittelson, W., Rivlin, L. & Proshansky, H. (1970). The Use of Behavioral Maps in Environmental Psychology. In H. Proshansky, W. Ittelson, & L. Rivlin (Eds.) *Environmental Psychology*. New York. Holt, Rinehart, & Winston. Volume III Number 3 Page 6

Loomis, R. J. (1987). *Museum Visitor Evaluation*. Nashville, TN: American Association for State and Local History.

Marans, R. W. (1975). Survey Research. In W. Michelson (Ed.), *Behavioral Research Methods in Environmental Design*. Stroudsburg, Pa: Dowden, Hutchinson, & Ross.

6

Glossary of Visitor Studies Terms

Adjective checklist

Paper-and-pencil method in which the visitor is asked to check descriptive adjectives that apply to an exhibit, program, or institution.

Advance organizers

Conceptual information given to visitors to assist in pre-organizing their experience; may include overviews, outlines, simplified maps, etc. (See Screven, 1986).

Applicability gap

The failure to get into practice ideas that are generated by research and development. (See Loomis, 1988).

Attracting power

The ability of an exhibit to attract the attention of visitors. Usually measured as the percentage of visitors who stop to look at an exhibit.

Audience research

Study of actual and potential audiences of an institution through the use of a variety of methods. See Hood (1986) for a description of methods (survey, focus group, etc.).

Behavioral mapping

An observational method which uses a drawn-to-scale map to record sequences of behaviors that occur in each area of a facility. (See Bechtel, Marans, & Michelson, 1987).

Circulation path

The route actually taken by visitors through an exhibit or facility. (See Melton, 1935).

Cognitive map

A mental representation of an environment. Visitors may be asked to draw a map of the floorplan in order to determine their state of orientation or disorientation in the setting.

Conceptual orientation

Understanding the theme or subject matter of an exhibit or exhibit area. Also called "thematic" orientation. (See Griggs, 1984).

Convergent validity

Degree to which a behavioral measurement correlates with similar measures of the same concept. For example, visitors' estimation of time should correlate with the actual time they spend in an exhibit.

Demographics

The factual characteristics of the audience being studied (e.g., gender, age, socio-economic status, and residence).

Developmental evaluation

Evaluation that is conducted during pre-installation of the exhibit or during the construction phase of exhibition.

Direct observation

A behavioral measurement technique in which visitors' behavior is counted or placed in categories rather than asking individuals to self-report their behavior.

Discriminant validity

Degree to which a measurement technique produces results that discriminate between different settings or programs.

Ecological validity

Degree to which measurement devices such as surveys are related to the real environment they are supposed to represent.

Exit gradient

Concept used by Melton (1935) to explain the fact that visitors spend less time at exhibits the closer they are to an exit. Melton assumed that exits attract visitors and the strength of attraction is directly related to distance from the exit.

Field experiment

Experimental study in a real-life situation.

Feasibility study

A study to determine if a project should be undertaken. It attempts to predict such factors as visitor reactions and cost-effectiveness.

Focus group method

A method from marketing research in which a small group of consumers participates in in-depth interview focused on a particular topic or product.

Focused observation

Direct observation of visitors' behavior at a particular site or exhibit; used when intensive study of one exhibit is desired.

Formative evaluation

Evaluation whose major purpose is to improve the functioning of the exhibit. (See McNamara, 1988; Screven, 1988).

Front-end evaluation

Evaluation undertaken before an exhibit is installed or project developed; used to help establish goals and objectives of the project. (See Loomis, et al., 1988).

Goal-free evaluation

Evaluation that is shaped from the information collected, attempts to not impose evaluators' goals and objectives before the start of the evaluation. (See Wolf, 1980).

Goal-referenced evaluation

Evaluation undertaken to assess whether or not specified objectives are being met. See Screven (1975) for detailed discussion.

Holding power

A measure of time spent viewing an exhibit. Often used as a ratio of average viewing time by uncued visitors as a fraction of average viewing time of visitors who are cued (asked to study all aspects of the exhibit). See Shettel (1968).

Importance performance analysis

A marketing research technique in which both a rating and a weighting are placed on a graph or grid to determine degree of consumer satisfaction and the importance of the factor being evaluated. (See Mullins & Spetich, 1987).

Interview

A self-report method in which visitors are verbally asked questions instead of paper-and-pencil administration.

Laboratory experiment

Experimental study conducted in a carefully controlled setting.

Landmark

A prominent feature of the environment that is easily used by visitors to find their way through a complex environment. Lynch (See Bitgood, 1987) divided environmental features into: landmarks, paths, intersections, districts, and boundaries.

Landscape immersion

Term used by Coe (1986) to describe zoo exhibitions that provide the illusion of "naturalism" to the point that visitors

are perceptually immersed in the environment.

Market research
A study of consumer reactions to products and services. Attempts to answer such questions as: "Whom are we serving?" "What new audiences do we want to develop?" "How do we reach new audiences?" (See Loomis, 1987 – Chapter 4).

Mock-up
An inexpensive simulation of an exhibit or object often used during formative evaluation in order to determine its effectiveness before a final exhibit is completed.

Naturalistic evaluation
Type of goal-free, qualitative evaluation advocated by Robert Wolf (1980).

Orientation
General term that includes conceptual orientation, wayfinding, and circulation.

Post-design evaluation
Evaluation of installed exhibits. See "summative evaluation."

Post-occupancy evaluation (POE)
Term used in architectural literature to mean evaluation of a building after the facility is in use. Similar to "post-design" or "summative" evaluation.

Pre-design evaluation
Another name for front-end evaluation. Takes place before the project begins.

Prototype
Another term for mock-up or model of an exhibit; often used during formative evaluation.

Psychographics
Lifestyle dimensions of individuals or groups of persons such as attitudes, values, opinions, expectations and satisfactions of visitors (See Hood, 1988).

Quasi-experimental design
Experimental study in which it is not possible to control the assignment of individuals to experimental conditions (see Cook & Campbell, 1979).

Questionnaire
Paper-and-pencil survey.

Rating scale
Survey device in which respondents are asked to judge some object, program, or other type of experience along some dimension (e.g., Excellent, Good, Neutral, Fair, Poor).

Reactivity
Situation in which some aspect of the procedure in a study

influences the person under study. For example, people view exhibits longer if they know they are being observed in a study.

Reliability

Consistency or stability of behavioral measurements. Any of several types of reliability may be important: interobserver reliability, test-retest reliability, split-half reliability, alternate form, etc.

Simulation

Study that attempts to create the important conditions of a real environment in order to study people's reactions. It assumes that people respond similarly to the real situation and the simulated situation.

Survey

Self-report method that includes questionnaires, interviews, and rating scales.

Summative evaluation

Evaluation of the extent to which a project is successful, usually in terms of goals and objectives.

Tracking

Direct observation of visitor behavior throughout an exhibit area or facility. It gives a more complete picture of the visitors' behavior than does focused observation as they move through the facility.

Validity

Term which refers to the accuracy of the conclusions about measurements and results. For example, does the measurement system really measure what you think it does?

References

References for the Glossary of Visitor Studies Terms

Bechtel, R., Marans, R., & Michelson, W. (Eds.) (1987). *Methods in Environmental and Behavioral Research*. New York: Van Nostrand Reinhold Company.

Bitgood, S. (1987). When is a Zoo Like a City? *Visitor Behavior*, 1(4), 5.

Coe, J. (1986). Towards a Coevolution of Zoos, Aquariums, and Natural History Museums. *AAZPA Proceedings*. pp. 366-376.

Cook, T. & Campbell, D. (1979). Quasiexperimentation. Chicago: Rand McNally.

Griggs, S. (1983). Orienting Visitors Within a Thematic Display. *International Journal of Museum Management and Curatorship*, 2, 119-134.

Hood, M. (1986). Getting Started in Audience Research. *Museum News*, 64(3), 24-31.

Loomis, R. (1987). *Museum Visitor Evaluation*. Nashville, TN: American Association for State and Local History.

Loomis, R. (1988). The Countenance of Visitor Studies in the 1980's. In S. Bitgood, J. Roper, & A. Benefield (Eds.), *Visitor Studies - 1988: Theory, Research. and Practice*. Jacksonville, AL: Center for Social Design.

Loomis, R., Fusco, M., Edwards, R., & McDermott, M. (1988). The Visitor Survey: Front-End Evaluation or Basic Research? In S. Bitgood, J. Roper, & A. Benefield (Eds.), *Visitor Studies - 1988: Theory, Research. & Practice*. Jacksonville, AL: Center for Social Design.

McNamara, P. (1988). Visitor-Tested Exhibits. In S. Bitgood, J. Roper, & A. Benefield (Eds.), *Visitor Studies - 1988: Theory. Research. and Practice*. Jacksonville, AL: Center for Social Design.

Melton, A. (1935). *Problems of Installation in Museums of Art*. New Series No. 14, Washington, D.C.: American Association of Museums.

Mullins, G. & Spetich B. (1987). Importance- Performance Analysis. *Visitor Behavior*, 2(3), 3,12.

Screven, C. (1976). Exhibit Evaluation: A Goal referenced Approach. *Curator*, 19(4), 271-290.

Screven, C. (1986). Exhibitions and Information Centers: Some Principles and Approaches. *Curator*, 29(2), 109-137.

Screven, C. (1988). Formative Evaluation: Conceptions and Misconceptions. In S. Bitgood, J. Roper, & A. Benefield (Eds.), *Visitor Studies - 1988: Theory, Research. & Practice*. Jacksonville, AL: Center for Social Design.

Shettel, H., Butcher, M., Cotton, T., Northrop, J. & Slough, D. (1968). *Strategies for Determining Exhibit Effectiveness*. Report No. AIR E95-4/68-FR) Washington, DC: American Institutes for Research.

Wolf, R. (1980). A Naturalistic View of Evaluation. *Museum News*, 58(1), 39-45.

Other references of interest on methodology

Henerson, M., Morris, L., & Fitz-Gibbon, C. (1978). *How to Measure Attitudes*. London: Sage Publications.

Direct observation

Diamond, J. (1982). Ethology in Museums. *Journal of Museum Education: Roundtable Reports* , 7(4), 13-15.

Hutt, S. & Hutt, S. (1970). *Direct Observation and the Measurement of Behavior*. Springfield, IL: Charles C. Thomas.

Bitgood, S. (1987). Knowing When Exhibit Labels Work. A Standardized Guide for Evaluating and Improving Labels. In the 1987 AAZPA *Proceedings*. Portland, OR: American Association of Zoological Parks & Aquariums. Also available as *Technical Report No. 87-90*, Jacksonville, AL: Psychology Institute, Jacksonville State University.

Serrell, B. (1983). *Making Exhibit Labels: A Step by Step Guide*. Nashville, TN: American Association for State and Local History. Program Evaluation

Fitz-Gibbon, C. & Morris, L. (1978). *How to Design a Program Evaluation*. London: Sage Publications.

Visitor orientation

Bitgood, S. (1988). Problems in Visitor Orientation and Circulation. In S. Bitgood, J. Roper, & A. Benefield (Eds.) *Visitor Studies - 1988: Theory. Research. & Practice*. Jacksonville, AL: Center for Social Design.

Originally published in Visitor Behavior (1988) 3(3), 8-10.

7

Designing Effective Exhibits:
Criteria for Success,
Exhibit Design Approaches,
and Research Strategies

1: Introduction and overview

This special issue of *Visitor Behavior* looks at three aspects of designing effective exhibits: the possible criteria for assessing the success of an exhibit; common exhibit design approaches or strategies; and the research and evaluation strategies used to gather information on exhibit effectiveness.

Criteria for success

Success of an exhibit can be judged in two ways – visitor measures and/or critical appraisal by experts. Visitor measures include behavior, knowledge, and affect. Critical appraisal by experts can take any of three perspectives – that of the expert in visitor studies, that of the expert in the subject matter, and that of the artist. Each of these criteria is described in Part 2 of this article.

Exhibit design approaches

While designers rarely adopt only a single approach, they sometimes place heavier emphasis on one approach at the expense of others. Both the nature of the exhibition and the bias of the designers are likely to play an important role in establishing the approach which guides exhibit development. Hopefully, the implications of the various approaches are considered in the design process. If the exhibit is to be a success in the broadest sense (in terms of multiple criteria for success), it is critical that the strategies guiding development be made explicit as well as be consistent with the goals and objectives of the exhibit.

The various exhibit design approaches are not mutually exclusive. Designers usually have more than one strategy in mind when they design exhibits. For example, museums are often concerned that exhibits be designed so that they have both educational and recreational outcomes. By considering the possible impact of each design approach, exhibits have a greater chance of meeting their goals and objectives. Below is a brief definition of each approach; a more detailed discussion is found in Part 3.

Design approaches

The subject-matter approach: the major emphases are in presenting complete and accurate information with less concern for how the message will be received by the exhibit's audience or for the aesthetic appeal of the presentation.

The aesthetic approach: the major concern is in the aesthetic appeal of the presentation. Aesthetics take precedence over the message or the impact on audiences other than the artistic community.

The hedonistic approach: the major concern is that the audience will have a good time. Enjoyment (entertainment) is the primary emphasis.

The realistic approach: the major focus is to create a simulated, realistic experience. For example, an exhibit may attempt to produce a simulated experience of a natural habitat or a ride in a space ship.

The hands-on approach: exhibits are designed with the assumption that hands-on activities are inherently more

effective than exhibits which require passive viewing.

The social facilitation approach: when taking this strategy, exhibit designers attempt to produce exhibits that allow for or stimulate social interaction among visitor group members.

The individual-difference approach: following this approach, designers attempt to develop exhibits for audiences who differ on one or more characteristics. Audiences may differ on learning preferences, learning style, cognitive ability, age, educational level, interest level, reasoning skills, etc.

While each of the above approaches has its merits, conflict often occurs when decision-makers either overemphasize one (or several) of these approaches and/or neglect approaches that may be appropriate to the exhibit's goals. For example, curators may believe that some forms of interpretive devices, although proven to be effective, "spoil" the aesthetic appeal of an exhibit gallery.

Research and evaluation strategies

Both quantitative and qualitative strategies are used in visitor studies to determine the characteristics of successful exhibits and whether or not a specific exhibit is successful. Usually these strategies are combined to take advantage of the strengths of both. Quantitative analysis gives us answer to the questions of how often, how long, how many, etc. Qualitative analysis can give additional meaning to these numbers with narrative descriptions and examples.

Quantitative strategies

The visitor perception strategy: exhibit design attempts to follow principles derived from research based on the visitors' perceptions of good exhibit design and the success of exhibits is determined by how visitors react to the exhibit.

The experimental strategy: design principles are derived and tested through experimental research in which the effects of design variables on intended visitor behavior are carefully studied.

Qualitative approaches

Qualitative approaches place more emphasis on words than on numbers. Traditional statistical analysis is replaced by paraphrasing and categorizing the statements of respondents. Goals and objectives are replaced with a "let's see what our observations reveal" approach. The naturalistic evaluation approach by Wolf (1980) and the ethological methodology used by Diamond (1986) are examples of the qualitative approach, although the methodology of Diamond appears much more rigorous than that of Wolf. Research strategies will be described in more detail in Part 4.

2: Criteria for success

Exhibition centers use two types of criteria for determining the success of exhibits. The first type is visitor measures. As noted, visitor measures are of three types: behavioral; knowledge acquisition; and affective. The second type of criteria for success is judgments of experts in the form of critical appraisal.

Visitor measures of success

The use of multiple visitor measures is usually necessary to assess the impact of an exhibit since, in most instances, there are several goals and objectives and consequently multiple criteria for success. Each type of measurement has utility for a specific purpose; but, no one type would be valid (accurate) for all purposes. It is critical that measurements be selected so they are reliable (consistent across data collectors, time, and place) and valid (accurate with respect to the purpose for which they are chosen). If visitors' self-reports significantly distort the occurrence of their actual behavior, then such invalid verbal reports may mislead exhibit designers into making invalid inferences (e.g., visitors say they are reading labels even though they are not).

Behavior measures

Behavioral measures involve observation and recording of overt visitor behavior. This type of measure is most valid when it is important to know exactly what people do.

It is important to realize that behavioral measures do not necessarily correlate with one another or with other types of measures. Thus, an exhibit may be highly attractive causing visitors to stop, but the exhibit may fail to hold attention long enough to deliver the critical message. Or, visitors may say they read labels when they actually gave no more than a cursory glance to the labels.

Behavioral measurement includes the following:

Stopping (attracting power): This is the fundamental

measurement for determining whether an exhibit captures visitor attention. Attracting power is a report of the percentage of visitors who stop at a specific exhibit. It is obvious that if visitors do not stop, there is no chance that the exhibit will deliver its message. The most interesting exhibit label ever written might as well not exist if it is not read by visitors.

Viewing time (often expressed as holding power): After the visitor has stopped, he/she must view for a minimum amount of time in order to obtain the message. An exhibit's ability to hold visitor attention long enough to deliver the message is another basic measure of success. Viewing time is often transformed into a measure of "holding power" in which the average visitor viewing time is expressed as a fraction of the total time it would take to "get the message" (see Shettel, Butcher, Cotton, Northrop, & Slough, 1968).

Social impact: At times it may be important to assess the ability of an exhibit to facilitate social interaction among members of a group. This is particularly important for family groups with young children who need interpretive information from parents in order to understand the message (e.g., see Diamond, 1986). Social impact measures may include: asking questions, giving information to other group members, pointing, giving instructions, etc.

Human factors impact: Human factors impact is especially important for hands-on/interactive exhibits in which the visitor is expected to make an overt response. Human factors principles require that the expected response should: be obvious to the visitor; produce feedback as to whether it is

correct or incorrect; and, not require an unusual amount of effort; and involve simple instructions.

Trace or decay measures: Occasionally, it is possible to measure some physical evidence of a response long after the response was made. For example, noseprints on the exhibit glass may be a valid, although rough measure of an exhibit's popularity with the visiting public.

Knowledge acquisition

While behavioral measures can provide the most valid method of determining what visitors actually do at exhibits, they cannot usually tell us what visitors are thinking or feeling. When visitors are talking at an exhibit, we may not know whether they are talking about the exhibit or what they will eat for dinner. Therefore, another type of measure is necessary to assess what visitors learn from an exhibit. Assessment of knowledge acquisition generally requires the use of language and some type of interview or written assessment. This approach is not without its problems, for example:

- some measures may be more sensitive than others (e.g., recognition is easier to remember than recall);
- the assessment may not ask for the specific information that visitors actually acquire;
- developing assessment devices requires an understanding of the processes of memory and learning;
- the knowledge measured may not be based on exhibit goals and objectives.

The two major types of knowledge acquisition are:

Memory: the ability to recall or recognize information from an exhibit. For our purposes we can categorize memory knowledge into three major classes:

- · semantic memory (general, objective knowledge about the world);
- · episodic memory (specific, subjective knowledge about an episode or experience);
- · and procedural memory (the ability to perform a mental or physical operation). See Visitor Behavior (1994), Volume 9, Issue No. 2 for more about memory.

Comprehension: the ability to reason from knowledge. Kinch (1994) reported a study indicating that, at least under some circumstances, text formats that improve memory do not improve comprehension or the ability to reason from the material. The implication is that simple measures of memory (recognition and recall) may fail to indicate more complex cognitive goals (making inferences from information).

Affective measures

The third type of measure is affective. Museums are often concerned with how the attitudes and/or interests of visitors are influenced by an experience at an exhibit or within the entire museum. Still another affective measure is visitor satisfaction.

Attitude change: Expressed goals for exhibits often include attitude change (shift in beliefs or the emotional intensity of

a belief). Attitude change is most likely to occur as a result of emotional appeals combined with supporting information. Attitudes related to common exhibit goals include preserving animal species or an ecosystem, the role of science in our daily lives, or feelings about modern art.

Interest level: It is often assumed that through an exhibit experience, visitors will increase their interest in the subject matter. It is not clear, however, what factors influence interest level and whether or not interest level is clearly discriminated from physical and mental states such as fatigue and satiation.

Satisfaction: Visitor satisfaction is undoubtedly an important factor in transmitting positive word-of-mouth communications of a visitor to family and friends in considerations for repeat visitation. Satisfaction is inferred from self-reports of an experience (e.g., "The exhibit is exciting!" or "I am very satisfied with the exhibit experience.")

Critical appraisal

Visitor measures are not the only way exhibits are judged to be successful. Another approach is to have knowledgeable professionals review the exhibit from an expert's perspective. This approach, if it proves to be a reliable and valid predictor of audience reaction, could save considerable resources. The "expert" perspective can take three distinct (and sometimes conflicting) forms:

Visitor perspective: A critique from the visitor perspective attempts to apply empirical knowledge from the visitor literature. Thus, an exhibit is considered better if visitors are

likely to attend to it based on the literature that demonstrates labels with fewer words receive more reading than labels with a large number of words. The predictive validity of this type of critique depends upon the knowledge of the expert as well as the quality of empirical research.

Aesthetic perspective: An expert from the artistic perspective would assess an exhibit from the point of view of artistic principles such as form, color, and linear perspective. One possible problem with this perspective is the reliability of the critique. Would other artists agree on whether the exhibit follows artistic principles?

Content-expert perspective: The content expert would analyze an exhibit from the perspective of the accuracy and completeness of information. Again, experts may not agree on judgments of accuracy and completeness. One expert may dispute the accuracy of a piece of information, while other experts may not.

While all three of these perspectives serve a purpose, too often the visitor perspective is either ignored or relegated a minor role. If exhibits are designed to have an impact on visitors, then the visitor perspective must be considered.

How should measures be selected?

While there are few hard and fast rules, measures should be consistent with the goals and objectives of the exhibit. Thus, if creating social interaction is a goal of the exhibit, then social impact should be measured. If knowledge acquisition (one or both types) is a goal, knowledge acquisition should

be measured. As a general rule, a combination of behavioral, knowledge acquisition, and affective measures is desirable to obtain a comprehensive view of the exhibition's impact. Overemphasizing one approach may result in less effective outcomes in one or more types of measure.

3: Approaches to exhibit design

Many of the conflicts among members of an exhibition design team can be traced to differences in basic philosophy of design. Some professionals (often experts in the specific discipline) attempt to saturate the exhibit with detailed information without regard to the interests and/or cognitive processing abilities of the audience. Here, this approach is called the "subject-matter" approach. Other professionals (often with training in art and design) may be primarily concerned with adherence to traditional principles of art. Such individuals emphasize the "aesthetic" approach. Still other professionals (often advocates of let-kids-play-as-an-end-in-itself) are concerned primarily with designs that produce fun experiences with less concern for educational or aesthetic goals. This is the "hedonistic" approach. While all three approaches have merits and should be considered, overemphasizing one and neglecting the other approaches is likely to create problems in exhibit effectiveness because of failure to communicate important messages, failure to be attractive, or failure to create a satisfying experience for visitors. Examples of conflicts resulting from such problems are described below.

In one project, visitor evaluation revealed that visitors did

not understand that a model of a small, little-known animal was magnified 200 times. When the evaluator suggested that a brief label be placed directly on the model indicating that it was magnified 200 times, the curator of design argued that a label would ruin the aesthetic appeal of the model. This curator clearly placed aesthetic considerations above didactic. Communicating with the audience was valued less than aesthetic appeal in this example.

In another project, visitors rarely paid attention to an interpretive device placed on a stand in front of an art object. The evaluator suggested that the device be made more visually salient by placing on the device bright colors or a sign with large letters indicating that information about the exhibit object was available. The curator, however, was concerned that these changes would detract from the appeal of the art objects. Again, communicating with the audience was considered less important than aesthetic presentation.

A children's museum asked a design firm to develop children's exhibits that would be fun. When the design firm attempted to develop these exhibits with accompanying educational goals, the museum staff argued that it doesn't matter if children learn anything as long as they have fun. It was argued that children should be given the opportunity to play, rather than forced to learn something. There was no appreciation of the fact that both could occur at once.

Recommendations

Design teams may minimize these conflicts by considering the

following during the development process:

Make clear each exhibit team member's biases at the beginning and throughout the design process.

Explicitly state who the intended audience(s) of the exhibition is going to be. This helps to make clear what design elements may be used to reach the audience(s). If the audience is primarily adults, then more involved label text is called for; if it is children, then more hands-on elements and less text is called for.

Negotiate goals and objectives. Each design team member should explicitly state the expected impact on the audience. Impact should be stated in terms of behavioral, knowledge, and affective measures. Is it acceptable if only 30% of visitors stop to view the exhibit? If only 10% read labels? If 15% can give the major point made in the exhibit?

Discuss whether or not the planned design will reach the audiences(s) in the most effective way in light of the goals and objectives.

Of course the ideal occurs when the subject-matter, aesthetic, and hedonistic approaches are combined in such a way that optimal performance levels on behavioral, knowledge, and affective measures are attained. Ideally, well-designed exhibits contain accurate information, communicate their messages, are attractive to look ' at, and produce visitor satisfaction.

Design approaches that employ realism
A common design strategy (especially in zoos and natural

history museums) is to create a visitor experience that simulates reality. Realistic exhibits may be justified for at least three reasons: it may be assumed that realistic exhibits have greater attracting and holding power; the experience of realism is assumed to have educational value in itself (visitors learn what an animal's habitat is like from a diorama); and/or realistic exhibits have more affective impact.

At least four examples of the realistic approach can be found. First, is the diorama approach to exhibit design. Dioramas in natural history museums were originally designed to convey information about the habitat of animals on exhibit (Wonders, 1993).

Second is the concept of concreteness formulated by Peart (1984), Kool (1988), and Peart & Kool (1988). These investigators argued that *concrete* exhibits (or realistic exhibits with three-dimensional objects) are more successful than *abstract* (or exhibits with text and no objects) in terms of attracting and holding power, but abstract exhibits are more effective in terms of teaching power.

A third example of the realistic approach is simulated immersion. Exhibits are designed so that visitors feel they are in the time and place simulated by the exhibition. Jon Coe (1985) has argued that landscape immersion exhibits in zoos provide an important educational experience to visitors.

Finally, virtual reality is still another approach to realism. Although museums are only beginning to use this technology, it will undoubtedly become a popular approach in the next few years. Virtual basketball is available now at a number of science

museums and shopping malls. More sophisticated virtual reality exhibits with clear educational aims are currently being planned by a number of museums.

While realism has been a significant influence on design philosophy, only recently has there been an attempt to empirically validate the assumptions of this approach.

Dioramas

Dioramas were initially developed over one hundred years ago in natural history museums in both the United States and Sweden exclusively (e.g., Wonders, 1993). Dioramas, in their purest form, present animal species within a context of natural habitat including three dimensional, realistic- looking objects (trees, rocks, etc.) and a background painting on the back wall. Only recently has the effectiveness of dioramas been objectively studied (Davidson, Heald, & Hein, 1991; Dyer, 1992; Guisti, 1994; Harvey, Birjulin, & Loomis, 1993; Marino &Harvey, 1994; Peart, 1984; Peart& Kool, 1988; Peers, 1991;Thompson, 1993). These studies suggest that:

1. dioramas are popular with visitors and tend to generate higher visitor attention than other types of exhibits;
2. and dioramas can be combined with "hands-on" and audio-visual media to increase the exhibit's impact on visitors.

Concreteness

Peart (1984) described exhibit types on a dimension from concreteness to abstractness. According to Peart, pure concrete

exhibits are three dimensional with objects; pure abstract exhibits are *one-dimensional*, lacking objects. He studied five exhibit variations ranging from *abstract to concrete*. The most abstract exhibit consisted of labels only; next, a label with a picture; an object only; an object with label; and an object, label, and sound. The latter was considered the most concrete. It is not clear from Peart's description of concreteness why the object-only condition was less concrete than the object-plus-label condition since labels are considered abstract rather than concrete. Peart found that the exhibit considered most concrete was most effective in terms of both behavioral (attracting power and viewing time) and knowledge gain.

Kool (1985) and Peart& Kool (1988) reported an analysis of exhibits based on the Concrete Index scale. This scale was objectively defined based on: three dimensionality (objects); diorama backdrop; openness of the exhibit (as opposed to a glassed in diorama); photographs and illustrations; text material; film or slides; sound; smell; and size of the exhibit (linear measure of frontage). It is curious that, in this scale, points were given for the presence of words (which would seem to be abstract in nature). It is also difficult to understand why touch was not added to the multi-sensory elements.

Immersion

Jon Coe (1985) describes "landscape immersion" in zoo exhibits:

It is an approach where the landscape dominates the architecture and the zoo animals appear to dominate the public. The zoo becomes a landscape with animals. In this approach, the

*visitor leaves the familiar grounds of an urban park called
a zoological garden, and actually enters into the simulated
habitat of the animals. The animals remain separated from
the public by invisible barriers, but the people do enter the
animal's realm and ... may even consider themselves to be
trespassers in the wilderness home of the plants and animals.
Every effort is made to remove or obscure contradictory ele-
ments, such as buildings, service vehicles, or anything that
would detract from the image or experience of actually being
in the wilderness. (Coe, 1985, p. 9).*

Yellis (1990) has described another type of immersion used at
Plimoth Plantation, a living history museum:

*What we are after is an environment, both physical and
human, so authentic and of a piece, an experience of such
critical mass and vitality that it becomes possible for the
visitor to discount the annoying, but undeniable, reality that
he is not in the past. It becomes desirable for him to relinquish
the present on some level, to let go, yield himself to whatever
experience he needs to have of the past, and take the initiative
in precipitating that experience. (Yellis, 1990, p. 52).*

Researchers have now begun to measure through self-reports
the degree to which exhibit environments create an immersion
experience. Bitgood (1990) reported three studies in which self-
reports of immersion were correlated with other variables. For
example, there was a strong relationship between ratings of
"feeling of time and place" and "excitement". This suggests

that feeling immersed in an exhibit experience is exciting. Such exhibits apparently have a powerful affective impact.

Thompson (1993) manipulated background context and degree to which visitors could enter the simulated environment (space surround). In this study participants were shown photographs of exhibits and asked to rate the exhibits along several dimensions. Some photographs presented a mounted animal with a white screen in the background, other photographs presented with the same animal with a naturalistic background context. This comparison attempted to assess the effects of the more realistic background context. In another comparison, one set of photographs included people touching the animals while another set showed people viewing the animals from behind a barrier. This comparison attempted to assess the impact of having the exhibit space surround the visitor. Both background context and space surround variables increased favorable ratings of the exhibit especially in terms of feelings of immersion.

Virtual reality

Harvey, Birjulin, & Loomis (1993) have extended the notion of immersion by comparing realistic environments in museums with virtual reality environments. Virtual reality, in addition to providing a simulated environment, involves kinesthetic feedback and interaction with the environment. The authors use as an example, evaluation work on exhibits at the Denver Museum of Natural History. While the exhibits they studied are far from true virtual reality environments, there is no doubt

that virtual reality will be a significant part of the museum of the future. It is easy to imagine virtual reality trips under water in a coral reef.

Summary

While approaches using dioramas, concreteness, immersion, and virtual reality all attempt to create realistic experiences, each is based on unique assumptions. The diorama approach assumes that something important is communicated by placing the object in context. The concreteness approach assumes that variables such as size, three-dimensionality, and contextual background influence attracting and holding power, but not communication. The immersion approach assumes that it is important to create a feeling of time and place. Virtual reality assumes that environmental feedback is critical.

The hands-on approach

"It is a widely held and influential dictum in mainstream education that the learner should be actively involved in the act of discovery" (Alt & Shaw, 1984; p. 33). In the last several years this dictum has led to the domination of "hands-on" exhibits in some informal learning institutions. Science centers and children's museums have especially emphasized the hands-on or participatory approach to exhibit design. Perhaps this is because children, more than adults are more attracted to such exhibits as indicated by visitor studies (e.g., Koran, Koran, & Longino, 1986; Rosenfeld & Turkel, 1982).

Koran, et al. found that children were more likely than adults to interact with hands-on exhibits. Similarly, Rosenfeld and Terkel (1982) found that children interacted more than adults with animals and a zoo game; adults, on the other hand, spent more time than children reading labels.

There is evidence to support the argument that hands-on activities produce more success (at least in terms of attracting and holding power) than passive ones (e.g., Melton, 1972), although hands-on components by themselves don't ensure success (e.g., Borun, 1977). Borun found that simple button pushing detracted from the impact of an exhibit. To ensure success, hands-on exhibits must be carefully designed and evaluated during the development process. An example of an unsuccessful hands-on exhibit may be instructive. An exhibit on gravity modelled after the "Falling Feather" Exploratorium Cookbook exhibit was evaluated in a science museum (Bitgood, 1991a). Eight steps had to be followed in order to understand that a feather and a piece of metal will fall at the same speed in the absence of air, but when air is present, the feather falls slower because of air resistance. Following all eight steps was complicated and took a considerable amount of time. Although about 45% of the visitors studied spent more than two minutes at the exhibit, only 25% of those who spend this amount of time were able to observe the phenomenon being demonstrated either because they did not follow instructions correctly or because the exhibit did not function properly. If this exhibit had been tested on visitors during development, it might have been altered to correct these problems.

Bitgood, Kitazawa, and Patterson (see Chapter 46) found that hands-on exhibits differ in the amount of participation they generate, some stimulating more child interaction while others produce more adult hands-on behavior. Thus, the design of such exhibits may determine who participates and how much.

If hands-on exhibits are to be successful, they should follow design principles outlined in the literature (e.g., Bitgood, 1991b; Kennedy, 1990; Norman, 1988). Some of these principles are summarized below. The hands-on device should be designed so that the:

- Visual appearance makes the appropriate response obvious.
- Instructions are simple and brief.
- Feedback is provided for appropriate and inappropriate responses.
- Errors are minimized.
- Controls follow ergonomic principles.
- The exhibit's message can be communicated in a short amount of time.

While hands-on exhibits may be preferred by visitors (especially children), it does not guarantee "minds-on". Borun and Adams (1991) have shown that designing these exhibits so that they deliver the intended message is often problematic. There is little doubt that the participatory approach to exhibit design has bred many successful exhibits. But, it is also important to note that exhibits can be successful

without physical participation. For example, dioramas can be appreciated without hands-on elements; art objects can be enjoyed by viewing. Passive experiences can make successful exhibits.

The social facilitation approach

Many have asserted that museum visitation is primarily a social event (e.g., Falk & Dierking, 1992). From this perspective, it is argued that people go to museums and zoos to be with family and friends. Consequently, exhibits should be designed to encourage such social interaction. An additional rationale for the social facilitation approach is that important learning can take place best within this social context.

The social facilitation rationale can be summarized as follows:

- Social goals are important to the vast majority of visitors and people usually visit in groups.
- Group members influence each other during their visit.
- Exhibits can be designed to facilitate social interaction.
- Social interaction is especially important when young children are part of the visitor group.

Visitor researchers have collected data on visiting groups since the late 1970s. Only a few examples will be provided here. However, reviews of family group behavior in museums can be found (e.g., Falk & Dierking, 1992; McManus, 1994). In one of the earliest reported studies, Cone & Kendall (1978)

observed family visitors at the Science Museum of Minnesota. They observed family interactions and attention to exhibits during the visit. Among other results, they found dioramas to be the most successful type of exhibit in terms of percentage stopping, viewing time, and recall data. Whether dioramas are more successful with families than all adult groups was not determined from this study.

Judy Diamond (1986) conducted a detailed analysis of family visits to two museums using an ethnological methodology. A sophisticated recording system documented many types of family interaction, both with each other and the exhibits. Her findings suggest that it is extremely important to study the family as a unit of analysis since family members clearly influence each other. For example, teaching behavior in the form of parents showing children what to do was commonly observed.

Diamond, Smith, and Bond (1988) in their report evaluating the California Academy of Sciences Discovery Room, argued that exhibits in a discovery room should be designed "to create a social environment as well as a physical structure." They suggested that an adult's presence influences children in two ways: it appeared to reduce the timidity of the child, and it caused the child to slow down long enough to attend to objects.

Evidence that adults behave differently with children than they do with other adults was shown in a study by Bitgood, Kitazawa, Cavender, and Nettles (1993). Dramatic differences in viewing time were found at a child-oriented exhibit – adults viewed the exhibit longer when they were with children than

when they were with other adults. The social facilitation approach is obviously important for exhibit designers to consider. It also has limitations. When a group is composed of older children, there is less need for social facilitation. Bitgood, Kitazawa, and Patterson (in press) argue that when children are young and cannot read themselves, they are dependent upon adults to provide information to "make sense" of an exhibit. Once children are old enough to extract information themselves, there is less need for high rates of social exchanges between parent and child. Another limitation of the social facilitation approach is that some topics may lend themselves poorly to social experiences. Still another limitation: group influences maybe distracting. For example, when an adult is attempting to read an exhibit label, a young child's demand for attention often prevents the adult from completing the reading task. There is no doubt that social behavior is an important part of the museum visit for the majority of visitors. But the nonsocial visitor should also be considered. In some situations, it might be appropriate to design an exhibit so that it provides different types of experiences for groups who wish to socially interact as well as for individuals who wish to experience an exhibit in a solitary manner.

The individual-difference approach

The individual-difference approach emphasizes the diversity of museum audiences. This approach attempts to design an exhibit in a way that provides something for everyone. There are several forms of this approach, only a few of which will be described.

Cognitive ability

Assuming that people learn in different ways according to their level of cognitive ability, Greenglass (1986) designed an exhibit for two different conceptual levels or information processing abilities. In the "high-structure" exhibit the tasks to be completed and the information to be learned were clearly stated; in the "low-structure" exhibit the visitors were given little or no guidance concerning the task. An independent measure of visitor conceptual level was used to objectively determine a measure of ability. Those who obtained high conceptual level scores learned equally well at both exhibits; whereas those with low conceptual level scores learned better with high structure exhibit than the low structure one. The implications of this study: designing for the lowest level of conceptual ability seems to produce desired outcomes for all levels.

Learning style

Vance and Schroeder (1991) studied the effects of two types of exhibit labels on visitor learning style. The learning style of visitors was determined by the Myers-Briggs Type Indicator test. Two types of labels were designed. An "intuitive" type of label was designed for learners who were interested in reading and problem solving. "Sensing" labels were designed for learners who directly apply their five senses to the exhibit. The major findings were that learners defined as "intuitive" on the Myers-Briggs test performed better on a test of knowledge when intuitive labels were present, while visitors defined as

"sensing" performed better when sensing labels were used. These results are consistent with the notion that learning styles influence visitor performance.

Interest levels

The *Prehistoric Journey* exhibition at the Denver Museum of Natural History (Marino, 1994) is being designed to accommodate three types of audiences: "discoverers," "explorers," and "studiers." *Discoverers* are assumed to spend the least amount of time with exhibits; they prefer hands-on exhibits and are most likely to respond if the exhibit contains some type of high interest material. *Explorers* are assumed to be those visitors who experience the exhibits in a more involved manner, occasionally looking closely at things that are of interest to them. *Studiers* are assumed to be highly motivated learners who spend the time necessary to absorb complex information. They read labels, study diagrams and discuss the exhibit with other group members. Even if data does not support the notion that visitors can be easily divided into these categories, designing for this range of audience interest may be a useful way to provide exhibit material for a wide range of interest levels and for varying interest levels within the duration of a visit.

Demographic characteristics

Numerous studies have found differences between males and females, between adults and children, and between more educated and less educated visitors. The characteristic of age

is often used as a basis for designing exhibits (e.g., children's museums). While exhibit design does not often consider gender differences, such considerations might prove useful to ensure that both male-female interests and points of view are represented.

Summary and critique

The individual-difference approach in its various forms can be criticized for the following reasons:

1. There has been no systematic replication of the studies by Greenglass and Vance & Schroeder.
2. Critiques argue that the dimensions selected represent continuums rather than discrete categories (e.g., Serrell, 1993).
3. There is often a problem in defining individual differences.
4. There is a danger of stereotyping visitors.

This approach also has its strengths:

1. It recognizes the existence of diverse audiences. This should encourage designing exhibits for the broadest range of audiences.
2. The individual difference approach gives credence to the possibility that interests, preferences, and/or cognitive abilities or styles may influence the impact of exhibits.

In summary, the individual-difference approach may have

merits, but the validity of the individual variations of this approach (e.g., learning style) has yet to be convincingly demonstrated.

4: Research and evaluation strategies

Quantitative strategies

Quantitative approaches have been the traditional research and evaluation strategies used in museums. These strategies rely on numbers and statistical data reduction methods. They base their approach on the basic assumptions of science. Below are two major types that are subsumed under the quantitative strategy.

The visitor perception strategy

The visitor perception strategy of research and evaluation starts with the visitor. Visitors are asked for their judgements concerning how exhibits are best described and what makes a successful exhibit. A variation of this strategy is to ask visitors to rate exhibits along some dimension and the results are used to formulate design guidelines. This strategy has the advantage of using descriptors in visitors own words rather than those which are created by the researcher and may not express the thoughts and feelings of visitors.

Alt & Shaw (1984) used this strategy to determine the characteristics of the "ideal museum exhibit" at the Natural History Museum (London). Characteristics were derived by asking visitors to identify descriptors that apply to exhibits and then with a second group of visitors applying these

characteristics to specific exhibits. They found that the following items strongly apply to the "ideal" exhibit:

- It makes the subject come to life.
- You can understand the points it is making quickly.
- There's something in it for all ages.
- It's a memorable exhibit.
- It's above the average standard of exhibit in this exhibition.

Other items were strongly negative with respect to the ideal exhibit:

- It's badly placed – you wouldn't notice it easily.
- It doesn't give enough information.
- Your attention is distracted from it by other displays.
- It's confusing.

While this research strategy may be fruitful, the Alt and Shaw results have an important limitation. Most of these descriptors are expressed more as visitor outcomes and do not provide guidance on how to design exhibits. If visitors describe a particular exhibit as "memorable," or "It makes the subject come to life," designers are still left with the problem of determining what characteristics make it memorable or make the subject come to life.

Another example of the visitor perception research strategy is provided by Finlay, James, and Maple (1988). They reported a study in which a group of individuals generated adjective pairs while viewing slides of animals in a variety of settings. Another

group rated the adjective pairs for their appropriateness in describing animals. Only the pairs rated as highly appropriate were selected for the study. Selected pairs included: harmful-harmless, friendly-unfriendly, graceful-clumsy, free-restricted, tame-wild, etc. Four groups were tested: a control group rated the eight animals on name alone; a naturalistic zoo group (shown slides of animals in naturalistic zoo surroundings); a zoo group (animals in cages); and a wild animal group (slides of animals in the wild). Perception of animals were very different depending on the context in which they were observed. Zoo animals were perceived as restricted, tame, and passive; wild animals were seen as free, wild, and active. The Finlay et al (1988) study provides us with one important relationship between design and impact – the background context of an animal is related to visitors' perception of that animal. Thus, this study is more directly useful to the designer than that of Alt and Shaw (1984).

Another form of the visitor perception strategy correlates survey items that describe design variables (e.g., "The lighting level helps to create a desirable atmosphere" and "It uses senses other than visual") with visitor impact items ("The exhibit is memorable" or "It makes the subject come to life"). Using many of the items from Alt and Shaw, Bitgood (1990) asked visitors to rate exhibition areas on a number of descriptors. Design factors were then correlated with impact factors. Some interesting relationships were found. For example, "It uses senses other than visual" was correlated (r=.521) with "It makes you want to learn more about the subject matter." It would

be an important outcome of this approach if it can be shown that adding multisensory components to an exhibit increases motivation to learn.

The experimental strategy

The experimental strategy starts with a logical analysis or empirical review of the design variables (e.g., size, location, movement, etc.) that are likely to influence visitor outcomes. Hypotheses concerning important design variables are formulated and then systematically tested through experimental studies in which design variables are manipulated and the effects on visitor outcomes are measured. Once effective design variables are identified, they are incorporated into the exhibit design process. If experimental research determines that short labels are more likely to be read by visitors, then exhibits are designed with short labels. This approach has adopted the research strategies traditionally used in social science and education.

Shettel, Butcher, Cotton, Northrop, and Slough (1968) have provided a model for this approach. They began by identifying three sets of variables involved in the effectiveness of exhibitions: exhibit design variables; exhibit effectiveness variables; and exhibit viewer variables. Exhibit design variables (considered to be independent variables or variables that are manipulated in a study) include: amount of verbal material; readability level of material; legibility of material; use of audio-visual communication; total amount of time required to view exhibit materials; location and sequence of displays; and use of

constant and dynamic models. Exhibit effectiveness variables (dependent variables or outcome variables) include: ability to attract attention; holding power; change in interest; change in attitudes; and knowledge acquisition. Exhibit viewer variables (variables that are generally held constant in research studies) include: age; education; knowledge of subject; viewing time; intelligence; initial level of interest; etc. According to the approach of Shettel and his colleagues, research progresses by manipulating or systematically changing exhibit design variables and determining the impact on exhibit effectiveness variables (visitor behavior), while holding viewer variables constant.

The use of this approach in museums dates back over 60 years. Melton (1935) in one of several visitor studies in which he controlled exhibit variables, hypothesized that the density of exhibit objects influences visitor attention. To test this hypothesis, he systematically altered the number of paintings in a gallery. His results were consistent with the notion that each object competes with every other object in a gallery. As the number of objects increased, the average attention for each object tended to decrease. The design implication is that exhibit objects will receive more attention when they are isolated from other objects.

The experimental approach is not without its critics (e.g., Munley, 1990; St. John, 1990). Some critics have argued that the experimental method cannot be used to study complex relationships in museums (e.g., St. John, 1990). However, there are many studies that demonstrate experimental

methods can be useful in understanding the role of multiple factors in exhibit settings. For example, Bitgood & Patterson (1993) studied the effects of several exhibit changes on visitor behavior. Independent variables included length of label (50 versus 150 words), number of labels (one, three, and six), size of text font, location of labels, presence of illustrations, and the presence of an additional exhibit object (a bronze bust) in the gallery. Dependent variables included visitor stopping, duration of viewing time, and label reading at all exhibit elements (Egyptian mummy cases, display of x-rays of mummified individuals, labels on walls, and a recreated bronze bust of one of the mummified individuals). Each time the conditions were changed in the gallery, visitors redistributed their overall pattern of attention to exhibit elements. For example, when the length of labels was reduced, more visitors read the labels and viewing time of the mummy cases increased. Another result that demonstrated how the experimental approach can detect complex processes relates to the difference between readers' and nonreaders' attention to exhibit objects. The addition of a bronze bust in the gallery increased non-reading visitors' viewing time of x-rays of the mummified individuals; however, reader's viewing time at the x-rays remained unchanged at a high level.

The experimental strategy has several disadvantages. They include:

- it is not always easy to control variables in the real world;
- it may be difficult to convince museums to allow the

necessary exhibit design changes to determine cause and effect relationships;

· it requires knowledge and skills in research methodology;

· if not carefully designed, the experimental situation may lack experiential realism (the visitor may not interpret the experience as real).

It should be noted that studies carried out in exhibition settings are rarely able to design a "true" experiment since participants are seldom randomly selected from the population of all visitors. Under such circumstances, the research is generally called "quasi-experimental" rather than "experimental." However, if careful sampling procedures are used to select participants, the study approximates a "true" experiment.

The correlational strategy

Another research strategy is to correlate design variables with visitor measures. For example, Bitgood, Conroy, Pierce, Patterson, and Boyd (1989) examined the correlation between visitor label reading and the number of words per label. A correlation of .71 was found between these two variables suggesting that visitors are more likely to read shorter labels. Correlational methods have become more sophisticated including factor analysis and cluster analysis, techniques that allow the investigator to identify complex patterns of correlation. The correlation strategy does not allow as strong

conclusions about the effects of design variables. A correlation tells us there is a relationship between two variables, but does not tell us if the design variable is actually causing the effect.

Summary of quantitative strategies

The visitor perception strategy begins with formulating exhibit characteristics in visitors' own words. It assumes that visitor descriptors can provide predictive information regarding what makes an exhibit successful. Also, in this approach, design variables are selected by visitors' descriptions of exhibits.

The experimental strategy argues that, whenever possible, exhibit design should be based on carefully controlled research in which design variables are manipulated and their effects on visitor behavior measured. Three major characteristics of this strategy are:

1. there are no *a priori* assumptions about what design approaches are more effective (the design variables identified as important by a particular approach must be empirically tested);

2. design variables are generally identified by the researcher rather than by the visitor; and

3. the impact of design variables is empirically determined.

The correlation strategy examines how variables correlate with one another. A simple correlation between two variables (visitor reading and number of words) may be examined. Or, more complicated techniques might identify clusters or

factors of variables. See Alt and Shaw (1984) for an example of cluster analysis and Harvey et al. (1993) for an example of factor analysis.

Qualitative strategies

As noted, qualitative strategies can help to give meaning to the quantitative data. Qualitative analysis deals with words rather than numbers. Data reduction methods summarize, paraphrase, and categorize respondents statements rather than statistically analyze. It is difficult to characterize qualitative strategies because advocates of qualitative methodologies differ from each other in their basic assumptions. At one end of the spectrum are investigators who accept the basic assumptions of science. They look for ways to combine quantitative and qualitative approaches so that these two strategies complement one another.

At the other end of the spectrum are investigators who reject the basic assumptions of quantitative strategies arguing against any attempt to formulate general laws of visitor behavior. "Instead there is a focus on the use of metaphor, analogy, informal inference, vividness of description, reasons – explanations, interactiveness, meanings, multiple perspectives, tacit knowledge." (p. 240, M. Scriven,1991).

Naturalistic evaluation

Scriven (1991) described Bob Wolf's definition of naturalistic evaluation as stressing:

- orientation toward current and spontaneous activities,

behaviors, and expressions rather than to some statement of prestated formal objectives;

- responding to educators, administrators, learners, and the public's interest in different kinds of information; and
- accounting for the different values and perspectives that exist.

Wolf's approach stressed unstructured interviews, observation, and meanings rather than mere behaviors. Scriven suggests that some of the advocates of this approach "may have gone too far in the laissez-faire direction (any interpretation the audience makes is allowable) and in caricaturing what they think of as the empiricist approach." (Scriven, 1991, p. 240).

Final thoughts

This article has attempted to identify three aspects of designing successful exhibits. The first is selecting the criteria for success. A multi-measure approach to visitor data collection is suggesting including behavior, knowledge, and affective measures. If critical appraisal is used as a criteria (visitor, subject-matter, or aesthetic), the perspective should be made clear and should have some basis for validation. Thus critical appraisal from the visitor perspective should be based on empirical visitor studies. The second part of this article describes design approaches that appear to dominate the museum world. An attempt was made to point out some of the strengths and weaknesses of each approach. The last part of

this article describes research and evaluation strategies used to obtain data related to the success of exhibits. Both quantitative and qualitative strategies are commonly used in museums, and each can contribute to a better understanding of what makes exhibits successful. A better understanding of the three issues discussed in this article can lead to more thoughtful design of exhibits, more careful consideration of approaches, and more reliable and valid measures of success.

Originally published in Visitor Behavior (1994) 9(4), 4-15.

References

Alt, M., & Shaw, K. (1984). Characteristics of ideal museum exhibits. *British Journal of Psychology, 75,* 25-36.

Bitgood, S. (1990). *The role of simulated immersion in exhibition.* Technical Report No. 90-20. Jacksonville, AL: Center for Social Design.

Bitgood, S. (1991a). Evaluation of the "Falling Feather" exhibit. *Visitor Behavior, 6*(4), 12-13.

Bitgood, S. (1991b). Suggested guidelines for designing interactive exhibits. *Visitor Behavior, 6*(4), 4-11.

Bitgood, S., Conroy, P., Pierce, M. Patterson, D., & Boyd, J. (1989). Evaluation of "Attack & Defense" at the Anniston Museum of Natural History. In *Current Trends in Audience Research.* New Orleans, LA. Pp. 1-4.

Bitgood, S., Kitazawa, C., & Patterson, D. (1995). A closer look at families in museums: Child's age correlated with group behavior. *Curator.* In revision.

Bitgood, S., & Patterson, D. (1993). The effects of gallery changes on visitor reading and object viewing time. *Environment and Behavior, 25*(6), 761-781.

Borun, M. (1977). *Measuring the immeasurable: A pilot study of museum effectiveness.* Washington, DC: Association of Science-Technology Centers.

Bonin, M., & Adams, K. (1991). From hands-on to minds-on: Labelling interactive exhibits. In A. Benefield, S.Bitgood, & H. Shettel. (eds), *Visitor studies: Theory, research, and practice, volume 4.* Jacksonville, AL: Center for Social Design. Pp.115-120.

Coe, J. (1985). Design and perception: Making the zoo experience real. *Zoo Biology*, 4, 197-208.

Cone, C., & Kendall, K. (1978). space, time and family interaction: Visitor behavior at the Science Museum of Minnesota. *Curator*, 21, 245-258.

Davidson, B, Heald, L, & Hein, G. (1991). Increased exhibit accessibility through multisensory interaction. *Curator*, 34(4), 273-290.

Diamond, J. (1986). The behavior of family groups in science museums. *Curator*, 29(2), 139-154.

Diamond, J., Smith, A., & Bond, A. (1988). California Academy of Sciences discovery room. *Curator*, 31(3), 157-166.

Dyer, J. (1992). New life for an old hall. *Curator*, 35(4), 268- 284.

Falk, J., & Dierking, L. (1992). *The museum experience*. Whalesback Books.

Finlay, T., James, L., & Maple, T. (1988). People's perceptions of animals: The influence of zoo environments. *Environment & Behavior*, 20(4), 508-528.

Greenglass, D. (1986). Learning from objects in a museum. *Curator*, 29(1), 53-66.

Guisti, E. (1994). The comparative impact on visitors of hi-tech and traditional exhibits in a natural history museum. In *Current trends in audience research, Volume 8*. Seattle, WA: AAM Committee on Audience Research & Evaluation. Pp. 21-25.

Harvey, M., Birjulin, A., & Loomis, R. (1993). A virtual reality and human factors analysis of a renovated diorama hall. In D. Thompson, et al. (eds.) *Visitor studies: Theory, research,*

and practice, volume 6. Jacksonville, AL: Visitor Studies Association. Pp. 129-139.

Kennedy, J. (1990). *User friendly: Hands-on exhibits that work.* Washington, DC: Association of Science-Technology Centers.

Kinch, W. (1994). Text comprehension, memory, and learning. *American Psychologist,* 49(4), 294-303.

Kool, R. (1988). Behavioral or cognitive effectiveness: Which will it be? In *Musee et Education: Modeles didactiques d'utilisation des musees.* Universite du Quebec at Montreal/ Societe des musee quebecois.

Koran, J., Koran, M.L., & Longino, S. (1986). The relationships of age, sex, attention, and holding power with two types of science exhibits. *Curator,* 29(3), 227-244.

Marino, M. (1994). *Personal communication.* Denver, CO: Denver Museum of Natural History.

Marino, M., & Harvey, M. (1994). *Boettcher summative evaluation: Observations of visitor behavior before and after renovation.* Denver, CO: Denver Museum of Natural History, Unpublished.

McManus, P. (1994). Families in museums. In R. Miles & L. Zavala (eds), *Towards the museum of the future: New European perspectives.* London: Routledge. Pp. 81-97.

Melton, A. (1935). *Problems of installation in museums of art.* American Association of Museums Monograph, New Series No. 14. Washington, DC: American Association of Museums.

Melton, A. (1972). Visitor behavior in museums: Some early

research in environmental design. *Human Factors*, 14 (5), 393-403.

Munley, M. E. (1990). *Educators and evaluators.* Presented at the 1990 AAM Annual Meeting, Chicago, IL.

Norman, D. (1988). *The psychology of everyday things.* New York: Basic Books.

Peart, B. (1984). Impact of exhibit type on knowledge gain, attitudes, and behavior. *Curator*, 2, 220-237.

Peart, B., & Kool, R. (1988). Analysis of a natural history exhibit: Are dioramas the answer? *The International Journal of Museum Management and Curatorship*, 7, 117-128.

Peers, B. (1991). *Improving the motivational power of museum dioramas.* Unpublished manuscript. Ottawa, Ontario: Canadian Museum of Nature.

Rosenfeld, S., & Terkel, A. (1982). A naturalistic study of visitors at an interpretive mini-zoo. *Curator*, 25(3),187-212.

Scriven, M. (1991). *Evaluation thesaurus*, fourth edition. Newbury Park, CA: Sage Publications.

Serrell, B. (1993). The question of visitor styles. In D. Thompson, et al. (eds), *Visitor studies: Theory, research, and practice, volume 6.* Jacksonville, AL: Visitor Studies Association. Pp. 48-53.

Shettel, H., Butcher, M., Cotton, T., Northrop, J. & Slough, D. (1968). *Strategies for determining exhibit effectiveness.* Report No. AIR E95-4/68-FR. Washington, DC: American Institutes for Research.

St. John, M. (1990). New metaphors for carrying out evaluations in the science museum setting. *Visitor Behavior*, 5(3), 4-8.

Taylor, S. (1986). *Understanding processes of informal education: A naturalistic study of visitors to a public aquarium.* Ph. D. dissertation. Berkeley, CA: University of California, Berkeley.

Thompson, D. (1993). *Considering the museum visitor: An interactional approach to environmental design.* Ph. D. Dissertation. University of Wisconsin-Milwaukee.

Vance, C., & Schroeder, D. (1991). Matching visitor learning style with exhibit type: Implications for learning in informal settings. In A. Benefield, et al. (eds.), *Visitor studies: Theory, research, & practice, vol. 4.*

Wolf, R. (1980). A naturalistic view of evaluation. *Museum News,* 58(1), 39-45.

Wonders, K. (1993). *Habitat dioramas.* Uppsala, Sweden: Uppsala University Press.

Yellis, K. (1990). *Real time: the theory and practice of living history at Plimoth Plantation.* Unpublished.

8

Practical Guidelines for
Developing Interpretive Labels

The first section of this special issue briefly reviews label guidelines from several sources. It should be helpful for those who wish to develop labels to consider some of the issues and guidelines found in the literature. Only brief outlines of publications are included here. The reader is encouraged to obtain the original sources for a more detailed discussion of label development. Information on where to obtain the references is provided for the reader.

Rand, J. (1985). *Fish stories that hook readers: Interpretive graphics at the Monterey Bay Aquarium.*
AAZPA 1985 Conference. Columbus, OH: American Association of Zoological Parks & Aquariums. [Also *Tech. Report # 90-30.* **Center for Social Design, Jacksonville, AL]**
This paper has some excellent examples of label content that illustrate Rand's guiding principles.

Considerations related to the objectives of the labels
1. Attract the readers' interest and draw them into the subject.
2. Correct misconceptions the visitor may have.
3. Reach the more advanced reader with more complex concepts rather than more complex language.
4. Do more than tell the facts; ask questions.
5. Present problems.
6. Express a sense of the unknown. (For example, in marine science, acknowledge unanswered questions about the oceans.)
7. Draw analogies.

8. Use a reader-relevant approach to explain things.

9. Write in easily understandable language aimed at the 7th-8th grade reading level.

10. Communicate in a conversational tone that is approachable, familiar, often humorous, but not flippant or formal.

11. Maintain a style characterized by active voice and vivid language.

12. Address the reader directly.

13. Anticipate and answer questions.

14. Be concise, friendly, highly interesting, inviting the audience to read and keep reading.

Techniques on how to transmit your message

1. Find your voice, then keep a steady tone.

2. Make every word count.

3. Watch your language!

4. Enjoy English as much as science.

5. Show your style.

6. Talk straight.

7. Surprise!

Rand, J. (1993). Building on your ideas.
In S. Bicknell & Farmelo, G. (eds.), *Museum visitor studies in*
***the 90s*. London, UK: Science Museum. Pp. 145-149.**

Use the PASS mnemonic

- **P**urpose: Why do we want to say this?
- **A**udience: Who do we want to say it to?

- Subject: What do we want to say?
- Strategy: How are we going to say it?

The literature tells us that:

1. Structured information facilitates learning.
2. Intellectual structure should be made clear.
3. Structure should be clearly and consistently contained in the physical structure and sequence of the exhibition.

Miles et al (1993): "The structure is not conceived as something to be imposed upon the visitor. Its purpose is solely to unify the presentation of the intellectual material and make it easier for the visitor to find his way around the exhibition, following his own inclinations."

Stages of interpretive strategy (Monterey Bay Aquarium)

1. Messages: choosing the main message; amassing the other messages.
2. Interpretive framework: ranking the other messages in importance; relating and organizing the messages in a concept outline; adding factual background
3. Storyline and development: shaping the framework into a storyline; using the framework to guide exhibition development and media choice.

Suggestions for writing the interpretive framework
Choosing the main message: What is the most important idea that you want people to leave with? Write it down in a single

sentence. Is it simple, direct, and clear? Will it interest visitors?

Ranking and relating the ideas: What do you want to say to support the main message? Write each idea on an index card. How does each idea relate to the main message? Rank the cards into most important, somewhat important, and less important:

- A primary message is one that we feel we must communicate to a sizable number of visitors (but fewer than main message). Subject of major labels.
- A secondary message is one we feel we should communicate to visitors (but less than for primary messages); label copy that supports primary messages.
- A tertiary message is one that we feel it might be nice to communicate to visitors (serve as a footnote function when there is room to include them).

Storyline development: Ways of organizing information:

- Location
- Alphabet
- Time
- Category
- Hierarchy (or continuum)

Handy all-purpose development tool

- Narration: What happened?
- Description/definition: What does it look like? What is it?
- Process analysis: How do you do it?

- Comparison/contraries: How are they similar? Different?
- Classification: How is it subdivided?
- Causal analysis: Why did it happen? What will this do?

**Screven, C. G. (1992). *Motivating visitors to read labels.*
ILVS Review, 2(2), 183-211.**

Components of labels

1. Content: text and message elements.
2. Structure: legibility, organization, size, typeface, density of information, colors.
3. Presentation format: interactivity, sound, graphics, video, computers.
4. Context: noise, lighting, sight-lines, competing stimuli.

Functions of labels

1. Information on visual content of exhibits
2. Instruct visitors
3. Personalize topics
4. Interpret exhibit content
5. Conceptual orientation (what to expect, how things are organized)

Goals for using labels

1. Attraction to labels or exhibit content
2. Focus attention
3. Correct misconceptions
4. Connect explanations to familiar experience/knowledge

5. Encourage active attention
6. Make ideas more familiar
7. Encourage visitors to draw analogies
8. Ask questions visitors commonly have about subject
9. Facilitate projection into an exhibit situation
10. Challenge visitors to problem solve

Motivating label use
1. Reward mindful reading and attention
2. Structure text
3. Format and placement of text
4. Presentation formats
 a. Information maps
 b. Leading questions
 c. Flipper labels
 d. Computer labels
5. Levels of interactive labels
 a. Conventional label
 b. Covert interaction
 c. Secondary interaction
 d. Direct interaction
 e. Adaptive interaction

Screven's excellent article is a thorough examination of motivating visitors to read.

Serrell, B. (1996). *Exhibit Labels: An Interpretive Approach.* Walnut Creek, CA: Altamira Press.

Beverly Serrell has been one of the leaders in publishing important and worthwhile material to exhibition centers of all types. This book is only one of many excellent sources of information.

Ten deadly sins of label design

1. Not related to a big idea, ramble without focus or objectives.
2. Too much emphasis on presenting information rather than offering provocation.
3. Fail to address audience's prior knowledge, misconceptions, or interests.
4. No apparent organizational system.
5. Difficult vocabulary.
6. Too long and wordy.
7. Ask questions of which visitors are not interested.
8. Interactive labels that lack integrated, logical instructions or interpretations.
9. Do not begin with concrete, visual references.
10. Hard to read because of physical characteristics (typeface, colors, lighting, placement).

Helpful research and evaluation findings

1. Visitors likely to spend more time and learn more when they have good conceptual and spatial orientation.
2. Visitors are more likely to use a higher proportion of exhibition and understand what it is about when they

spend more time.

3. Higher percentage of visitors read shorter labels.

4. A broad cross section of visitors will be attracted to the most popular part of a good exhibition.

5. The same adult audience read labels and use interactive devices.

6. Location is important: labels placed out of the visitors' line of sight receive less attention; labels get more attention if they are next to the objects they describe.

7. Labels accompanying concrete objects are more likely to be read than labels from text-only displays.

8. Increased reading is likely to occur if information is chunked into short paragraphs.

9. Visitors are more likely to read-look-read-look and to point and talk if the labels contain concrete, visually referenced information.

10. Visitors are more likely to read aloud labels that visitors find interesting; social interaction is enhanced by reading aloud.

11. Readers spend more time and do more things in exhibits than non-readers.

12. Adults are more likely to read text to children if labels are easy to read out loud without having to paraphrase or translate the language to children.

13. Labels are more likely to be read by children if they provide easily accessible and useful information.

14. Visitors find labels more meaningful and memorable if images and words work together.

Doing It Right: A Workbook for Improving Exhibit Labels.
Published by The Brooklyn Children's Museum (1989).
This publication was the result of a two-year label assessment project; it was concerned with how well labels communicate with the intended audience and about what tools help develop improved labels. The project involved the following steps:

1. Set objectives, keep in mind resources at hand and the character of the institution.
2. Allocate resources (time, staff, and money).
3. Investigate alternative approaches used by others.
4. Conduct audience surveys and develop an audience profile.
5. Assess current situation and evaluate its effectiveness.
6. Develop guidelines for writing, designing, and evaluating labels in the future.
7. Write new labels, conducting formative evaluation on the draft copy before the final labels are produced.

Organising the project
Set objectives: This section gives advice on setting goals that are attainable and show immediate tangible results from the team approach. It suggests setting up a time table so that each task will have a completion date or target. Objectives might be to:

· Evaluate all existing labels and change labels that have proven to be ineffective
· Develop an audience profile
· Establish guidelines for writing and design for future labels

· Identify and formalize the label-writing process for your institution

Appoint a committee: The Brooklyn Children's Museum chose one member from each of the program departments such as collections, exhibitions, and education. The director supervised the project. The book advises that individuals be selected: who trust each other's opinions, who are interested in the project, and who have few preconceived notions about labels. The use of a task chart is recommended to help divide the work and clarify each team member's role.

Assessing the current situation

Learn from other institutions: Visiting institutions in your area and investigating label techniques used elsewhere will help to spark ideas. Examine a variety of institutions similar to your own as well as ones that are different. Include art museums, zoos, historic houses, and even retail businesses such as supermarkets.

Understand your museum's mission: Figure out your museum's goals and decide what kind of experience you want to provide before you evaluate whether you have achieved your goal.

Profile your audience: Formulate a visitor profile by finding out the composition of visitor groups such as age range, geographic distribution, socio-economic status, and educational background. Then determine areas of interest and visitor return. Conducting surveys is a good way to assess visitors' perception of a museum. Since this is a major

undertaking, museums often depend on outside consultations to help design a study.

Assess your labels: Ask questions such as: Are labels well lit? Do they reflect too much glare ? What about size, color, and placement? Do they call too much attention to themselves ? The workbook suggests that labels be classified by type and function. This will help identify each labels function. You will want to set criteria such as minimizing type size for each category.

Review your label development process: A good label arises out of a need to communicate a particular point. A formative evaluation is best. Prototypes should be developed and tested to ensure the most effective communication. Label copy must undergo review by a group that may include a content specialist, an editor, and an educator. After the reviewers and the writers reach a consensus on the content of labels, they need to be tested out on visitors.

Conducting evaluation

Front-end research and formative evaluation: A description of evaluation intended for the novice is provided in this section. Front-end research and formative evaluation refer to research and evaluation done before an exhibition is installed. Summative evaluation refers to evaluation conducted when the exhibition and the finished labels are in place.

Summative evaluation: Summative evaluation of labels can be measured using three measures: attracting power; holding power; effective transfer of information.

Setting guidelines for the future

The cast of characters: How do you decide which components of an exhibition should be evaluated, when, and how? At the Brooklyn Children's Museum, the exhibition developers make those decisions, since they are most familiar with the exhibition communication goals. Other choices could be the writer of the labels, a member of the exhibition development team, staff members, or someone who has had no prior dealings with the exhibition.

Some hints on writing: The book points out different ways to present information since you cannot write one kind of label and expect it to fulfil each visitor's need. Some institutions layer their labels, so that the most basic information is in large type, and more detailed information is spelled out beneath it. You may also put the most important information in the first sentence or two and follow it with more details. An average label should contain no more than 130 to 150 syllables per 100 words and no more than 15 words per sentence.

Some hints on design: The book presents handy guidelines for legibility when designing labels:
- Provide strong contrast between type and background.
- Mix upper and lower case letters.
- Lines should contain fewer than 60 characters.
- Labels more than 50 words should be broken into 2 or 3 smaller chunks.
- Placement and lighting can greatly affect attracting power of a label.

Other publications on label development

Bitgood, S. (1990). The ABCs of label design. In S. Bitgood, A. Benefield, & D. Patterson, *Visitor studies: Theory, research, and practice, vol. 3.* Jacksonville, Al: Center for Social Design. Pp. 115-129.

McLean K: (1993). *Planning for People in Museum Exhibitions.* Washington, DC: Association of Science Technology Centers.

McDermott-Lewis, M. (1990). *The Denver Art Museum's Interpretive Project.* Denver: Denver Art Museum.

Minneapolis Institute of Arts, The Interdivisional Committee on Interpretation (1993). *Interpretation at the Minneapolis Institute of Arts: Policy and Practice.* Minneapolis:. Minneapolis Institute of Arts.

Schloder, J., Williams, M_ & Mann, C.,G. (1993). *The visitor's voice: Visitor studies in the Renaissance Baroque galleries of the Cleveland Museum of Art 1990-1993.* Cleveland: The Cleveland, Museum of Art..

Visitor Behavior. (1989). Volume 4, Issue #3. Special Issue on Label Design

Update: Since 1996, there have been many additional publications that might be useful to interpretive label developers. Here are only a few of the more recent publications that may be of interest to readers:

Bitgood, S. (2000). The role of attention in the design of effective interpretive labels. *Journal of Interpretation Research,* 52(2), 31-45.

Bitgood, S., Dukes, S., & Abby, L. (2007). Interest and effort as

predictors of reading: A test of the general value principle. Current trends in audience research and evaluation. Vol. 19/20. *AAM Committee on Audience Research and Evaluation.* Boston, MA. Pp. 5-10.

Bitgood, S. (2010). *An attention-value model of museum visitors.* The Center for the Advancement of Informal Science Education.

Originally published in Visitor Behavior (1996) 11(4) 4-7.

9

Visitor Evaluation:
What Is It?

There are many concepts and issues related to evaluation discussed in the visitor studies literature. This article is a brief summary of some of these issues as I see them. Readers are encouraged to seek more detailed papers for a better understanding of the issues and terminology.

Research vs. evaluation

Many writers (Friedmann, Zimring, & Zube, 1978; Patton, 1987; Screven, 1988) have made a distinction between *research* and *evaluation*. Others (e.g., Loomis, 1988) see evaluation as a specific form of research. Below is a summary of some of the distinctions made by those who argue research and evaluation are distinct. These distinctions are not universally accepted. I am among those who see little difference between research and evaluation:

- Research attempts to control extraneous factors, while evaluation attempts to describe these factors.
- Research is concerned with discovering the causes for behavior, evaluation is concerned with factors that influence behavior.
- Research aims to reduce the number of factors; evaluation examines complex systems.
- Research uses rigorous methodology; evaluation is less formal.
- Research uses quantitative, statistical analysis; evaluation is more likely to be qualitative.
- Research requires highly trained professionals; evaluation can be conducted by those who have less training and knowledge.

- Research is expensive and time consuming; evaluation can be carried out quickly and inexpensively.

While these distinctions can be made in extreme cases, there are many studies (e.g., Loomis, Fusco, Edwards, & McDermott, 1988) that seem to serve both purposes.

Formative vs. summative evaluation

Formative evaluation attempts to assess an exhibit or program midway and use these results to improve the exhibit/program. Thus, in museum/zoo exhibits, formative evaluation involves obtaining input (direct observation, self-reports) from visitors and using the input to improve the impact of the exhibit on the visitors. Formative evaluation is usually carried out during the planning and development of new exhibits, although it can be used to make improvements on already existing exhibits also. Screven (1975; 1986; 1988) has been among the leaders in advocating the use of formative evaluation in visitor studies. Inexpensive mock-ups are usually used during formative evaluation. Summative evaluation has different purposes: identification of what works and doesn't work for future exhibits; evaluation of cost-effectiveness; and decision making on whether or not an exhibit should be replaced or changed in the future. Summative evaluation is generally focused on installed exhibits. It evaluates the extent to which an exhibit/ program is meeting its objectives, without attempting to build-in improvements.

Goal-free vs. goal-referenced evaluation

This distinction refers to whether or not evaluation is designed to answer specific objectives. Goal-referenced evaluation (e.g., Screven, 1975) is based on measurable outcomes that are specified before evaluation begins. Goal-free evaluation (e.g., Wolf, 1980) attempts to be open to unexpected behavioral or attitudinal effects. Screven argues that there is a place for both types of evaluation. Goal-free evaluation is useful during initial stages of a project to obtain information upon which to formulate goals and objectives. While there may ' be specific learning objectives for an exhibit, visitors may react in unexpected ways and these reactions are an important element of evaluation.

Developmental vs. post-design evaluation

Developmental evaluation is carried out while the exhibit is being developed. This phase is an ideal time for formative evaluation (evaluation that uses visitor reactions to improve its impact). Post-design evaluation, on the other hand, would be carried out after the exhibit has been installed. In the field of architecture, post-design evaluation is usually called "post-occupancy evaluation" (POE).

Qualitative vs. quantitative evaluation

This distinction usually emphasizes the difference between a statistical versus non-statistical approach to data analysis. The quantitative approach would summarize the results in terms of average scores, distribution of scores, etc. A

qualitative approach would describe what people might say or do but would not provide numerical analysis of the results. In the extreme, both approaches are problematic. Descriptive statistics fail to capture the variety and richness of human responses. On the other hand, a complete lack of quantitative description makes it difficult to see the orderly patterns of behavior that are evident when behavior is measured by numbers.

Front-end evaluation

This term refers to the evaluation of plans, ideas, and concepts for a proposed exhibit or program. It is used to establish goals and objectives of a project.

Originally published in Visitor Behavior (1988) 3(3), 6.

References

Friedmann, A., Zimring, C., & Zube, E. (1978). *Environmental Design Evaluation*. New York: Plenum Press.

Loomis, R. J. (1988). The Countenance of Visitor Studies in the 1980's. In S. Bitgood, J. T. Roper, & A. Benefield (Eds.) *Visitor Studies - 1988: Theory, Research and Practice*. Jacksonville, AL: Center for Social Design. pp. 12-24.

Loomis, R. J., Fusco, M., Edwards, R. & McDermott, M. (1988). The Visitor Survey: Front-End Evaluation or Basic Research? In S. Bitgood, J. T. Roper, & A. Benefield (Eds.), *Visitor Studies - 1988: Theory, Research and Practice*. Jacksonville, AL: Center for Social Design. pp. 144-148.

Patton, M. Q. (1987). *Creative Evaluation*. 2nd Ed. Newbury Park, CA. Sage Publications.

Screven, C. G. (1975). Exhibit Evaluation: A Goal- Referenced Approach. *Curator, 19*(4), 271-190.

Screven, C. G. (1986). Exhibitions and Information Centers: Some Principles and Approaches. *Curator, 29*(2), 109-137.

Screven, C. G. (1988). Formative Evaluation: Conceptions and Misconceptions. In S. Bitgood, J. T. Roper, & A. Benefield (Eds.), *Visitor Studies - 1988: Theory, Research, and Practice* . Jacksonville, AL: Center for Social Design. pp. 73-82.

Wolf, R. L. (1980). A Naturalistic View of Evaluation. *Museum News, 58*(1), 39-45.

10

Assessing the Readability of Label Text

One of the problems to be overcome in label development is assessing the readability of labels. One possible solution is to apply readability formulas to the text. However, the outcome of readability formulas can be very misleading. Label text is a very different type of communication than that found in textbooks. Another solution is to obtain visitor input. These alternatives are discussed below.

Readability formulas: are they the answer?
Carter, J. (1993). How old is this text? *Environmental Interpretation*. Pp. 10-11. Also in Durbin (1996).

The above article describes how to use two readability tests – the Fry test and the Cloze procedure. Below are directions for computing readability.

Fry test
1. Select at random three passages of 100 words.
2. Count the total number of sentences in each passage and take the average of these numbers.
3. Count the total number of syllables in each passage and take the average.
4. Plot these two averages on a graph that relates sentence length to number of syllables.

The Fry test only measures complexity of language. It can't tell you whether an audience actually understands the message.

Cloze procedure

1. Select a passage from text and prepare a version in which every fifth word is replaced by an equal size blank. Passage should start at the beginning of a paragraph. Leave the first and last sentences intact and don't remove proper nouns unless they have already occurred.
2. Show this text to a sample of your audience, ask them to guess the missing words.
3. Calculate the score as a percentage.
4. Scores below 40 show real difficulty with text.

Scores above 60% are good. (Note: We have applied several readability formulas to the same text and found radically different reading level scores!)

What's wrong with using readability formulas?

1. Results vary from one formula to another. What do you do when the formulas conflict? Obviously, the formulas do not measure the same thing. So, what is readability?
2. The formulas assume you have a large amount of text; however, good labels are short.
3. Adhering to a formula may result in omitting important technical terms. Of course, unfamiliar terms should be defined.
4. The text may end up readable, but boring.

Visitor evaluation: the alternative

Obtaining visitor input is a more valid way to determine

readability. Here are several ways to assess the readability of labels using visitor input.

Front-end evaluation: As most readers of *Visitor Behavior* know, front-end evaluation surveys potential visitors during the planning stage of an exhibition project. Evaluation during this stage attempts to assess the audience's pre-knowledge, misconceptions, interests, preferences, and attitudes.

Formative evaluation: In *cued testing*, visitors are asked to read the label text to determine whether the message is accurately communicated and assess emotional characteristics of the message. One way to test labels is to randomly select visitors in the museum, ask them to read the text, and then ask questions to determine the effectiveness of the text. Another technique is to ask a group of individuals (e.g., a class of students) to read the text and complete a survey. For *uncued testing*, visitors are unobtrusively observed reading the label. Uncued testing allows you to determine the attracting and holding power of the exhibit label.

Remedial evaluation: Even after an exhibition is installed, visitor input can provide valuable information for fine-tuning the labels.

While collecting evaluation data with people may take a little longer, it allows the designers to readability more accurately and can be used to obtain other important types of information (for example, what level of interest is there for the text material?)

Originally published in Visitor Behavior (1996) 11(4) 14.

References on types of visitor evaluation

Bitgood, S. (1994). Classification of exhibit evaluation: How deep should Occam's razor cut? *Visitor Behavior,* 9(3), 8-10

Bitgood, S. & Loomis. R. (1993). Introduction to environmental design and evaluation in museums. *Environment and Behavior,* 25(6); 683-697.

Bitgood, S. & Shettel, H. (1994). The classification of evaluation: A rationale for remedial evaluation. *Visitor Behavior* 9(1) 4-8:

Miles, R. (1994). Let's hear it for Mr. Occam: A reply to Bitgood & Shettel on remedial evaluation. *Visitor Behavior,* 9(3), 4-7.

11

Sampling for a Visitor Survey: Finding Your Way Through the Maze

Sampling for a visitor survey is like finding your way through a complex maze. There are many turning points and the wrong choice can lead you into a dead-end path. At each turn in the maze, you are confronted with an important decision on how to proceed. Extreme care and thought is needed in formulating questions and in sampling the audience if you hope to obtain useful results from a survey. The purpose of this paper is to offer you a brief introduction to the process and methodology of survey sampling. However, I recommend that before attempting to conduct a survey by yourself, you refer to the suggested readings at the end of the paper.

Four major sampling issues will be discussed in this presentation: defining the population from which to sample; selecting a sample size; choosing a procedure for sampling; and obtaining a high response rate.

Defining the population

The first step in the maze of survey sampling is to define the group or population you wish to study. To successfully navigate the maze of survey sampling, you must know who the population is before you can select a sample. Otherwise, the results you obtain will be inaccurate and the inferences you make from these results invalid. Defining the population is not as easy as it might first appear. Many difficult questions arise. You must be clear about the purpose(s) of the survey. Are you interested in drawing inferences about all visitors throughout all seasons or only summer visitors? Seasonal visitors may have different motivations and demographics profiles (e.g.,

Hood, 1988). Are you interested in collecting information on all of the people in the geographic community or only those who are likely to visit? If your purpose is to look for new audiences, then it would be a mistake to only survey current visitors. Are you interested in what both adults and children think about marine mammals or do you wish to restrict your population to adults only? Whatever your purposes, they should be carefully thought out.

Once you have defined the target population, your next step is to select a sample that is representative of this population. One must be ever cautious not to attempt to extend results and interpretations beyond this target population. People who visit art museums are very likely to be different than people who visit zoos and aquariums. It would be an error to assume that art museum visitors and aquarium visitors have similar attitudes about marine mammals or modern art.

Selection of sample size

Selecting individuals for your sample confronts you with another complex part of the maze of sampling. It is usually not practical to sample all members of a population. Time and economics require selecting a limited number of people to survey. How many people should be sampled? Unfortunately, there is no easy answer to this question. Loomis (1988) argues that small sample surveys can be useful if they are carefully conceived and designed. Loomis offers several suggestions if the sample must be small. Three of these suggestions include: use a limited focus in your survey, avoid attempting to collect

detailed visitor descriptions, and keep the survey questions simple.

In general, sample size should depend on several things: the precision of result needed; the amount of detail desired; the resources available to collect information; time availability; and finally, the need for credibility. Obviously, precision is less important if the results will not be widely distributed or if erroneous decisions based on the results will have a minor impact. If, however, your survey is part of an evaluation funded by a granting agency, greater precision may be desired.

The amount of detailed information desired should also influence sample size. If you are not interested in segmenting the population into subgroups, a smaller sample may be adequate. If, however, you wish to determine if museums or zoo society members are more likely than other groups (e.g., concert subscribers, sports enthusiasts) to visit the museum/zoo, you will need a larger sample in order to have enough respondents in each of the subgroups you wish to study.

Resources available to collect information will obviously influence sample size. A large-scale survey is a costly project. There is rarely enough money and personnel to carry out a survey project the way that evaluators would really like to. Time, of course, is also a common problem. Time constraints are a fact of life we all deal with.

Finally, the need for credibility is important. If you need to persuade a sophisticated governing board, a larger sample size is likely to be more convincing than is a smaller one. Data prepared for publication is also more convincing if larger

sample sizes are used. Unnecessarily large sample sizes, however, can be a waste of resources.

How do you determine sample size? You may use either statistical or non-statistical methods. Statistical methods are often used when: high precision is needed; adequate resources are available; and detailed information about the population is desired (see Fink & Kosecoff, 1985, for a straight forward statistical method of determining sample size).

Non-statistical methods for selection sample size rely on personal judgment or rules of thumb. An example of a rule of thumb is provided by the publication, *Surveying Your Arts Audience* (1985), published by the National Endowment for the Arts. This publication provides a table suggesting sample size for specific levels of precision desired by the survey results.

Choosing a procedure for sampling

How should you select the sample of people to be included in the survey? The sampling maze becomes very tricky here. There are dead ends everywhere! The most important point is to select a method that will minimize selection bias as much as possible. Remember that the purpose of sampling is to obtain a group that is as similar as possible to the overall population you wish to study. I recently caught one of my female students selectively approaching only good looking young men to survey. Needless to say, her selection motives were at odds with unbiased sample methods. Not only did we have to throw out all of the data she collected, but she was not successful in getting a date! Justice prevailed!

There are several ways of selecting a sample for study.

Simple random sampling: Written reports often claim that their sample was random. Unfortunately, many if not most of these claims are inaccurate. Although it is not widely used in visitor surveys, simple random sampling is a natural place to start a discussion on sampling procedures. This is the simplest method and it provides the foundation for many of the other methods. In simple random sampling one attempts to select a sample of individuals who do not differ significantly from the population itself. Every person in the population should have the same chance of being selected in the sample. A lottery method is a good example of simple random sampling. Each name is placed on one of many identical discs. The discs are then placed in a large container, thoroughly missed, and then a sample is selected. Of course, the validity of the selection process depends on the assumption that the discs have been thoroughly mixed so that each has an equal chance of being selected.

A more common way to select a simple random sample is by means of a random number table (or a computer program with a random number generator). Each individual from the population such as a membership society is assigned a number (for example from 1 to 800). The survey sample is then selected by applying the random number table or computer program. Each time one of the assigned numbers is encountered in the table, the individual corresponding to that number is placed in the sample. After the required number has been selected (e.g., 200), the selection process ends.

Unfortunately, this method is not always possible. You

do not usually have access to the names of visitors before they enter your zoo or aquarium. Since there is no suitable sampling frame (list of people from which a sample is selected) when you survey visitors on-site, most of the sampling methods developed by political pollsters and government survey workers cannot be used. The next method, systematic sampling, can be useful in such cases.

Systematic sampling: This method reduces the amount of effort necessary to select a sample. And, it is easy to apply. You can simply take every 5th or 10th person after a random start. This pathway through the sampling maze also leads to possible dead ends. For example, if you collect your sample only on Tuesday morning or only on Saturday afternoon, your sample may be biased by the type of people who visit at those particular times. Complete family groups are more likely to visit on Saturday afternoon. On the other hand, mothers with young children are more likely to visit on Tuesday morning.

Stratified sampling: Stratified sampling can be used when you wish to divide the population into subgroups or strata based on some characteristics such as seasonal visitation or frequency of visiting. You can then select separate samples from each of the subgroups. For example, you could select samples of visitors from different seasons of the year (e.g., Hood, 1988) and compare these groups in terms of demographic and psychographic characteristics.

Cluster sampling: This method selects groups to sample rather than individuals. For example, if you wish to study students who are part of school visits, you could survey 7th

grade classes from several schools, rather than individual students. This method is administratively simple; it is not necessary to identify individuals in the selection process. Its major drawback is that the results may be influenced by the characteristics of the group. Group members often acquire similar characteristics such as being exposed to the same information from teachers.

Accidental sampling: An accidental sample is one that you get because people are available. If on Friday afternoon you survey 50 people as they leave the education department of the zoo/aquarium, your sample would be accidental. Although this method is convenient, it may be unrepresentative of all the visitors you wish to study. The specific day and time may attract different types of people. Another possible problem is that many visitors may visit other parts of the zoo/aquarium, but not visit the education department where the surveys are actually being conducted.

Purposive sampling: With purposive sampling you select a sample based on your judgment (hopefully informed). You may select visitors to survey from the gift shop area because in the past you found visitors selected from this area are similar to visitors from all other areas of the facility. Generally, you should be suspicious of this method unless you have good reason to support your selection procedures.

A suggested selection procedure
Given the above choices for sampling, what is a practical method of selecting visitors for surveying within your

institution? Here is a procedure described by Miles, Alt, Gosling, Lewis, & Tout (1988) that should give you a good sample:

> ...the day is divided into four two-hour interviewing blocks. Interviewers are instructed to station themselves at their allocated interviewing point and draw an imaginary line on the floor next to them. Two minutes after the beginning of a two-hour interviewing period, they attempt to interview the first person to cross the line, they attempt their second interview 20 minutes after this time, and so on... If a person they approach refuses to be interviewed or is ineligible for interview (i.e., not in the survey population), they wait 30 seconds only before approaching the next person to cross the imaginary line. If more than one person crosses the imaginary line simultaneously, they use a random method of selecting the person to be interviewed. (p. 156)

Obtaining a high response rate

A high response rate is extremely important if you hope to collect information that can be extended to all people in the population of interest. Some survey techniques under normal conditions, however, produce very low rates of survey completions and returns. For example, mail out surveys or surveys left on a table or desk for respondents to pick up may result in fairly low rates or return. On the other hand, handing questionnaires to visitor as they leave an exhibit and collecting the completed forms when they finish, generally produces a high response rate.

If one does not obtain a high response rate, careful analysis of the reasons should be made. Low response rate may include a sample of only those who are sufficiently motivated to respond (i.e., those who were the most or least satisfied). Oversampling (selecting more people than you really intend to use) is one way to overcome the response rate problem. However, it is important to understand the reasons for not responding. Respondents may not wish to respond because the survey is too long or because their children are tired and irritable. Note that oversampling does not solve the problem of having only highly motivated respondents in your sample.

Summary

Survey sampling should start with a clear definition of the population you wish to study. Next you must determine your sample size based on the degree of precision needed, the nature of the questions you wish to ask, and the resources available. Third, you need to choose a method of selecting individuals for your sample while attempting to minimize bias. Finally, you need to ensure that you obtain a high response rate so that you have enough respondents in your survey and so that you minimize selective responding that might bias your findings.

Originally published in AAZPA 1990 Annual Proceedings, American Association of Zoological Parks & Aquariums, Indianapolis, IN. Pp. 88-93.

References and suggested readings

Fisk, A., & Kosecoff, J. (1985). *How to conduct surveys: A step-by-step guide.* Newbury Park, CA: Sage Publications.

Fowler, F. (1984). *Survey research methods.* Newbury Park: CA: Sage Publications.

Hood, M. (1986). Getting started in audience research. *Museum News,* 64(3), 24-31.

Loomis, R. (1987). *Museum visitor evaluation: New tool for museum management.* Nashville, TN: American Association for State & Local History.

Loomis, R. (1988). Using small surveys to collect visitor information. *ILVS Review,* 1(1), 109-111.

Miles, R., Alt, M., Gosling, D., Lewis, B., & Trout, A. (1988). *The design of educational exhibits* (2nd ed.), London: Allen & Unwin.

Surveying Your Arts Audience. (1988). National Endowment for the Arts, Washington, DC

THE PSYCHOLOGY OF VISITOR STUDIES

12

Some Thoughts on Cued Versus Non-Cued Visitor Evaluation

The importance of looking closely at all of the evidence before drawing conclusions was recently highlighted at the 2000 Annual Conference of the American Association of Museums. John Falk stated unequivocally that cueing visitors (asking them to cooperate before they see an exhibition) has no effect on their behavior or knowledge when assessed after the visit. Falk reported a study conducted at the National Aquarium in Baltimore comparing cued and non-cued visitors; the first two groups were cued. Three hundred visitors were divided into three groups: a group of 100 who were asked to construct "personal meaning maps" as they entered, another group of 100 who were interviewed as they entered, and a third group of 100 visitors who received no pre-visit attention (non-cued). All 300 were interviewed at the end. Falk argued that, "there was no evidence at all that talking to people before they walked in changed – and we tracked them too – there was no evidence that it changed their behavior, there was no evidence that it changed the amount of time they spend in the exhibit, nor was there any evidence that they got smarter or tried harder."

It is difficult to believe that visitors were completely unaffected by cueing in Falk's study. I prepared a response to the above statement by Falk shortly after the Conference, but did not publish it because Beverly Serrell (2000) published her paper addressing cueing in *Visitor Studies Today*. After comparing Beverly's paper with my own, I thought it worth expanding on Beverly's ideas.

Why is this important? Cueing is an important methodological issue in evaluation because it has serious

implications for how we collect our evaluation data and the conclusions we can make from the data. Given basic knowledge of research design, we would expect that any type of cueing is likely to produce a reactive effect on visitors; that is, cueing is likely to influence their experience by sensitizing them to the exhibit content. We generally expect that visitors will pay closer attention when cued in any way. If we assume there is no effect from cueing, and there really is a significant effect, we are likely to make inferences about the exhibition that are not true; and more seriously, we might take actions to modify exhibits based on false inferences.

What is cueing? Serrell (2000) states that:

"when an exhibit evaluator recruits a visitor to be a subject in an evaluation study before the visitor has seen an exhibit, the subject has been 'cued" that he or she will be asked questions after looking at the exhibit. If the evaluator asks visitors questions about an exhibit without recruiting them beforehand, the visitors were not cued (i.e., uncued or noncued visitors)." (p.3)

More formally, I propose that cueing is any contact with visitors prior to their viewing an exhibit or exhibition that:

1. sensitizes them to the exhibit content (e.g., asking questions the answers of which are found in the exhibition);

2. requests that visitors examine an exhibit or exhibition and then answer questions when they are done;

3. asks visitors if they can be observed as they view an exhibit or exhibition.

Let's look at each of these aspects of cueing.

Sensitizing the visitor to exhibit content: When attempting to establish causation, it is important to identify and control confounding variables. If visitors are asked about the exhibit content before they visit, it is very likely that they will look for this information as they view the exhibition, especially if they believe they will be asked questions later. Consequently, one doesn't know if it was the exhibit alone or the exhibit in combination with cueing that accounted for what they recall. The only way to tell for sure is to compare the cued group with a non-cued one.

Maximum effectiveness assessment: During the process of exhibit evaluation, visitors are often cued to examine exhibits and are later asked questions to assess their reactions to the materials in terms of understand, feelings, and/or attitudes. It is assumed that cueing increases visitor motivation and give the exhibit its best "shot" at delivering the message. If visitors don't understand the message under this highly motivated state, then they are even more unlikely to get the message under "normal" visitation conditions. Shettel, et al (1968) were the first to take this approach.

If one wishes to know if the exhibition is capable of delivering its message (i.e., "teaching efficiency" in Screven's (1990) terminology, then cueing visitors to look at an exhibit or exhibition can be useful. This does not, however, give information about the motivational effectiveness (how much attention the exhibit/exhibition will given under normal visits). Non-cued visitors must be studied in order to assess

whether visitors give an exhibit attention and how focused the attention might be.

Obtrusive observation: The third type of cueing can be called obtrusive observation. When visitors know they are being observed as they view exhibits, it is likely to result in closer or more focused attention. Most visitor observations studied use unobtrusive observations in which visitors do not know they are being observed in order to avoid the added motivational effect of cueing. Those who use obtrusive observation must assume the burden of showing it makes no difference.

Why do evaluators cue visitors? There are several possible reasons. The most common reason is to assess the educational power of exhibits. What impact will the exhibit have if the visitor is highly motivated? If visitors don't learn under highly motivated conditions, then the exhibit is not likely to have much educational power. Thus, cueing is a way to test educational power. Factors that influence visitor motivation are not directly assessed in this case.

A second possible reason for cueing visitors addresses an ethical question. Some may argue that visitors should be informed if they are to be observed. I am aware of only a few who would take this position. In general, if the visitor activities are public, and if the identity of the visitor is not compromised in reporting the study, there is no potential harm to the individual.

A third reason for cueing is assess pre-visit knowledge and attitudes. However, if the goal is to assess the impact of an exhibition on visitors, then a pre-test/post-test comparison

with the same visitors would be misleading. To control for this, researchers compare one group before their visit with another group who experienced the exhibition, but was not approached before the exhibition experience.

Serrell's (2000) analysis of cueing

Serrell (2000) examined the data from 13 exhibitions from her database (Serrell, 1998). The exhibitions varied in size, topic, type of institution, and many other characteristics. All of the exhibitions were part of the regular admission to the museum (no added fee) and included permanent, temporary, and travelling exhibitions. Cued visitors spent a longer time in all but one of the 13 exhibitions. In 10 of these exhibitions the amount of time was significantly (in fact, the average total time was 24% to 100% higher) for cued than for noncued visitors. Serrell suggested that cueing heightens awareness of the topic, elements, and boundaries of the exhibition giving them a "better sense of readiness to deal with it in an attentive way."

In summarizing her review of studies, Serrell stated:
"When the average time spent by non-cued visitors was 20 minutes or more, other factors were at work. Apparently, when non-cued visitors were naturally spending a relative long time, cueing did not have an effect." (p 4).

Why the different outcomes for cueing?

We can only speculate why Falk's study did not show any difference between cued and noncued visitors. One possibility might be the instructions given to visitors. In two of Serrell's

early evaluations (Darkened Waters and Messages) instructions to visitors were designed to be motivating: "spend a little more time than usual" and "...at least 10 minutes). These instructions appeared to result in longer viewing time than instructing visitors "to spend as much or as little time as you wish").

Conclusions

While Falk's data from the National Aquarium may be valid, they apparently are not indicative of how visitors normally respond to cueing. We must not assume that cueing has no impact just because one study did not show an effect.

My conclusion: cueing is one way to increase motivation to pay attention to exhibits. If other aspects of an exhibition provide added motivation to attend, the impact of cueing is likely to be small or nonexistent.

From an unpublished paper written in 2001.

References

Falk, J. (2000). *Panel session: Transforming the museum: New research on visitor learning and experience.* Annual Meeting of the American Association of Museums.

Screven, C. (1990). Evaluation before, during, and after exhibition design. *ILVS Review, 1*(2), 33-66.

Serrell, B. (1998). *Paying attention: Visitors and museum exhibitions.* Washington, DC: American Association of Museums.

Serrell, B. (2000). Does cueing visitors significantly increase the amount of time they spend in a museum exhibition? *Visitor Studies Today, 23*(2), 3-6.

Shettel, H., Butcher, M., Cotton, T. S., Northrop, J., & Slough, D. S. (1968). *Strategies for determining exhibit effectiveness.* Report No. AIR E95-4/68-FR. Washington, DC: American Institutes for Research.

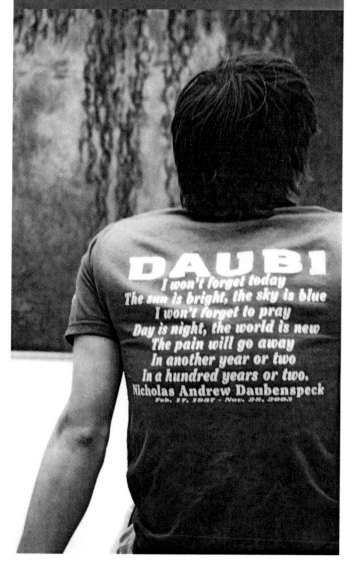

13

An Attention-Value Model
of Visitors in Exhibition Centers

An understanding of visitor attention is in its infancy. Over the last 80-plus years, many have addressed this concern (e.g., Bitgood, 2000; Carlson, 1993; Koran, et al, 1986; Lightner, 1998; Melton, 1935; Robinson, 1928; Rounds, 2004; Screven, 1999); however, there has been only modest systematic research to test these proposed models. Carlson and Lightner conducted dissertation projects, but have not followed up with additional research on their respective models. Rounds (2004) outlined an intriguing model based on optimal foraging theory, but has not conducted studies to test his model. Screven (1999) attempted to synthesize literature from various disciplines that seemed to relate to visitor attention; he provided a number of principles, but did not tie them together into a coherent model that could be tested. More recently, my colleagues and I have been developing and testing a model that views attention as a three-level process (capture, focus, engage). This model gives "value" a major role in visitor motivation to focus and engage attention on exhibit elements. Prior to our current work, the only other systematic research on visitor attention was conducted by Robinson and Melton in the 1920s and 30s.

Robinson (1928) and Melton (1935) reported a series of landmark studies that examined several aspects of visitor attention including "isolation" (lack of multiple objects competing for attention), "museum fatigue," and visitor circulation patterns through exhibition halls. Although these works are often cited in the visitor literature, their value appears to be under-appreciated and misunderstood. While the body of work must be considered in historical perspective,

it provides a beginning point for our model of visitor attention and value.

There are several points of departure between the Robinson-Melton view and our model of attention and value. One point relates the concepts of "interest" and "attention." Robinson and Melton use these terms interchangeably. However, we agree with Lightner (1998) that a distinction should be made: "interest" is a more stable construct that reflects what visitors bring to the museum, while "attention" measures (percent stopping and viewing time) are outcomes that may be influenced by "interest" as well as the immediate setting variables (e.g., exhibit characteristics). A second point of departure deals with the mechanisms involved in object competition. Robinson-Melton seem to argue for perceptual distraction, while we suggest that choice plays a primary role in object competition, i.e., when a number of exhibit objects are available simultaneously. A third important point of departure is the role of self-report data. Robinson and Melton, consistent with the popular psychology of their day, dismissed such data, relying exclusively on direct observation measures. Appreciation of self-report measures has changed and we believe that self-report can provide important information about a visitor's thoughts/feelings/motivations. In fact, we have attempted to quantify "value" by combining direct observation (e.g., reading of text), self-report ratings of interest, and exhibit characteristics (e.g., length of text passages) in a series of simulation studies.

Key concepts

Robinson and Melton introduced the key concepts of attention, interest, and object competition (isolation) into the museum literature. These concepts are discussed in this section along with the concept of choice, which was not included in the discussions of Robinson and Melton.

Attention and interest

Attention and interest were considered as equivalent concepts in the Robinson and Melton publications. There are two reasons why this is problematic. First, there may be a logical argument for making a conceptual distinction between a dependent variable or measure of behavior such as looking at, approaching, stopping at, etc. and a possible independent variable (cause) such as curiosity about a subject matter, attitude developed from past experience with the subject matter, etc. It is important not to confuse a cause with an outcome (Lightner, 1998). The concept of interest implies an intellectual and/or affective construct which can best be measured by self-report data (e.g., "Rate your interest in biology."). Attention is a more situational outcome that is subject to the immediate surroundings (e.g., "My attention was captured by the sound of the train whistle at the zoo and we turned to watch the train go by").

A second reason why attention and interest should be considered distinct concepts is that self-report measures ("how interested would you be in seeing information about this artwork?") are not always highly correlated with attention

measures such as reading text (Bitgood, Dukes, & Abby, 2007). Visitors may be highly interested in an exhibit's subject matter, but because of poorly placed exhibit labels or because of perceived high cost, do not read the text associated with the exhibit. We have found that participants in a museum simulation study often gave high ratings of their interest in seeing information about an artwork, but read only a small proportion of long text passages associated with the artwork (see Fig. 1). On the other hand, if short passages were available, a higher proportion of these passages were read even when the interest level was relatively low.

Object competition (isolation)

Melton concluded that every object competes for attention with every other object in a museum gallery. Since Melton was not specific about the mechanism of competition other than to attribute it to "distraction," we are left to infer the specifics of this mechanism. From his writings, we assume that Melton believed that all objects in the visual field compete for attention and that non-target objects (those not directly focused upon) serve as perceptual distracters resulting in a decrease in attention to a specific target. A target object by itself (in isolation) receives the greatest amount of attention, but any additional object(s) serve as perceptual distracters and decrease the level of attention to the target object. It is the mere presence of another object that is distracting according to this view.

One of Robinson's (1928) studies serves as an illustration

of the competition process. Robinson, in a laboratory study, had subjects view 100 art prints either one, two, or ten prints at a time. Subjects were instructed to view each one as long as they liked. He found that presenting more than one print at a time resulted in decreased viewing time per print. When more than one print was present during each trial, he measured total time and divided by the number of prints to derive time per print. Robinson interpreted these results as evidenced for competition based on the distracting impact of having multiple prints available simultaneously. However, he did not measure viewing times for each print and it is possible that participants concentrated their attention on a preferred print when multiple prints were presented at one time. It is also possible that object satiation occurred from viewing multiple prints per trial with no break between prints.

Melton (1935) conducted a study in an actual art museum gallery that also attempted to examine competition. In this study, the number of artworks in the entire gallery was increased from 6 to 36 in increments of 6. Each time the number in the gallery was increased, percent of objects viewed (percent of stops) was decreased; but the average viewing time once stopped remained about the same (10 sec.). Again, the decreased attention (in this case, percent stops) from increasing the number of objects in the gallery was attributed to the distracting effect of additional objects. Bitgood, Mckerchar, and Dukes (2008) re-examined Melton's study and suggested that distraction was not the only explanation for the findings.

There is a seeming important conflict in the findings of these studies. Robinson found that competition decreased viewing time per artwork, while Melton found no such difference in average viewing time. In Melton's study the difference in gallery density (total number of artworks) had an influence on the proportion of artworks viewed (attracting power) rather than how long each one was viewed (holding power). This difference may suggest a couple of things: (1) when choice is available as in Melton's study, a different process is operating; and/or (2) the difference between sitting at a table and walking through an art gallery involve different phenomena. For example, the actual time and/or distance between artworks was shorter/smaller in the lab study than in the actual museum gallery and the act of moving through space may involve different phenomena or processes (e.g., faster satiation in the lab study with rapid viewing of prints).

While Melton's perceptual distraction hypothesis used to explain the impact of object density seems reasonable, he failed to consider another possibility: choice has an influence on attention. As the number of choices increase, the individual may become more selective in what he/she chooses to attend. The Robinson study did not involve any explicit choices (which artwork to attend to), while the choice of stopping or not at each artwork was implicitly fundamental to the Melton study. As noted above, we have re-examined Melton's gallery density study (Bitgood, et al, 2008) in terms of choice. We have also conducted a study to assess the relative influence of distraction and choice in measures of attention (Bitgood, Burt, & Dukes, 2010).

Choice

Museum visits are all about choice. Visitors choose how much time they spend in the museum, which exhibition halls to visit, at which objects to stop, how long they view an object, etc. Rounds (2004) provided one possible approach to accounting for visitor choices by applying optimal foraging theory to the curiosity-driven visitor. Visitors are assumed to attend if the potential payoff is high and the "search" and "handle" time low. Decision-making theories in psychology offer a variety of models that may be appropriate for visitor experiences in exhibition (see the literature for temporal discounting and optimal foraging). "Attention" is closely related to choice. To attend, one must detect an object and find relatively high value in it if one is to choose to engage attention.

The attention-value model

Another view of choice behavior is provided by our attention-value model of visitors (e.g., Bitgood, 2000; Bitgood, 2006a; 2006b; 2007; 2008; 2010; Bitgood, Dukes, & Abby, 2007). Value is assumed to be a ratio of utility (satisfaction) divided by costs (time, effort). At any moment there are multiple alternative objects to which an individual may attend. In an exhibit, the visitor may attend to one object or exhibit element rather than another because this target object is perceived as providing higher utility (satisfaction) and lower costs (time and effort). Instead of perceptual distraction, this type of object competition is based on choice: visitors choose to attend to the objects/elements that provide the highest value (i.e., high

utility with minimal costs). In some ways, this is similar to the kind of decision making that Rounds proposed. However, we believe that our concept of value can be quantified more easily than that of Rounds. We have attempted to quantify "value" by using an interest rating to represent utility and by using a workload indicator (number of words in the text passage) to represent cost. The ratio of interest/number of words has been an excellent predictor of how much participants actually read in our museum simulation studies (see chapters x, y, and z).

Fig. 1 provides an overview of the attention-value model. Capturing attention can occur through either orienting or searching. Orienting is an automatic response to a powerful stimulus such as a loud noise. Searching is the process of scanning the exhibit environment for something of possible value (high utility or interest or satisfying and low cost in terms of time and effort). Searching can be either serial or simultaneous. Serial searches examine one object after another until something of interest is found. Simultaneous searchers scan an entire stimulus complex and look for something to "pop out" such as a large or unusually shaped object. Actions during the capture stage of attention include looking at an exhibit element, approaching the element, and actually stopping to view.

The focus level of attention occurs once an object or exhibit element is found that is of potential value. For example, an identifying label may be sought to find out the name or origin of the object or animal in the exhibit. This level of attention involves shallow processing and attention can be easily

Level of attention	Actions	Variables that influence action
CAPTURE • Orienting • Searching	• Look at • Approach • Stop	• Orienting distracters (sounds, flash of light, movement) • Other perceptual distracters that compete for attention • Attention facilitators: proximity, line-of-sight placement
FOCUS	• View for short time (up to about 5-10 sec) • Shallow processing	• Value (utility/costs) • Distractions (orienting stimuli, other)
ENGAGE	• Read • Discuss • Think about • Deep processing	• Value (utility/costs) • Action tendencies (mental strategies, patterns of reaction such as persistence) • Processes associated with "fatigue"

Figure 1: An overview of the attention-value model.

distracted away from the object by sounds, movements, etc. The actions are brief and may involve reading identifying information, touching or simple manipulation without "mind's on," etc. However, this level of attention does not involve sustained, involved attention to the exhibit content. Exhibit design techniques that direct attention to an object are useful for attention focusing. For example, spot lighting an object, placing it on a raised platform above other objects, or isolating an object in some other way are likely to increase attention focusing.

The engagement level of attention is the most difficult to attain. It involves deep processing of exhibit content and sensory, intellectual, or affective immersion. Physical

interaction with exhibit elements may occur, but this is not essential. Engagement is associated with constructs such as learning and thinking. Actions that show evidence of engagement include reading of text, discussing exhibit content with group members that involve analysis or synthesis of content, and thinking about the content in a critical way. This level of attention is rare compared with capturing and focusing, and requires high value (utility/costs) for the visitor. Engagement is also influenced by action tendencies (e.g., mental strategies for engaging such as asking questions, learned patterns of behavior such as persistence) and physical and mental states (fatigue, satiation, energy level).

Some predictions of the attention-value model:

- Capturing attention is influenced by a number of variables (see Bitgood, 2000). For example, consistent with Robinson and Melton, the size, isolation, and location of exhibit elements are critical to the capture of attention.

- Perceptual distractions, especially in the form of loud noises, sudden movements, flashes of light that cause orienting responses, are one of the most serious threats to sustained attention to exhibit elements. However, object competition of any type (presence of multiple objects) may, to some degree, influence the level of attention to exhibit elements.

- Higher value objects receive the most attention. As the number of objects in the visitors' visual field increases, visitors will become more selective in that they will

attend to a decreasing proportion of those available.

- Choice will maximize value. Objects selected for attention by choice have higher value (utility/costs) because the perceived utility (satisfaction) of more interesting objects is higher when one ignores low-interest objects.
- Engagement that requires low costs (e.g., reading a short text passage) may have a high value compared to engagement that demands high costs when the perceived utility or benefit remains the same.
- Those who read the most should rate mental effort higher and are more likely to show mental fatigue (decreased attention over successive trials) with sustained exhibit viewing.
- Trained persistence (or Eisenberger's "learned industriousness" concept) will produce deeper engagement with exhibit elements. For example participants who are instructed to describe or compare art works will work harder (i.e., read more) when later given an opportunity to read a text passage.

Evidence for the attention-value model
A brief literature review

Since much of this literature has been reviewed before (Bitgood, 2000; Screven, 1999), only a brief summary will be given here.

Capturing attention: In a previous article (Bitgood, 2000) we suggested that attention is captured by powerful (salient)

stimuli, by line-of-sight placement of objects, and by proximity to objects as visitors move through an exhibition space. The studies that support the influence of these factors were reviewed in the article and later in a chapter in the Handbook of Environmental Psychology (Bitgood, 2002).

Focusing attention: Several methods have been tried to focus attention on exhibit elements. One of the earliest and most often used is museum guides or handouts that isolate important points (Robinson, 1928; Porter, 1938; Bitgood, et al, 1987, etc.). Another attention-focusing technique has involved adding provocative questions to exhibit elements (e.g., Hirschi & Screven, 1988).

Engaging attention: Much has been written about visitor engagement. Definitions of engagement differ from one author to another. Engagement may be defined in terms of length of attention to an exhibit element and level of processing. We argue that reading of exhibit text passages is one of the most obvious signs of engagement. Many of our studies over the years have documented factors associated with reading.

Another source of supporting evidence comes from studies such as Alt and Shaw (1984). The authors attempted to determine how visitors perceive exhibits and to identify the most effective exhibit by developing a list of exhibit descriptors used by visitors. A content analysis was conducted of visitor responses and 48 exhibit attributes were isolated. Using this list, a second sample of visitors was then asked to rate 45 exhibits according to these attributes. For our purposes, the important aspect of this study was that most of

the attributes identified by visitors fit into the three levels of attention (capture, focus, engage).

Simulation studies conducted in our laboratory

Several museum simulation studies have been conducted in our laboratory setting in which art prints are presented to subjects, ratings of interest are obtained, and subjects are then given an opportunity to read (as much or little as desirable) a text passage that includes information about the art and artists. Subjects are instructed to read out loud so that an accurate measure of actual reading is obtained. Text passages vary in length from about 50 to over 250 words. These studies were modelled after Robinson (1928) who used black-and-white prints. The studies in our laboratory used color prints. Robinson's dependent measure consisted only of viewing time while ours included interest ratings and percentage of a text passage read. While these studies may lack in experiential validity, they do allow isolation of specific independent and dependent variables.

In the first couple of studies, it was shown that the proportion of the passage read was weakly to moderately correlated with interest rating and strongly correlated with the length of the passage (potential workload). However, the strongest correlation was found between reading and the value ratio (interest rating/length of the passage). The value ratio takes into account both what visitors bring to the task (interest in each specific artwork) and the cost or workload necessary to read the passage. These studies support the argument that the

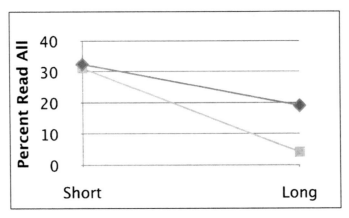

Figure 2: Length of labels

value of engaging in the task (i.e., reading text) is a function of both perceived utility and the cost or workload required.

In our studies, interest level and cost (number of words per text passage) interacted as shown in Fig. 2. If the text passage was short, interest level was not much of an issue, the participant read about the same number of passages. However, if the text passage was long, very little reading occurred unless the interest level was high.

In another study (Bitgood, New, & White (2007), designed to examine "persistence," we compared three groups of subjects. The first group served as a control and was similar to the studies described above: subjects rated the artwork for interest and then were given the choice of reading as much of a passage as they wanted. A second group was instructed to describe the print first; then, they gave a rating of interest, and finally, given a chance to read. The third group was instructed to compare multiple artworks, then give a rating of interest, and finally

Condition	N	Percent read	Interest rating
Control	12	48.5	5.0
Describe	12	55.5	5.0
Compare	14	62.4	5.5

Figure 3: Attention, distraction, choice and persistence.

read as much as they wanted. The "compare" condition resulted in the most reading; the "describe" condition next, and the control group read the smallest proportion of the text passages (see Fig. 3). Eisenberger's (1992) "learned industriousness" principle appears to apply to this finding. Persistence training (instructions to describe or compare) required more time and mental effort and seemed to generalize to reading. However, the persistence techniques (compare or describe) did not have a significant impact on the interest rating, suggesting that "interest" is a more stable construct than "attention" and is not as easily manipulated in a single experience. "Learned industriousness" or persistence is assumed to be one of many variables under "action tendencies" found in Fig. 1.

Two recent studies (Bitgood, Burt, & Dukes, 2010) provide additional evidence for the attention-value model. These studies attempted to experimentally separate mechanisms of object competition: the influence of perceptual distraction from choice. In addition, we attempted to replicate the study reported above on "learned industriousness" or persistence and compare its impact with choice and distraction.

Choice: In one study, we examined the influence of choice by making it an explicit part of the method ("Choose your favorite

View time	Seconds
Choice (1 of 3)	13.7
No Choice (3)	9.4
Single print	11.7
Interest	**Rating**
Choice (1 of 3)	7.1
No Choice (3)	5.7
Single print	5.0
Reading	**Percent**
Choice (1 of 3)	60.0
No Choice (3)	39.8
Single print	44.5

Figure 4: The influence of choice.

of these three art prints"). The choice condition was compared with a no choice condition in which subjects were instructed to examine all three art prints presented. It was assumed that when given a choice, subjects would give the artwork selected a higher interest rating on the average than when no choice was presented. Higher interest is assumed to create a higher value ratio (interest/workload) and thus produce a larger amount of reading than if no choice is given. As predicted, Fig. 4 reveals that choice resulted in higher overall interest ratings (7.1 vs 5.7), longer viewing times (13.7 vs 9.4), and more reading (60.0 vs 39.8%).

Distraction: Fig. 4 also allows a comparison between an isolated print and perceptual competition among three prints: No Choice (3) condition vs Single Print condition. We did find perceptual interference with the three-at-a-time condition compared with the isolated single print. However, the impact

Viewing time (sec)	Choice	No choice
Describe	29.8	25.4
View only	13.7	9.4
Interest rating	**Choice**	**No choice**
Describe	6.2	4.6
View only	7.1	5.7
Percent read	**Choice**	**No choice**
Describe	60.7	56.3
View only	60.0	39.8

Figure 5: The persistence effect.

of perceptual interference was much less than the impact of choice as evidenced by Fig. 4. More specifically, Fig. 4 shows the influence of object competition by sensory distraction by comparing viewing time, interest, and proportion of text read for trials of one print at a time (single print) versus trials of three prints at a time. Isolation (single print) resulted in longer viewing times (11.7 vs 9.4 average sec) and slightly more reading (44.5 vs 39.8%), but isolation (single print) did not result in higher interest ratings (5.0 vs 5.7) .

Persistence: In another segment of this study, we attempted to replicate the "persistence effect" found in a study described above (Bitgood, New, & White, 2008). Two additional conditions were designed in which prints were shown three at a time, half of the trials involving a choice (one of three) and half of the time no choice (view all three of three). All participants in this study were instructed to describe the artwork before giving an interest rating. Results were then compared with the View Only condition from the first part of the study. As

expected (see Fig. 5), when participants had to describe the prints, much longer viewing times were produced (25.4 to 29.8 for the describe condition and 13.7 and 9.4 for the View Only condition). Choice (choosing a favorite from three prints) also made a little difference in viewing times.

When compared to the View Only condition, the "describe" technique did not significantly increase interest rating. In fact, it seemed to have the opposite effect (View only rated prints higher in both the choice and no choice conditions). We are not sure how to explain this impact on interest rating.

The percent reading data indicate an interaction between conditions (describe vs view only) and choice. When a choice is available, there was little difference between the describe and view only conditions (60.7 for describe and 60.0 for view only). However, when no choice was available, the describe condition resulted in significantly more reading (56.3%) than the view only condition (39.8%). Perhaps choice is so powerful a variable that it overwhelms the persistence factor. The fact that the percent reading outcome is the opposite of the interest rating outcome suggests that "interest" and "attention" must be considered as different phenomena.

Discussion

The attention-value model suggests that managing visitor attention and offering high value (utility/cost) is fundamental to successful exhibition experiences. Object competition is a given in any exhibition and may be the result of either sensory distraction or selectiveness in choice. Our simulation

studies provide evidence that both distraction and choice are phenomena that must be addressed, but choice seems to be the more potent variable.

Engagement is assumed to be the third level of attention and requires high value from the visitor perspective. Visitors are likely to increase the value of their experience by selecting the higher interest objects to view and by minimizing the "cost" by being selective in how many objects they view and how much of the text they read.

References

Bitgood, S. (2000). The role of attention in design effective interpretive labels. *Journal of Interpretation Research*, 52(2), 31-45.

Bitgood, S. (2002). Environmental psychology in museums, zoos, and other exhibition centers. In R. Bechtel & A. Churchman (eds.), *Handbook of Environmental Psychology*. John Wiley & Sons. Pp. 461-480.

Bitgood, S. (2006). An analysis of visitor circulation: Movement patterns and the general value principle. *Curator*, 49(4), 463-475.

Bitgood, S. (2010). *An attention-value model of museum visitors*. Center for the Advancement of Informal Science Education. http://caise.insci.org/uploads/docs/VSA_ Bitgood.pdf

Bitgood, S., Burt, R., & Dukes, S. (2010). *Competition, choice, and persistence: How do they influence interest and multiple measures of attention*. Manuscript in preparation.

Bitgood, S., Dukes, S., & Abby, L. (2006). *Interest and effort as predictors of reading: A test of the general value principle*. Current trends in audience research and evaluation. Vol. 19/20. AAM Committee on Audience Research and Evaluation. Boston, MA. Pp. 5-10.

Bitgood, S., McKerchar, T., & Dukes, S. (2008). *Melton's study of gallery density: A Re-analysis*. Presented at the Southern Society for Philosophy and Psychology. New Orleans, LA.

Bitgood, S., New, B., & White, K. (2008). *Projective focusing, engaged attention, and value: How do they relate to interest*

and reading? Paper presented at the Annual Meeting of the Southern Society of Philosophy & Psychology. New Orleans, LA.

Carlson, S. (1993). *Cognitive model for learning in educationally oriented recreation facilities.* Ph.D. Dissertation, East Lansing, Michigan State University.

Eisenberger, R. (1985). *Learned industriousness.* Psychological Review, 98(2), 248-267.

Hirschi, K., & Screven, C. G. (1988). Effects of Questions on Visitor Reading Behavior. *IL VS Review,* 1(1), 50-61.

Lightner, J. (1998). *An attention model for museum exhibits.* Ph.D. dissertation, Michigan State University, East Lansing, MI.

Melton, A. (1935). *Problems of installation in museums of art.* New Series No. 14. Washington, DC: American Association of Museums.

Robinson, E. (1928). *The behavior of the museum visitor.* New Series No. 5. Washington, DC: American Association of Museums.

Rounds, J. (2004). Strategies for the curiosity-driven museum visitor. *Curator,* 47(4), 389-410.

Screven, C. (1999). Information design in informal settings: Museums and other public places. In R. Jacobson (ed.), *Information design.* Cambridge, MA: MIT Press. Pp. 131-192.

14

"Museum Fatigue"
A New Look at an Old Problem

"Museum fatigue" has been a troublesome problem to define, to measure, and to ameliorate. Definitions have tended to either lack specificity or been restricted to a single phenomenon, although several appear to be involved. Measures of fatigue have varied from percent stopping at an exhibit element, to time viewing, to time sampling the focus of visitor attention, and, finally, to self-reports of boredom and/or physical or mental tiredness/exhaustion. In addition, there has been very little systematic attempt by museum professionals to find ways to reduce or eliminate "fatigue."

This article summarizes some of the material discussed in two of my recent publications (Bitgood, 2009a; 2009b) as well as adds a few new ideas. I hope to provoke more concern about the multiple phenomena associated with "fatigue" because of the negative impact that these phenomena have on the visitor experience. These phenomena are responsible for curtailing many museum visits and for limiting the amount of learning and enjoyment experienced by visitors. Several phenomena associated with "fatigue" will be discussed and some of the misconceptions held by museum professionals will be identified and corrected. Finally, this article will propose ways to minimize the negative impact of "fatigue" and to suggest the need for further research. To accomplish these goals, a question and answer format will be used.

What is "museum fatigue"?

To the visitor who, after several hours of trudging through exhibit gallery after exhibit gallery, "museum fatigue" is simply

the awareness of being physically and mentally exhausted. "Museum fatigue" has a different meaning to the researcher who must carefully analyze its components. What has been called "museum fatigue" includes two types of outcomes. First, it refers to a collection of phenomena associated with systematic decreases in attention to or interest in exhibition elements over successive viewings. It also refers to self reports of decreased interest levels, of increased feeling of mental or physical tiredness/exhaustion, or of boredom after the exertion of viewing exhibitions. These phenomena include mental and/ or physical tiredness/exhaustion, object satiation (boredom), a depleted capacity to attend to exhibit elements over time, and an increased selectiveness in what objects receive attention.

Additional complications arise when considering the relationship of "museum fatigue" to other phenomena such as "directed attention fatigue" proposed in Kaplan's Attention Restoration Theory (e.g., Kaplan, Bardwell, & Slakter, 1993). According to Kaplan, a museum visit can be a restorative experience to ameliorate "directed attention fatigue" (caused by extended attention to daily tasks). However, it is only the experienced visitor who is likely to benefit; the infrequent visitor does not experience restoration in the museum according to Kaplan and his colleagues. Not addressed by Kaplan is the question: "How can a museum experience both create and eliminate "attention fatigue?"

I have argued (Bitgood, 2009a; 2009b) that "museum fatigue" should be operationally defined in terms of both the causal or precipitating factors (workload, homogeneous

exhibit objects, etc.) and the visitor outcome (decreased attention to exhibit elements over time, etc.). There is likely to be more than one reason why visitor attention decreases. For example, in addition to "fatigue" phenomena, decreased attention may be attributed to poorly designed exhibitions, to the processes involved when objects compete for attention with one another and to information overload.

What phenomena should not be called "fatigue"?

With respect to attention, the distinguishing factor between fatigue and other phenomena is that fatigue involves a systematic decrease in attention over successive viewing, while non-fatigue phenomena are not defined by a systematic decrease over time. One of these non-fatigue phenomena is "object competition" – a decrease in attention to a target object resulting from simultaneous visual exposure to multiple objects. Melton (1935) argued that every object competes for attention with every other object that is visually available at any moment. While Melton (and Robinson, 1928) believed that this competition had a perceptually distracting impact on attention, it is more likely that visitors become more selective (choose the more interesting objects to view) as the number of alternatives increase.

Another phenomenon sometimes confused with "fatigue" is "stimulus or information overload." Overload is similar to competition in that it requires simultaneous presentation of multiple objects. Overload can be defined as an inability to process the amount of incoming information. Matamoros

(1986) titled her thesis "Information Overload" but did not actually provide an "overload" measure. Rather, she examined decreased attention (percent stop and viewing time) over the course of the aquarium visit – clearly a "fatigue" phenomenon. She also collected self-report data of fatigue-like feelings from an independent group of visitors.

While "competition" may include an "overload" component (e.g., too many objects to view at one time), decision-making processes may also be involved. For example, a visitor may select for attention only the most potentially interesting objects when confronted with a large number of choices (Bitgood, Mckerchar, & Dukes, 2008).

Competition and overload, while not meeting the operational criteria for "fatigue," may increase the rate at which "fatigue" occurs as predicted by such theories as Kaplan's Attention Restoration Theory and environmental load theory (Bell, Greene, Fisher, & Baum, 2005). However, the studies of Robinson (1928) and Melton (1935) did not show such an effect.

What are the outcome measures used to indicate "fatigue"? One of the confusions in the literature is the apparent assumption that all "fatigue" measures are equivalent. Gilman (1916) used a photographic record of one individual who was given instructions to find answers to questions posed by Gilman. The photos show the man stretching and straining in an attempt to obtain the required information from the exhibition. No doubt the participant had to pose while Gilman

readied his camera. As evidence of "fatigue," these photos are questionable. However, they do indicate the obstacles built into poorly designed exhibitions and Gilman was an early champion for more visitor-friendly design.

Robinson's (1928) and Melton's (1935) measures of "fatigue" included both percentage of stops at paintings and/or viewing time per painting. Robinson compared patterns of visitor attention across several different museums and in a laboratory simulation study. Melton focused on single exhibitions rather than entire museum visits. The importance of this difference between the impact of an entire visit and of a single exhibition cannot be overemphasized. Different phenomena are very likely to be involved in each of these situations.

Falk, Koran, Dierking, & Dreblow (1986) developed a time sample measure that indicated the focus of visitor's attention (exhibits, social, etc.) in 5-second intervals and pooled this time-sampling data into 3-minute periods. For several reasons it is unlikely that this recording method is equivalent to those used by Robinson and Melton. The Falk et. al study is the only one employing time samples and the reader should be aware of some of the methodological problems. First, since attention was not recorded to specific exhibit elements, the peaks and valleys of attention typically found in exhibitions were not evident. Second, it is very likely that the data was confounded with reactivity in which the procedure influences the outcome. Individuals were asked permission at the beginning of their visit and the researchers accompanied the visitor through the Museum. Serrell (2000) reported a meta-

analysis of studies comparing cued (individuals approached and asked to participate) and non-cued (individuals observed unobtrusively) visitors. The vast majority of the studies found that cued visitors showed higher measures of attention than non-cued visitors.

In a master's thesis conducted at the New England Aquarium, Matamoros (1986) examined both complete visit patterns of observational measures (percent stops and viewing time) as well as self-reports of visitor experiences in a paper-and-pencil survey. Observational data showed a systematic decrease across aquarium sections, but these data were not entirely consistent with self-report measures collected from another group.

Cota-Mckinley (1999) also used self-report measures by adapting a NASA workload impact scale on a simulated visit to a natural history exhibition. She found that a group given limited time reported heavier workloads and pressure than a group given unlimited time to view the PowerPoint simulation of the exhibition. This suggests that the workload measures used in the study are sensitive to task conditions and may be useful in further "fatigue" research.

Recently, two students (Renee Burt and Stephany Dukes) under my direction have completed simulation studies using art prints in a laboratory (in some ways similar to Robinson's study) that collected three measures of fatigue: viewing time, interest rating of each art print, and the proportion of a text passage read. Half of the participants were instructed to describe the art print as they initially viewed it; the rest

of participants simply viewed as long as they wished. All participants were then asked to rate the print in terms of "how interested would you be in seeing information about this artwork and its artist?" Finally, participants were shown a text passage and instructed to read as much or as little as they desired. Results indicated that (1) the vast majority of participants showed signs of "fatigue" (decreased view time, interest rating, and proportion of passage read) across trials of the study; and (2) the participants who had to describe the print, showed a higher amount of "fatigue" or systematic decreases in the three measures than participants who passively viewed the prints. Obviously, physical exertion was not a factor in this study. However, mental exertion (having to describe the art print) was apparently a strong factor since the describe condition resulted in greater "fatigue" than the view-only condition.

Unfortunately, there has been little concern about the equivalence of these various "fatigue" measures. My recent articles identified some potential difficulties with some of the outcome measures (Bitgood, 2009a; 2009b). At the very least, the pattern of findings in the literature suggest that different measures are sensitive to different factors.

What is the evidence for mental and physical exhaustion?

While there is a lack of published evidence, it is difficult to argue that physical tiredness/exhaustion does not play a role in "fatigue." We have all experienced exhaustion after a long day at a museum or theme park. However, physical or tiredness is

only one of the possible outcomes associated with "fatigue." Physical exhaustion is more difficult to study because of the long time frame necessary to produce it.

Gilman (1916) suggested that his photographs provided evidence for physical exertion as a cause of "fatigue." However, there was no indication that the participant's attention or interest systematically decreased during the demonstration or that the participant reported feelings of tiredness/exhaustion.

While physical exhaustion is difficult to demonstrate because of the time necessary to produce it, mental tiredness/exhaustion may be easier to demonstrate. As noted above, the results of our museum simulation studies suggested that greater mental exertion (describing an artwork) produced more "fatigue" (as defined by decreased attention across time) than simply viewing the artwork.

What is the evidence for object satiation?

"Satiation" differs from "mental tiredness/exhaustion" in that, in the former, individuals are exposed to objects in a way that fails to stimulate the individual either intellectually or affectively, while in the latter individuals are given a heavy mental workload. Decreased attention to homogenous objects across time appears to be a common outcome. Decreased attention can occur with little physical exertion. For example, it has occurred while a participant viewed art prints while seated at a table (Robinson, 1928) or viewed successive snakes within a small exhibition space (Bitgood, Patterson, & Benefield, 1986).

What is the evidence for decision-making processes?
In addition to tiredness/exhaustion and satiation, the role of decision-making processes must be considered. Visitors become more selective in the focus of their attention as the visit progresses. Such behavior is sometimes described as "cruising" (Falk & Dierking, 1992). However, "cruising" would seem to imply a decrease in both the number of stops at exhibit elements and the viewing time per stop. Although not a "fatigue" study, Melton (1935) reported a decrease in the percentage of artworks given attention (percent of stops) as the number of artworks increased; but, once stopped, the viewing time averaged a constant 10 seconds.

The specific processes of decision-making in "fatigue" phenomena are not clear at this point, but it may be something like this: As tiredness or boredom increase with systematic viewing of exhibit elements, visitors choose to focus on fewer elements, primarily those that have the highest perceived worth or attractiveness. Thus, the difference in performance measures (stopping and viewing time) may indicate that visitors are not too tired or bored to view (viewing time remains constant), but are more selective in their choices, perhaps to conserve more of their energy. There is evidence that people engage in a variety of behaviors (taking the fewest steps to a destination, refusing to backtrack, etc.) that may be designed to conserve energy (Bitgood, 2006; Bitgood & Dukes, 2006).

Is there selective bias in reporting "museum fatigue"?
There is undoubtedly a strong bias in which research studies

reach publication. Negative results are usually not published, either because professional journals reject them in the review process or researchers fail to submit them for publication. There are many reasons why studies may fail to produce a result, including poor experimental controls or because there is no strong phenomenon involved. We published (Bitgood, et al., 2001) a failed attempt to replicate Robinson's (1928) laboratory study, but emphasized the increased attention produced by participants having to describe an art print. Many of our evaluation studies over the years have also failed to find systematic decreases in attention over successive exhibit elements. The typical finding is a series of high and low measures of attention to various exhibit elements depending upon the characteristics of the exhibit element and the characteristics of the visitor circulation pattern. Consequently, it is difficult to assess the strength of the "fatigue" phenomena since we do not know if the literature represents an accurate indication of its presence or absence.

Where do we stand on "museum fatigue" phenomena?
After almost one hundred years of studying "museum fatigue," we know relatively little. The total number of published studies addressing "fatigue" can be counted on three or four hands (under 20). The findings from published studies are somewhat inconsistent and conflicting. This should be of concern. In addition, there is a lack of theories or models that can boast predictive validity (that is, under what conditions we can predict "fatigue").

Despite the lack of a clear road map, we can perhaps draw some conclusions from the literature:

- There are several phenomena that fit into the "fatigue" framework. These include tiredness/exhaustion, object satiation, and greater selective attention over time.
- All observational measures are not the same. Because of the paucity of research, it is not clear how each measure relates to the others.
- Observational measures do not always agree with self-report measures. One would expect consistency between these two types of measures, but more studies are needed to establish this connection.
- There is a tendency to oversimplify the nature of "fatigue." The conditions and outcomes involved in these phenomena must be considered together.

What can we do to minimize "fatigue"?

Given that we know relatively little about "museum fatigue," we can only offer intelligent guesses on how to minimize the impact of "fatigue."

1. Provide attention-focusing aids: Handouts, pamphlets, or guides for both individual exhibitions or for the entire museum appear to help (Bitgood, Patterson, & Benefield, 1992; Porter, 1938; Robinson, 1928). These aids may be effective for two reasons: they seem to reduce the amount of mental energy necessary for visitors to decide where to focus their attention; and, if effectively designed, they are likely to increase the interest level by provoking curiosity.

2. Design to minimize physical and mental exertion by pacing visitor viewing: Assuming prolonged physical and mental exertion create "fatigue," exhibitions can be designed to slow visitors down and to provide short rest periods. For example, placing a sit-down video in a theater in the middle of a large exhibition may help the visitor recover before continuing the visit.

3. Provide effective and easy wayfinding: Having to constantly make decisions about where to go next, which way to turn, etc. places a heavy burden on visitors and is likely to hasten "fatigue." Easy-to-follow pathways, minimal choice points, and effective directional signage are among the principles for effective orientation (Bitgood, 2006).

4. Minimize the mental processing workload: The connections between interpretive text and the exhibit objects should be obvious to visitors and the text passages should be designed for easy processing (Bitgood, 2000). Text passages should be short, bulleted when possible, use simple language, and be supported by clear illustrations where appropriate. Because of the mental workload, visitors are unwilling to read "textbooks on walls."

5. Maintain high interest with provocative design: Questions that make visitors think can often be effective in increasing visitor curiosity. In one of our evaluation projects, the question, "Can you identify the three animals in the totem pole" in an art museum resulted in a high percent of visitors stopping to find the answer. Judy Rand (1986) offered a number of suggestions for effective label writing that "hook" the reader.

6. Encourage visitors to take breaks: A well-placed coffee shop

in the middle of a museum might encourage visitors to rest for 15 or so minutes. Of course, the caffeine in the coffee might also be helpful for increasing the visitor's energy level.

Conclusion

"Museum fatigue" is not inevitable and we have the responsibility of minimizing it whenever possible if we want visitors to optimize learning and to create a satisfying visitor experience. However, more research and theory are needed to formulate effective principles that lead to a reduction in "fatigue."

There are a number of variables that need further study: pacing of viewing, variety of exhibit elements, etc. Examples of variables in need of study: pacing the visitor workload through the exhibition; the parameters and impact of object competition; and the relevant factors that cause information overload and its relationship to "fatigue." With respect to pacing, how quickly or slowly exhibit elements are processed may be related to the massed versus distributed practice phenomenon in the learning/memory literature of psychology. Is the impact of pacing in exhibitions similar to that of massed versus distributed practice? (See Cepeda, Pashler, Vul, Wixted, & Rohrer, 2006 for a recent review of the literature.) Taking breaks between trials of learning or memorizing has been shown to improve performance in motor and verbal tasks. Do museum visitors experience a similar process as they view exhibitions?

While there is much yet to be learned about "fatigue," we

should at least be sensitive to visitor needs and look for and correct design problems that may cause "fatigue."

Originally published in Informal Learning Review (2009), July-Aug.

References

Bell, P., Greene, T., Fisher, J., & Baum, A. (2005). *Environmental psychology.* Philadelphia, PA: Routledge Publishing.

Bitgood, S. (2006). An analysis of visitor circulation: Movement patterns and the general value principle. *Curator: The Museum Journal,* 49(4), 463-475.

Bitgood, S. (2009a). When is "museum fatigue" not fatigue? *Curator: The Museum Journal,* 52(2), 193-202.

Bitgood, S. (2009b). Museum fatigue: A critical review. *Visitor Studies,* 12(2), 1-19.

Bitgood, S., C. Devia, P. Goodwin, C. Rudin, A. Trammell, and B. Zimmerman. 2001. *Projective focusing: Motivated attention to works of art.* Current Trends in Audience Research vol. 14. St. Louis, MO: AAM Committee on Audience Research and Evaluation.

Bitgood, S., & Dukes, S. (2006). Not another step! Economy of movement and pedestrian choice point behavior in shopping malls. *Environment and Behavior,* 38(3), 394-405.

Bitgood, S., Dukes, S., and Abby, L. (2006). *Interest and effort as predictors of reading: A test of the general value principle.* Current Trends in Audience Research and Evaluation vol. 19/20. Boston, MA: AAM Committee on Audience Research and Evaluation

Bitgood, S., Patterson, D., and Benefield, A. (1986). *Understanding your visitors: Ten factors that influence visitor behavior.* American Association of Zoological Parks and Aquaria Annual Conference Proceedings, Minneapolis, MN. Pp. 726-743.

Cepeda, N., Pashler, H., Vul, E., Wixted, J., & Rohrer, D. (2006). Distributed practice in verbal recall tasks: A review and quantitative synthesis. *Psychological Bulletin*, 132(3), 354-380.

Cota-Mckinley, A. (1999). *An empirical investigation of workload on the visitor experience: Effects of exhibit size and time constraints on performance*. Ph.D. dissertation. Ft. Collins, CO: Colorado State University.

Davey, G. 2005. What is museum fatigue? *Visitor Studies Today* 8 (3): 17-21.

Falk, J., and L. Dierking. 1992. *The Museum Experience*. Washington, DC: Whalesback Books.

Falk, J., J. Koran, L. Dierking, and L. Dreblow. 1985. Predicting visitor behavior. *Curator: The Museum Journal* 28 (4): 249-257.

Gilman, B. 1916. Museum fatigue. *Scientific Monthly*, 12: 67-74.

Johnston, R. 1998. Exogenous factors and visitor behavior: A regression analysis of exhibit viewing time. *Environment and Behavior* 30 (3): 322-347.

Kaplan, S., Bardwell, L., & Slakter, D. (1993). The museum as a restorative environment. *Environment and Behavior*, 25(6), 725-742.

Marcellini, D., and T. Jenssen. 1988. Visitor behavior in the National Zoo's Reptile House. *Zoo Biology*, 7: 329-338.

Matamoros, M. (1986). *Information overload*. Master's thesis in Management, University of Massachusetts at Boston. Boston, MA.

Melton, A. 1935. *Problems of Installation in Museums of Art*. New Series No. 14. Washington, DC: American Association of Museums.

Rand, J. (1990). *Fish stories that hook readers: Interpretive graphics at the Monterey Bay Aquarium*. Technical Report No. 90-30. Jacksonville, AL: Center for Social Design (originally published in the 1986 Annual Conference Proceedings of AAZPA).

Robinson, E. 1928. *The Behavior of the Museum Visitor*. New Series No. 5. Washington, DC: American Association of Museums.

Roper, J. S. Bitgood, D. Patterson, and A. Benefield. 1986. Post-occupancy evaluation of the Predator House at the Birmingham Zoo. *Visitor Behavior* 1 (2): 4-5.

Rounds, J. 2004. Strategies for the curiosity-driven museum visitor. *Curator: The Museum Journal* 47 (4): 389-410.

Serrell, B. 2000. Does cueing visitors significantly increase the time they spend at a museum exhibition? *Visitor Studies Today* 3 (2): 3-6.

15

The Concept of Value Ratio and Its Role in Visitor Attention

Update: This chapter provides a summary of papers presented at conference sessions during the last four or five years. The first paper was an overview of the general value theory. The three studies following the first paper were all completed in a laboratory setting with university students as participants.

General value theory: an umbrella for cost-benefit phenomena

Major theories in biology, psychology and economics share the basic assumption that the ratio between costs and benefits is a major predictor of choice behavior. These theories include, but are not limited to, optimal foraging theory in biology (Stephens & Krebs, 1986), information foraging in information science (Pirolli & Card, 1999), and temporal, probabilistic, and effort discounting in psychology and economics (Critchfield & Kollins, 2001). Optimal foraging theory hypothesizes that a predator chooses a prey based on the ratio of energy obtained from consuming the prey (benefit) over the time for searching and handling the prey (costs). In information foraging, information replaces the prey, and searching and handling of this information are the costs. Rounds (2004) has suggested a similar analysis for visitor behavior in museums.

Discounting theory, another major cost-benefit explanation, assumes that the value of a reward/experience is decreased, or discounted, as the costs (e.g., temporal delay, lowered chance of obtaining the reward, effort) are increased.

Thus, temporal discounting occurs when an individual chooses a smaller, immediate reward over a larger, delayed one. Effort discounting would refer to the selection of a lower quality, low-effort choice over a higher quality, high-effort one.

The above theories (foraging and discounting), as well as other theories such as social exchange theory, can be subsumed under the umbrella of general value theory (Bitgood, 2005). The value of an experience/reward is determined by both the quality of the outcome **and** by the costs in obtaining the outcome. The basic assumptions of a general value theory are: (1) choice behavior is a function of the comparative "value" of alternatives available; (2) "value" depends on the ratio of benefits divided by costs (and this function is nonlinear, probably hyperbolic in shape); (3) costs can be perceived or actual and are defined by resources used (e.g., time, effort, money); benefits can also be perceived or actual and are defined in terms of outcomes (positive or negative rewards/experiences).

General value theory helps explain a number of diverse choice behaviors such as a lack of self control (e.g., drug abuse, overeating), failure to engage in preventive health measures, and failure to invest in retirement. In addition, Bitgood & Dukes (2006) have suggested that walking patterns in public places such as museums and shopping malls conform to the principle of minimal costs (fewest number of steps) for maximum benefits (arriving at a destination quickly).

This session describes three applications of general value theory related to visitor behavior. The first reports on a

simulated art museum study in which respondents rated art prints' interest level and then were given the choice of reading all, some, or none of the text materials (labels) associated with the prints. The second study presented participants with successive choices between shorter, lower quality humorous passages with longer, higher quality ones. Finally, the third study involved choice between shorter, lower rated films with longer, higher rated ones. These studies all required making decisions based on a combination of benefits (quality, interest level) and costs (time and/or effort).

Interest and effort as preductors of reading in a simulated art museum

Stephen Bitgood, Stephany Dukes and Brandalyn New

It is often observed that visitors read very little exhibit text material in museums. Numerous reasons have been offered: "there is too much to read," "visitors never read," "there is little interest in the topic," "visitors have a different agenda," etc. General value theory (Bitgood, 2005) suggests that, to a large extent, the decision to read is determined by a cost-benefit or value ratio. Museum visitors are likely to perceive the benefits of reading as low if there is low interest in the subject, and the costs of reading as high if there is significant effort required.

The current study simulated a museum experience in order to assess the contributions of interest level and effort on reading of text passages. Interest level in reading about an art work is assumed to be a perceived benefit, and length of text passage is assumed to be a cost (amount of effort). The study was able to separate interest from effort by requiring participants to rate the interest of art prints before exposure to the text material.

Method

Forty-three undergraduate students from Jacksonville State University served as participants and given extra credit in their course for their time. They were shown 20 prints of well-known paintings from famous artists and asked to rate each one from "1"(low) to "10" (high) indicating their degree of interest

in viewing information about the art work. After an interest rating was obtained, participants were instructed to turn the print over and view a text passage. They were then instructed to make a choice between reading none of the passage, reading some of the passage or reading all of the passage. Participants were instructed to read out loud so that the amount of reading could be determined. Passages varied between 49 and 315 words.

Results

Both interest and effort predicted reading as shown in the following table (Fig. 1) which summarizes the multiple regression analyses for each reading outcome (none, some, or all of the text passage).

Variable	No reading	Some reading	Read all
Number of words	0.790 (.4402)	4.382 (.0004)**	6.533 (.0002)**
Interest ratings	2.714 (.0147)*	2.714 (.0147)*	1.180 (.2543)
Statistical significance was indicated by either $p < .05$ (*) or $p < .01$ (**)			

Figure 1: t-values and probabilities (in parentheses)

Interest rating was significant for the "No Reading" passages ($p = .0147$); it approached significance for the "Some Reading" passages ($p = .0662$), and it was non-significant for the "Read All" passages ($p = .2543$). Number of words, on the other hand, was non-significant for "No Reading" ($p = .4402$), but significant for both "Some Reading" ($p = .0004$) and "Read All" ($p = .0002$).

Discussion

Clearly, the number of words was shown to predict how much of the passage is read while interest level predicted whether or not any reading occurred. The shorter labels were read whether or not interest level was high; however, reading longer labels required high interest. Reading the entire label was very much predicted by the length of the label – very few long labels were read in their entirety

This study suggests that both benefits (satisfying interests) and costs (reading effort) are important in understanding why visitors read or don't read exhibit labels. Given the size of statistical outcomes, the costs (number of words) may be the more important factor! Such a result may also indicates that, at least in some cases, the design of the exhibit (e.g., text length) is more important than what visitors bring to the museum.

Viewing time of films:
why visitors don't view long film in museums

Stephen Bitgood & Layla Abby

Miles (1989) reported a meta-analysis of studies of audiovisuals conducted at the National History Museum, London and reported that audio-visuals (AV's) tend to have poor attracting and holding power, especially longer duration media. It is paradoxical that, in movie theaters, the public pays for movies that are typically two or more hours in length! Temporal discounting may account for at least some of this discrepancy.

Temporal discounting occurs when individuals choose a smaller, immediate reward when the time delay is long, but a larger, delayed reward if the time delay is short (e.g., Critchfield & Kollins, 2001). The current study attempted to assess whether this phenomenon occurs when films are selected that differ in terms of duration and critical rating. Discounting would be observed if participants chose the longer, higher-rated of two films when the durations were short (e.g., 5 versus 10 min films), but the shorter, lower-rated of two films when the durations were long (40 versus 80 min films). This situation is similar to museum visitors being confronted with a large number of choices, many of them between media that may require a shorter versus longer time with unknown payoffs in terms of satisfying curiosity. Temporal discounting may explain why visitors are not willing to invest large amounts of time in an AV when there are alternatives (e.g., exhibits) that require less time.

Method

Sixty-five participants were presented with a film festival scenario in which they had to choose between shorter, lower-rated films versus longer, higher, critically-rated films. The films varied between 5 and 80 minutes with choices always between a value and its double (e.g., 5 versus 10, 20 versus 40, etc.). Critical ratings were given as either high, medium, or low. Thus, combinations of film length and critic ratings included comparisons such as: 5-min, low rated versus 10-min, medium rated, etc. The study was conducted during the class periods of two psychology classes (introductory and positive psychology).

Results

As Fig. 2 indicates, a temporal discounting effect was found: participants chose the longer film when the intervals were short (e.g., 5-10 minutes), but chose the shorter film when the intervals were long (40-80 minutes). In addition, when the choice was between a low, rated versus a high rated film, participants were more likely to choose the longer, highly rated film than the shorter, lower rated one compared to films that were given a low versus medium rating. Both duration of film and magnitude of difference between perceived benefits (critic rating) were statistically significant using a Chi-square test.

Discussion

Results of this study found a temporal discounting effect with choices of films that differed in terms of both duration

Low-medium rating	Duration of film		
	5-10 mins	20-40 mins	40-80 mins
Shorter/lower rated film	15.4%	63.5%	76.9%
Longer/higher rated film	84.6	36.5	23.1
Low-high rating	Duration of film		
	5-10 mins	20-40 mins	40-80 mins
Shorter/lower rated film	5.8%	13.5%	63.5%
Longer/higher rated film	94.2	86.5	36.5

Figure 2: Percent choice of film when duration and critical ratings vary.

and critical rating. In addition, the magnitude of comparison (low versus medium; low versus high) was also shown to be a significant factor. The cost-benefit ratio (quality of film divided by the duration of A-V) may also explain visitors' choices of media in a museum environment. Visitors are confronted with a choice of viewing an exhibit for a short time versus a film for a longer time period. Unless the film is perceived as having a high benefit, it is not likely to hold attention for very long.

Choosing to read when quality of information and amount of effort vary simultaneously

Stephen Bitgood and Stephany Dukes

If visitors choose to read exhibit labels based on a cost-benefit ratio, they are likely to engage in discounting as the amount of effort and interest level varies (i.e., choose to read higher interest rather than lower interest labels when the label length is short; but choose lower interest labels when the length is long). Temporal and probability discounting have been found in many studies (Critchfield & Kollins, 2001; Green & Myerson, 2004). However, we could not find a discounting study conducted with humans that demonstrated effort discounting. Effort discounting would occur if individuals choose a low-effort alternative (fewer words) when the quality is low (e.g., less interesting), but a higher-effort alternative (e.g., more words) when the alternative is high quality (e.g., more interesting).

This study had two purposes. The first was to assess whether a discounting effect could be produced with choice between combinations of effort (number of words to read) and ratings of funniness (low, medium or high) of jokes. Thus, would participants select a longer, funnier joke when the number of words is low, but a shorter, less funny joke when the number of words is high? A second purpose of the study was to test two methods of presenting the choices. One method exposed the decision maker to a visual comparison of the jokes and the other method involved a verbal comparison

(i.e, "Would you like to read a 25-word, low rated joke or a 50-word, high-rated joke?"). Visitors choose to read exhibit labels based on a visual inspection of the perceived effort. There may be a difference when the perceived effort is presented verbally rather than visually.

Method

The study attempted to produce a discounting effect by giving participants a series of choices between a less funny, shorter joke and a funnier, longer joke. Jokes ranged from 25, 50, 100, and 200 words. Based on independent ratings, they were given ratings of high, medium, or low in terms of funny. Two procedures were compared. The first (visual condition) required participants to select between two jokes based on visual inspection of the jokes. The second condition (verbal condition) required participants to select a joke based on verbal description (e.g., "Would you like a 50-word joke rated low, or a 100-word joke rated high?"). For both conditions, the participant was required to read the joke after the selection. A total of 40 participants (20 in each condition) were recruited from psychology classes at Jacksonville State University.

Results

As indicated by Fig.3, the two conditions produced different results. The visual conditions produced a discounting-like effect (participants chose longer jokes 69% of the time when the comparison was between 25 and 50 words, but only 38% of the time when the comparison was between 100 and 200

	25-50 words	50-100 words	100-200 words
Visual presentation	69%	51%	38%
Verbal presentation	74%	72%	70%

Figure 3: Percent choosing jokes with more words

words. However, in the verbal condition, a high percentage of longer jokes were selected across all combinations of number of words.

Discussion

An apparent effort discounting outcome was found when the jokes were selected visually, but not when the choices were presented verbally. Since visitors select exhibit text based on visual inspection, it is likely that a discounting effect would occur with label reading in museums as well.

Originally a paper presented at the 2006 Visitor Studies Conference: General value theory - an umbrella for cost-benefit phenomena.

References

Bitgood, S. (2005). *General value theory: The cost-benefit ratio as a predictor of choice.* Jacksonville State University. Unpublished manuscript.

Bitgood, S., and S. Dukes. 2006. Not another step! Economy of movement and pedestrian choice point behavior in shopping malls. *Environment and Behavior 38* (3), 394-405.

Critchfield, T., & Kollins, S. (2001). Temporal discounting: Basic research and the analysis of socially important behavior. *Journal of Applied Behavior Analysis, 34:* 101-122.

Green, L., & Myerson, J. (2004). A discounting framework for choice with delayed and probabilistic rewards. *Psychological Bulletin, 130*(5), 769-792.

Pirolli, P. & Card, S. (1999). Information foraging. *Psychological Review, 106*(4), 643-675.

Rounds, J. (2004). Strategies for the curiosity-driven museum visitor. *Curator, 47*(4), 389-412.

Stephens, D., & Krebs, J. (1986). *Foraging theory.* Princeton: Princeton University Press.

Miles, R. (1989). Audiovisuals: A suitable case for treatment. In S. Bitgood, A. Benfield, & D. Patterson (eds.), *Visitor studies: Theory, research, and practice, Vol. 2.* Jacksonville, AL: Center for Social Design. Pp. 245-252.

16

Behavioral Economics and The Value Ratio in Visitor Studies

In the last few years, behavioral economic theories have become a common way to approach a number of psychological, economic, and biological problems in both humans and animals. This paper will examine three of the many possible approaches to behavior economics. These theories include temporal discounting (e.g. Critchfield & Kollins, 2001), optimal foraging theory (Stephens & Krebs, 1986; Pirelli & Card, 1999), and the matching law (Hernnstein, 1997). Although popular among psychologists and economists, we will not cover prospect theory (Kahneman, 2003), an approach somewhat more complicated and possibly less parsimonious. Behavioral economic approaches all share the concept of value as the major theoretical concept, and analyze behavior outcomes in terms of economic transactions influenced by costs and benefits.

As with any economic approach, behavioral economics examines behavior in terms of economic transactions. This includes exchanges of economic units for some cost in order to derive satisfaction/benefit from consumption of the economic unit. Consumption refers to the behavior involved in utilizing the economic units. Utility refers to the benefit or satisfaction derived from consuming the economic unit. Cost includes the price of the economic units or resources used in the exchange (e.g., money, time, effort). Value can be defined as utility divided by cost and measured by what commodities are chosen.

In the case of exhibition centers such as museums, parks, and zoos, the economic unit is viewing/experiencing exhibits

and educational programs. Viewing exhibits (consumption) creates satisfaction (utility) at a cost (entrance fee, time of viewing exhibits, mental and physical effort). Utility can be increased in at least two ways: (1) by selecting high interest exhibit content; and/or (2) by designing exhibit elements that stimulate curiosity. In both cases, evaluation data is essential. Front-end evaluation is an effective way to identify high interest exhibit content. Formative evaluation is a way to develop content that is effective in stimulating curiosity. Costs can be reduced by minimizing the time and effort it takes to "consume" exhibit elements. Exhibit organization or layout that makes sense to visitors is one way to minimize cost. Providing short rather than long blocks of text in labels, using bulleted information rather than paragraphs, providing diagrams with conceptual maps are a few ways to minimize costs (e.g., Bitgood, 2000; Screven, 1992).

This paper provides a brief overview of three approaches to behavioral economic theory. It will also describe how behavioral economics has been and can be applied to visitor choice behavior in interpretive centers. Applied to visitors, behavior economic models take into account the cost associated with visitor behavior (time and effort) as well as the benefits of the visitor experience (satisfying curiosity). Versions of this approach have been suggested by Rounds (2004) and Bitgood, Dukes, & Abby (2007).

An overview of selected behavior economic theories
An introduction to behavioral economic theories include how

Theory	Utility	Cost
Temporal discounting	Magnitude of reward	Time
Probability discounting	Probability of reward	Proportion of events that receive reward
Optimal foraging (Information foraging)	Energy gain Acquisition of information	Search & handle time
Consumption-effort hypothesis	Quality of product	Effort State of energy level
Attention-value model	Benefits, reward, satisfaction	Time Effort Other resources (money)

Figure 1: Value, utility and cost.

these theories differ from classical economics, the range of behaviors that have been examined by these theories, and some brief descriptions of the techniques used to develop such models. These models have been expressed mathematically and typically use curve-fitting techniques to increase the predictive validity of the model. Each of the theories has been modified by adding parameters to the predictive formula and some have argued that the all three theories can be reduced to the same mathematical formula. The theories examined here can be expressed by the following formula: value = utility/costs. Fig. 1 summarizes various approaches in terms of what variables are involved with utility and costs.

Temporal and probabilistic discounting

Temporal discounting theory (from economics and psychology) assumes that the value of a choice decreases with increasing "cost" – the cost being the delay of experiencing a

reward. In research studies, temporal discounting is typically studied by offering participants a series of choices between a smaller, more immediate reward and a larger, more delayed reward. For example, the participant may be given a choice between $100 today or $200 a year from now. The delay between now and next year decreases or "discounts" the value of $200. Increased delay is a "cost" that decreases value. By sampling a range of delays and amounts of money, it is possible to map out where people shift from choosing a smaller, sooner reward to a larger, later one. Temporal discounting has been used to explain a number of psychological and economic problems (Critchfield & Kollins, 2001; Frederick, Loenstein, & Donaghue, 2001; Green & Myerson, 2004). Probabilistic discounting is similar except that it examines the probability of a reward outcome instead of delay.

"Value" defined as a benefit/cost ratio with delay as a cost is not an uncommon notion. For example, Whittman and Paulus (2007) describe an explanation for temporal discounting in these terms. They argue that impulsive individuals experience time differently (with a higher cost). Such people overestimate the duration of time intervals and therefore discount the value of rewards more than others.

This type of decision making may explain why visitors become more selective (i.e., view a smaller percentage of exhibit displays) when there are a larger number of choices/ exhibits to view. We used the data from one of Melton's (1935) classic studies to illustrate how temporal discounting can be applied to visitors (Bitgood, McKerchar, & Dukes, 2008).

Melton varied the number of paintings in a gallery from 6 to 36 over successive phases of his study. As the number of paintings increased, the average percentage of visitors stopping at each painting decreased. We believe that this is evidence for a type of discounting. As the number of alternatives to view increases, visitors can be more choosy and pick those with the highest interest value. The value of viewing any particular artwork is therefore discounted.

Optimal foraging

Optimal foraging theory has been applied to animals and humans (Stephens & Krebs, 1986). For predator selecting a prey, the value of a choice is assumed to be a function of energy gained/search and handling time. Predators do not always consider their favorite prey in terms of energy obtained (benefits) because of the cost (search and handling time). Pirelli & Card (1999) have extended the foraging model to searching for information on the internet. More recently, Rounds (2004) has suggested an application to visitors. Rounds model is discussed and critiqued below. In biology, optimal foraging theory predicts that the value of a choice (e.g., selection of a prey by a predator is determined by the ratio of benefit derived from the choice divided by the search and handling time to "consume" the selected alternative. Foraging has also been applied to information searches by humans (Pirelli & Card, 1999).

In a thought-provoking article in *Curator*, Rounds (2004) has applied foraging theory to museum visitors. Rounds argues that the curiosity-driven visitor chooses to focus attention on one

exhibit element or another based on potential value determined by interest level as well as the time and effort required to search and experience the exhibit component. Rounds' rules for search, attention, and quitting include the following.

Search Rules (guidelines for scanning exhibit elements):

1. Assume that the interest landscape is rugged. "The visitor's initial search strategy should be based on scanning widely throughout the museum, rather than focusing the search only in one area." (Rounds, 2004; p 402)

2. Get moving. Don't use up valuable time planning; start with the nearest exhibit that has potential and get on with the search for content that satisfies curiosity.

3. Scan exhibits, not exhibitions. Don't make a commitment to each exhibit element; maximize the chance of finding as many potentially-interesting elements as possible.

4. Follow the crowd to water, but be slow to drink. Look for exhibit elements where other visitors appear to be engaged, but apply the attention rules before engaging.

Attention Rules (rules that indicate when to stop searching):

1. Follow your nose. Foraging theory has introduced the concept of "scent." Text panels with too many words, difficult jargon, etc. give a negative scent and should be avoided.

2. Don't make large down payments. Don't invest a large amount to time to try to understand what the exhibit is all about. If you can't figure it out quickly, move on to something with more potential.

3. Satisfied. Simon (1976) suggested that decision making cannot be perfect. Stop searching when you find something that meets your basic criterion rather than looking for something that is perfect. "Satisfied" suggests a satisfactory target rather than the best target.

Quitting Rules (rules that specify when to stop attending to an exhibit element):

1. Cut your losses. Give up on an exhibit element that does not show immediate promise.
2. Three strikes, you're out. Quit the exhibition hall or gallery if you encounter several exhibits in a row that do not satisfy curiosity.
3. Stop eating when your appetite is satisfied. When interest from a particular exhibit element is satisfied, move on.
4. Don't stay for leftovers. "... quit when new selections prove to have less interest value than the average value you have received for elements up to that point." (p.406)

Rounds approach is contemporary and unique compared to other approaches. Optimal foraging theory has become a significant approach in biology, psychology, and information science and has intriguing potential relevance to museum visitors. It is the first approach to visitor attention that is based on a decision-making model.

The major weakness of his model may be the difficulty required to test the validity of the search, attention, and quitting rules. At first glance, one might think that simple self-

report data would allow us to assess when his decision rules (search, attention, and quitting) are being applied. However, he has noted that the decision-making process involved is not necessarily a conscious process. Obviously, animal predators are unlikely to apply conscious reason to their predatory efforts, yet the model applies well to animals . Since Rounds offered no data to support his model, the question remains how useful it will be.

The matching law

The matching law suggests that choice behavior matches its outcome/benefits (Hernnstein, 2000). This simple statement has important mathematical implications that lead to accurate predictions of behavior. This theory has been applied to many types of behavior including the probability of shooting two- and three-point shots in basketball and running or passing in football. We applied the matching paradigm to some of our data asking questions such as: "How accurately will variables such as interest rating (perceived benefit) and cost (number of words to read on a label) predict reading behavior?" In simulated museum studies, we have found that a ratio of benefits/costs (interest ratings/number of words per text) was a better predictor that either interest rating or number of words by themselves. Interest rating was the least predictive of how much was read. See Figs. 2-4 for examples.

Fig.2 shows how well the number of words in a passage matches choices in the simulation study. If the matching was perfect, every dot should fall on the long diagonal line. As can

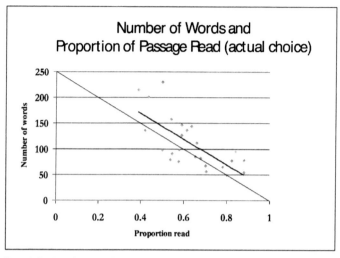

Figure 2: Number of words and proportion of passage read.

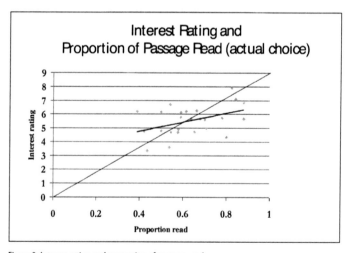

Figure 3: Interest rating and proportion of passage read.

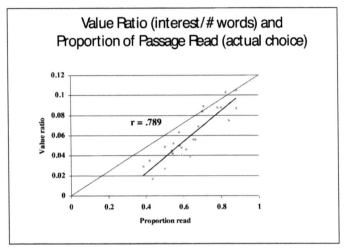

Figure 4: Value ratio and proportion of passage read.

be seen, the actual choice overmatches slightly (the trend line for the actual data is above the line for the perfect match.

Fig.3 examines how well interest ratings match the proportion of text passages read. The matching graph suggests a weak relationship between choice and interest.

Fig.4 plots the value ratio (interest rating divided by number of words in the passage) as a function of proportion of the passage read. The relationship is very high ($r = .789$), stronger than either workload (number of words) or interest rating by itself.

References

Bitgood, S. (2008). *Applying behavioral economics to museum visitors.* Presented at the Annual Visitor Studies Conference, Houston, TX.

Bitgood, S., Dukes, S., & Abby, L. (2007). *Interest and effort as predictors of reading: A test of the general value principle.* Current trends in audience research and evaluation. Vol. 19/20. AAM Committee on Audience Research and Evaluation. Boston, MA. Pp. 5-10.

Bitgood, S., New, B., & White, K. (2007). *Mindfulness and the value ratio: Predicting the reading of text passages.* Presented at the 2007 Visitor Studies Conference, Ottawa, Ontario.

Critchfield, T., & Kollins, S. (2001). Temporal discounting: Basic research and the analysis of socially important behavior. *Journal of Applied Behavior Analysis,* 34(1), 101-122.

Frederick, Loewenstein, & Donoghue (2001). Journal of Economic Literature, 40, 351-401.

Hernnstein (2000). *The matching law: Papers in psychology and economics.* Cambridge, MA: Harvard University Press.

Kahneman, (2003). A perspective on judgment and choice: Mapping bounded rationality. *American Psychologist,* 58(9) 697-720.

Pirelli, P., & Card, S. (1999). Information foraging. *Psychological Review,* 106(4), 643-675.

Rounds, J. (2004). Strategies for the curiosity-driven museum visitor. *Curator,* 47(4), 389-410.

Stephens, D., & Krebs, J. (1986). *Foraging theory.* Princeton, NJ: Princeton University Press.

17

A Parametric Study of
Text Passage Length,
Size of Font, and
Proximity of Text to Pathway

DONALD THOMPSON & STEPHEN BITGOOD

The following paper is an updated version of *The effects of sign length, letter size, and proximity on readings* in S. Bitgood, J. Roper, Jr., & A. Benefield (eds.) *Visitor studies – 1988: Theory, research, and Practice.* Jacksonville, AL: Center for Social Design. Pp. 101-119.

Update: This study came from Don Thompson's master's thesis in 1987. Some wording of the original paper has been changed and graphs introduced to make the linear relationship between text passage length and attracting and holding power a little clearer. This study was one of many that supports the attention-value model (Bitgood, 2010). Text passage length and proximity to visitor pathway both involve a cost in time and effort. Since the value ratio (utility/cost) is inversely related to cost, and since capturing and engaging attention is assumed to be influenced by the value ratio, this study is a good test of some aspects of the attention-value model. Font size may influence both attention capture (ease of detectability) and value (ease of reading the font).

Educators from informal learning institutions have argued that the effectiveness of exhibit signs and labels greatly influences the success of the educational role of the facility (e.g., Fruitman & DuBro, 1979; Loomis, 1983; Mosca, 1982; Rabb, 1975; Serrell, 1979; Wilson & Medina, 1972). The task of designing effective signs is made difficult, however: (a) by the large number of factors (content, length, size, placement, use

of illustrations, etc.) which interact to determine whether or not signs are read and understood, (b) by the lack of carefully gathered empirical data concerning the effect of these factors, and (c) by an attitude, common among label designers, that they know how to do their job regardless of the lack of empirical guidelines.

A few studies have experimentally manipulated the variables that are likely to control visitor reading of interpretive signs and labels. For example, Bitgood, Nichols, Pierce, Conroy, and Patterson (1986) showed that the number of words per label, the size of the type, and the position of the label in relation to other exhibit objects determined the percentage of visitors who read exhibit labels in a museum. In that study the total number of words presented was held constant, while the number of labels on which they were displayed was varied.

In another study, Borun and Miller (1980) varied the length of labels by presenting from one to five topics in each label. Labels with three, four, or five topics produced less learning in terms of test score gains than labels with one or two topics. In addition, as the number of topics was increased, the percentage of visitors reading the whole label decreased. Visitors tended not to read long labels, even though they expressed a preference for labels longer than those actually read.

As the above studies by Bitgood et al (1986) and Borun and Miller (1980) indicate, label length has been studied and it has been generally found that short signs are more frequently read than longer ones. However, the literature lacks parametric

studies which attempt to map out visitor reactions across more than two points on the dimension of label length. The current study attempted to provide this type of parametric analysis.

The current study examined three variables: (a) text passage length, (b) font size, and (c) proximity of the text passage to the visitor. The number of words was varied from 30 to 240 in geometric increments (i.e., 30, 60,120, and 240), and three values of type size (18-, 36-, and 48-point) were studied. Finally, the labels were positioned either on-path or off-path with respect to the visitors' usual circulation path through the exhibit area.

Method

Subjects: Subjects for this study were 5822 visitor groups which passed through The Predators building of the Birmingham Zoo between August and December of 1987. Each group contained at least one individual appearing to be 13 years of age or older.

Procedure: All research was carried out in the entrance area of The Predators building in the Birmingham Zoo. The back wall of this room is covered with large pictures of predatory animals, and the wall to the left upon entering is entirely of glass, behind which visitors can observe leopards in a naturalistic setting. In this study, text passages were displayed in this area on an easel, and visitors were unobtrusively observed to determine their reaction to them.

The text passages, designed to serve as a general introduction to the facility, contained a composite of information about predatory animals which could be found at

exhibits throughout the building. Since the text passages were selected in 30, 60, 120, and 240 word lengths, 8 short (30 words) blocks of text were developed, each describing something different about predators. These blocks were simply added to, or deleted from, the background as needed. Longer passages presented a greater number of topics than did short ones, and not just more words. All passages were of black text on a white background, and the background size of these signs was maintained at 24 by 30 inches. Observations were conducted primarily on Saturdays and Sundays, since it was on these days that the traffic flow was moderately steady.

Data were collected under three conditions.

Length of text passage: Study 1 examined the effects of signs of varying length: 30, 60, 120, and 240 words. These passages were presented for periods of one-half hour each, on a consistently rotated basis, varying the order of presentation each day. These passages, all in 36-point type (3/8 inch letter height) were placed 10 feet inside the entrance to The Predators Building, directly in the path of visitors. Visitor reaction was unobtrusively noted and recorded as to whether a chosen individual (for example, the first adult in each group through the door) from each group of visitors read the text, and the length of time spent reading by those who did stop. In order to be counted as reading, the individual must have been stopped directly in front of the sign, faced toward and remaining visually fixed on it. In all, 1850 groups of visitors were observed in this manner in Study 1.

Font size: Study 2 involved the use of similar methods to

determine visitor reaction to signs in a combination of type sizes and total lengths. Signs in 18-point (3/16 inch), 36-point (3/8 inch), and 48-point (1/2 inch) type sizes, and variations of 60 and 120 words, were presented. Again, half hour rotations were maintained, and signs remained 10 feet inside the door. For this phase, however, data were collected differently in that any group member's reading incidence was recorded, rather than solely that of a chosen individual. This change in procedure attempted to include many of the visitors who read the signs, but were not the first adult who entered the building. A total of 3060 groups were observed in Study 2.

Proximity of text passage to visitor pathway: Since it was hypothesized that the amount of effort required of those visitors who wished to read text might have a moderating effect on the importance of the previously studied factors, Study 3 concentrated on differences in length of passages and size of type, as influenced by placement of the text passages 20 feet from the entrance of the facility (approximately 10 feet from traffic flow). Sixty-word passages in 18-point and 48-point type were alternated in the off-path location, as were signs of 60 and 120 words in 36-point. Data were collected on 912 groups in a manner identical to the first two studies.

Analytic procedures

For each of the interpretive text passages which was displayed, the percentage of visitors passing by at that time who stopped and read (attracting power) was determined. The statistical significance of this attracting power was determined with Chi-

Number of words				
	30	60	120	240
Percent of visitors stopping	15.15	14.88	11.33	9.73
Read time (sec) per word – visitors	.19	.17	.14	.11
Read time (sec) per word – control	.24	.23	.23	.24

Figure 1: Visitor reading and number of words.

Square analysis. Also of interest was the length of time spent by those who did stop to read (holding power). However, rather than simply comparing average reading durations, these were divided by the number of words in each sign, resulting in a time-per-word figure. Time per word is assumed to control for the differences in the number of words per text passage. Time-per-word was analyzed with Analysis of Variance (ANOVA). The significance level, $p < .05$, was used in all cases. Results were calculated with the StatView 512+ (BrainPower, 1986) computer program on a Macintosh computer.

Text passage length and attention

Attracting power: As shown by Fig. 1, there was a consistent, linear decrease in attracting power of the text passages as the number of words increased. Passages of 30 words resulted in 15.15% readers; 60-word signs had 14.88% readers; 120-word signs, 11.33%; and 240-word signs, 9.73%. Despite this systematic reduction in visitor stopping as the number of words increased, Chi-Square analysis found no significant difference among the attracting powers of the signs containing

30, 60, 120, and 240 words.

Holding power: Reading time can be examined in at least two different ways: (a) mean reading time, and (b) reading time-per-word. Mean reading times for the four conditions in Study 1 were 5.62 seconds at 30 words, 10.01 at 60 words, 16.18 seconds for 120 words, and 26.25 seconds for 240-word signs. In order to control for the total number of words, the average total reading time was divided by number of words in the passage. Figure 2 shows the linear decrease in read time as the length of the passage increases. The control condition, on the other hand shows no decrement. The 30-word passages received an average of .19 seconds of reading for each word, the 60-word signs received .17 seconds-per-word, the 120-word sign, .14 seconds-per-word, and the 240-word sign, .11 seconds-per-word. ANOVA of time-per-word found the progressive loss of reading time per word accompanying the increase in text passage length to be significant [F= 6.89; df= 3, 219; p<_.05].

Discussion

Consistent with predictions derived from the literature, overall text passage length was found to influence visitor reading. However, contrary to a number of studies (Robinson, 1930; Hodges, 1978; Serrell, 1981; Bitgood, Nichols, Pierce, Patterson, & Conroy, 1986; Bitgood, Patterson, Benefield, & Thompson, 1987) there was no statistically significant effect in terms of attracting power despite the fact that the percentage of visitors decreased from 15.15 in the 30-word condition to 9.73 in the 240-word condition. Statistically, the major effect of number

of words in this study was on the reading time per word. The greater the number of words on the sign, the less reading time per word. It appears that visitors read a smaller and smaller proportion of the label as the number of words increase.

There are several possible reasons why the attracting power results did not achieve statistical significance. Studies by Robinson (1930), Hodges (1978), and Serrell (1981) appear to have confounded their findings by manipulating more than one label factor simultaneously. These studies may have obtained a larger effect because of the contributions of other variables in addition to number of words per label. The study by Bitgood, Nichols, Pierce, Patterson, & Conroy (1986) did not actually reduce the number of words presented, but merely divided large signs into three smaller ones. They therefore assessed visitor reaction to the presentation of label information in smaller "chunks," rather than to labels containing fewer words and less information. It is possible that label reading is determined to a large extent by the surrounding context (i.e., the number and spacing of other visual stimuli) rather than by the number of words alone. Whether this methodological difference actually influences visitor reading is not known and will require further study. Another possible contributor to the smaller-than-expected effects with number of words may be the placement of the signs with respect to exhibit objects/animals. The Egyptian mummy exhibit at the Anniston Museum, used by Bitgood, et al (1986), in their label study, is encountered by the visitor near the end of his/her tour through the facility, rather than at the entrance as was the case in the

current study. It is possible that visitors are impatient to see exhibits when they enter a building and do not take time to read interpretive material until after they encounter the exhibits they came to see. In addition, the predator signs in the current study were competing with live animals, while the mummy signs were competing with inert mummy cases.

The decrease in reading time per word found in the current study was attributed to visitors reading a smaller and smaller proportion of the label as the number of words increased. However, since there may be a "warm up" time required of readers of all passages, it is possible that longer signs show a progressive decrease in time-per-word as the visitor warms up during reading. To rule out this possibility, we collected data that contradicts a possible "warm-up" effect. In a sample of individuals (control group) who were asked to read every word of various length text passages at a normal rate, there was a very consistent multiplicative increase of reading time as the length of the passage increased. As a result, the mean time-per-word of these test subjects was nearly identical, with a range of .23 to .24 seconds-per-word for passages of from 30 to 240 words. To illustrate this, Fig.1 presents a comparison of control subject reading time vs. zoo visitor reading time. These results strongly suggest that readers of longer passages are, in fact, reading less of the sign.

This consistent and significant deterioration in seconds spent for each word in the text passage has definite implications for the ability of interpretive labels to educate. While a great deal more research is needed in the area, this finding suggests

	Size of type		
	18pt	36pt	48pt
Percent of visitors stopping:			
60 word condition	30.79	30.72	34.04
120 word con dition	17.11	23.39	24.23
Read time (sec) per word:			
60 word condition	.13	.13	.15
120 word condition	.11	.14	.12

Figure 2: Size of type and number of words.

that increasing the amount of material included in a text material may actually result in a smaller percentage of it being read (and consequently a smaller percentage of the material being learned). Borun and Miller (1980) demonstrated that visitors learned less when four or five topics were included on the label than when only one or two topics were present.

Size of font

Fig. 2 summarizes the results of Study 2. The percent of visitors stopping (attracting power) and the reading time per word (holding power) are listed for the three type sizes.

Attracting power: There were statistically significant differences in attracting power for both number of words and type size. A higher percentage of visitors read the 60-word passages (31.91) than read the 120-word passages (22.55)[$X2 = 36.34$, $p < .001$]. For the 120-word condition, there was also an increase in the percentage of readers as the size of type increased ($X2 = 6.36$, $p < .05$).

Holding power: ANOVA of reading times found no

significant differences between the holding powers of the various passages of varying font size.

Discussion

The major finding in Study 2 was the effects of type size: there was an increase in reading by visitors as the type size increased, particularly in the 120-word condition. Although this effect was statistically significant, it did not approach the magnitude of difference that was observed in the study by Bitgood et al (1986) in which an increase in type size increased the percentage of readers by 15 percent. The less-than-ideal conditions of this study (e.g., placement of signs so that they competed with live animals) may be responsible for the difference in findings. Study 2 also found a significant difference between the 60- and 120-word conditions. As expected, more visitors read the shorter passages. The percentage of readers were higher than in Study 1 because of a change in the recording procedure. During the first study only the first member of a group to enter the exhibit building was chosen for recording. This method of recording missed a considerable number of readers. In Study 2 any member of a group who read was monitored.

Proximity of text passages to visitor pathway

Study 3 assessed the result of displaying text passages of different type size in the off-path condition. As in the previous studies, no significant differences in either attracting or holding could be attributed to changes in type size.

Attracting power: Similar to the results of Study Two,

	Size of type		
	18pt	36pt	48pt
Percent of visitors stopping:			
60 word condition	19.78	20.49	25.09
120 word condition	—	16.42	—
Read time (sec) per word:			
60 word con dition	.18	.18	.14.
120 word con dition	—	.13	—

Figure 3: Font size and attention to labels (off-path).

passages of 120 words brought a decrease in the percentage of visitors who stopped, compared with those of 60-word length. This reduction in attracted readers, however, was found not to be statistically significant by Chi-Square analysis at p<_.05.

Holding power: ANOVA of time-per-word figures found that the shorter reading times which accompanied longer signs in 36-point type size (.18 seconds per word at 60 words, and .13 seconds per word at 120 words) to be large, but not significant at p<_.05.

As noted in Study 2, it was hypothesized that text passages located on-path were being read by visitors, regardless of manipulation, because they could be seen easily in any condition, and little effort was required of those who wished to read. If this was the case, then it seemed likely that factors such as type size could play an important role in the effectiveness of passages placed some distance from traffic. This issue of a sign's ability to attract readers, regardless of the extra effort required, can be conceptualized as its "drawing power," while its ability to attract readers when it is placed in traffic is an indication of "stopping power." To test these ideas, signs were

placed off-path in Study Three, to see whether differences attributable to changes in type size or sign length would become more prominent. However, consistent, but less than significant, differences were found only in attracting and holding between passages of 60 and 120 words. While there also appears to be a deleterious effect of increasing word length, the lack of significant effect due to type size is puzzling, especially since it was presumed that type size would become a factor as signs were placed farther from visitor traffic.

Proximity to visitor pathway and text passage length

Comparisons were made between results obtained in Studies Two and Three in order to determine the effects of placing signs away from the usual visitor circulation path. The following results were found:

- On-path signs received more visitor stops than off-path signs for all text passage comparisons.
- 60-word signs produced a higher percent of stops than 120-word signs.
- 60-word signs in 18-point type attracted 30.79% on-path, and 19.78% off-path. 60-word signs of 36-point type brought 30.72% readership on-path, and 20.49% off-path; while 60-word signs of 48-point type received 34.04% readers on-, and 25.09% readers off-path.
- The text passage of 120-word length showed 23.39% attracting on-path, decreasing to 16.42% off-path. (Fig.4 offers a comparison of on-path vs. off-path attracting power of passages containing 60 words).

	Size of type		
	18pt	36pt	48pt
Percent of visitors stopping: On-path condition Off-path condition	30.79 19.78	30.72 20.49	34.04 25.09
Read time (sec) per word: On-path condition Off-path condition	.13 .18	.13 .18	.15. .14

Figure 4: Comparison of on-path and off-path (60-word).

Chi-Square analysis showed the loss of attracting power which accompanied off-path placement to be statistically significant for 60-word signs [$p_<.05$]. For 120-word signs, however, the difference in on-path and off-path attracting power approached, but did not attain significance.

ANOVA of time-per-word figures between the two positions showed that there was a significant overall increase for text passages in the off-path position [$F= .0013; df= 2, 699; p<_.05$]. There was also a significant interaction between position and type size [$F= 3.798; df= 2, 699; p5.05$]. The interaction between position and type size for 60-word signs can be seen in Figure 5, as time-per-word for on-path text passages increases slightly as type size is increased. Time-per-word for off-path text passages, however, can be seen to display an inverse relationship with type size, decreasing as the size is increased from 36- to 48-point.

Obviously, the proximity of a sign to normal traffic flow influences the way in which visitors react to it, since the attracting power of most signs drops significantly when they

are placed ten feet from traffic. Two possible reasons for the lower attracting power of off-path signs are: (a) visitors didn't notice signs placed farther from their usual circulation path, or (b) visitors weren't willing to make the effort to read signs requiring them to go out of their way. In addition, for 18-point and 36-point type, those visitors who were willing to make the effort to read the off-path signs were likely to read more than visitors who read the 48-point type. One can only speculate on why this result was obtained. It may be that the criteria used to consider a visitor as reading were responsible for this apparent inconsistency. Since a person was required to be stopped in front of a text passage to be counted as a reader, he or she may have actually been able to begin reading off-path signs of 48-point type while still approaching, resulting in shorter recorded reading times. Various other criteria of "reading" may need to be tried in order to determine whether or not this is the case.

Conclusions

The parametric study of text passage length, font size, and proximity of text passages to the visitor pathway obtained results consistent with the attention-value model, although the magnitude of effects were somewhat disappointing. Nevertheless, the model predicts that increasing cost (text length and distance from visitor pathway), will result in lower value and less reading of text. Size of font might influence either cost (more difficult to read) or detectability or salience of the text.

References

Bitgood, S., Nichols, G., Pierce, M., Conroy, P., & Patterson, D. (1986). *Effects of label characteristics on visitor behavior.* Technical Report No.86-55. Jacksonville, AL: Psychology Institute, Jacksonville State University.

Bitgood, S., Patterson, D., Benefield, A., & Thompson, D. (1987). *The exhibition of poster presentations: A demonstration of some controlling variables.* Technical Report No. 87-50. Jacksonville, AL: Psychology Institute, Jacksonville State University.

Borun, M. & Miller, M. (1980). *What's in a name? A study the effectiveness of explanatory labels in a science museum.* Philadelphia: Franklin Institute.

BrainPower, Inc. (1986). StatView 512+. Calabasas, CA.

Fruitman, M.P., & DuBro, L.S. (1979). Writing effective labels. *Museum News,* Jan/Feb, 57-61.

Hodges, S. (1978). *An ecological approach to the study of zoo visitor behavior: Implications for environmental management and design.* Unpublished doctoral dissertation, Virginia Polytechnic Institute and State University, Blacksburg.

Irwin, J.W. & Davis, C.A. (1980) Assessing readability: The checklist approach. *Journal of Reading,* 24(2),124-128.

Loomis, R.J. (1983). *Four evaluation suggestions to improve the effectiveness of museum label.* Technical Leaflet No. 4, Austin: Texas Historical Commission.

Mosca, C.A. (1982). Role of graphics in zoos and aquariums. *Proceedings of the 1982 American Association of Zoological Parks and Aquariums Annual Conference,* (pp. 318-323).

Rabb, G.B. (1975). Signs - essential link to the public. *Proceedings of the 1975 American Association of Zoological Parks and Aquariums Annual Conference*, (pp. 140-143).

Robinson, E.S. (1930). Psychological problems of the science museum. *Museum News*, (5), 9-11.

Sewell, B. (1979). A plan for writing interpretive signs. *Curator*, 22(4), 299-302.

Sewell, B. (1981). Zoo label study at Brookfield Zoo. *International Zoo Yearbook*, 21, 54-61.

Wilson, D.W., & Medina, D. (1972). *Exhibit labels: A consideration of content*. Nashville, TN: American Association for State and Local History.

ORIENTATION
& CIRCULATION

18

Visitor Orientation and Circulation:
An Introduction and Update

The need for effective orientation and circulation systems in exhibition centers is often either misunderstood or ignored by architects, designers, and museum staff. Poorly designed systems lead to confusion, frustration, and/or fatigue for visitors. From the museum perspective, poorly designed systems represent missed opportunities to engage visitors with programs and exhibitions as well as wasted time giving visitors directions. A well-designed system, on the other hand, can reduce the physical and mental cost or effort of navigating through a museum and it allows visitors to concentrate on what the museum has to offer rather than wondering where to go next.

What are orientation and circulation?
Orientation is awareness of what's in the environment, what to see and do, how to organize the visit, where you are at any moment, how to find your way around, and where to find specific destinations. It includes two types: conceptual and physical.

Conceptual orientation: includes the main ideas to be found in the exhibit/exhibition /museum; what there is to see and do; and information about the organization of the space. Conceptual orientation information is important because it helps visitors plan their visit, organize their thoughts about their visit, and it gives meaning to the experience by helping communicate the main ideas of the museum, exhibition, and/ or exhibit.

Wayfinding (physical orientation): the ability of an individual

to navigate through a facility. It requires information that allows visitors to independently find their way through the facility, to locate rest rooms and other amenities, to find their way back to the parking lot and their vehicle when leaving.

Circulation: how people move through public spaces. This includes both the direction of movement and the pace or speed of movement. Obviously, goal searching is an important factor in circulation. Museum visitors search to view high value objects and events. In some cases, they may be searching for a specific exhibition, but either way, they look for experiences that are satisfying and beneficial with a minimum of cost in terms of time, effort, entrance fees, etc.

The conceptual framework

It is important to make clear our perspective in contrast to others. First, we argue that orientation and circulation must be considered together since they are intimately tied in any scheme of navigation through an environment. Second, we take an empirical, data-driven approach offering strong evidence that behaviors associated with orientation and circulation are not random, nor are they based exclusively or even heavily on one set of factors (visitor, setting, or the interaction between the two). Finally, we argue that there is a definable set of guiding principles for orientation and circulation that, if followed, will improve achieving the museum's goals as well as the visitor experience.

As with any topic dealing with visitor studies, orientation and circulation can be approached from one of three different

perspectives: visitor, setting, or interaction (e.g., Bitgood, 2006; Shettel, 2005). The visitor perspective places the heaviest burden on what visitors bring with them into the museum. Such variables as visitor agendas, pre-knowledge and skills, and interests are considered the most noteworthy factors to examine at the expense of how the setting and the visitor-setting interaction contribute to what visitors do, think, and feel. A setting perspective places heavy emphasis on the characteristics of the environment while minimizing the possible influence of visitor factors. Finally, an interaction perspective distributes causal explanation to all three factors – visitors, setting, and the interaction between visitors and setting. Many of those in the field of environmental psychology have taken the interaction perspective, emphasizing the behavior-environment relationship as a focus of study.

Visitor perspective

John Falk has championed the visitor approach in many of his publications. For example, Falk (1993) stated:

> A considerable body of research documents that visitors to museums rarely follow the exact sequence of exhibit elements intended by the developers ... Visitors will fulfil their own agendas, for example turning right (Melton, 1972; Porter, 1938) or leaving from the first available exit (Melton, 1972) rather than doing what the developers intended. (p. 117)

I take issue with several parts of Falk's statement. First consider the argument that turning right is part of a visitor

agenda. I suspect very few, if any, visitors go to a museum with the mantra, "I'm going to turn right whenever I come to an intersection." Further, turning right at intersections is not a consistent pattern when one examines the literature (Bitgood, 2006). In fact, visitors are likely to turn left if and when it requires the fewest number of steps. Supported by a considerable amount of data, I have argued that, when pedestrians in public places do turn right, it is usually because it involves the fewest steps through an intersection (Bitgood, 2006; Bitgood & Dukes, 2006; Bitgood, Davey, Huang, & Fung, 2011). Pathways involving the fewest number of steps are a characteristic of the setting and are certainly not independent of the psychological mechanisms involved with choice behavior at intersections.

Another problem with Falk's statement is that it presents a false dichotomy ("either-or" fallacy): either visitors follow their own agenda or they do what the developers intended. Agendas are rarely so specific that they dictate how visitors will turn at intersections. There is also evidence that visitor agendas change during the course of their visit (Briseno-Garzon, Anderson, & Anderson, 2007). Falk, Moussouri, & Coulson (1988) made clear that when they use the term, "agenda," they are talking about pre-visit agenda (what visitors bring to the museum). Briseno-Garzon, et al (2007) convincingly show that agendas change as a result of the visitors' ongoing experiences during a visit. If agendas do change as visitors interact with the environment, the argument for a strong visitor-centered approach is weakened.

"Leaving by the first available exit rather than doing what the developers intended" is another "either-or" fallacy. The interaction between the architecture (e.g., number of open doors) and the decision-making mechanism (exit at an open door) is obvious. As Melton (1935) discovered, closing the open door is all it takes to encourage visitors to circulate through a larger part of the gallery. Clearly, an intervention focused on the setting rather than on the visitor's pre-visit agenda makes sense in this case. If the visitors were determined to go through the door whether or not it was open, Melton would have found a very different result. Events in the environment influence what people do.

Setting perspective

The setting approach focuses primarily on the characteristics of the environment. I am reminded of Conway's (1968) article, "How to Exhibit a Bullfrog: A Bed-time Story for Zoo Men," as an example. The paper argued that any exhibit topic can be made interesting and attention-getting if effective exhibit design is employed. Conway may not have taken it to an extreme, but clearly there was heavy emphasis on the setting perspective in this article.

An architectural approach called space syntax (Hillier & Hanson, 1984) is another example of the setting approach. Hillier and Tzortzi (2006) state that "space syntax is a theory of space and a set of analytical, quantitative, and descriptive tools for analyzing the layout of space in buildings and cities." This approach assumes that spatial configuration

controls movement. Two methods are used: a graph-based examination of patterns of physical connections; and a geometric-based analysis of perceived spatial relations. Diagonal lines drawn in the spaces being analyzed represent potential lines of movement within that space. The vocabulary of space syntax includes a complicated collection of concepts such as: integration, axial lines, convex spaces, etc. Computer models are usually applied to compute such things as "degree of integration."

I should be cautious about the space syntax approach because I am not intimately familiar with the literature, nor have I spent enough time considering its strengths and weaknesses. It does appear that the computations used in space syntax are cumbersome and they do not take into account such factors as visitor motivation for moving through a public space. For example, the theory appears to say little about the role of value (utility/cost) in influencing movement.

Interaction approach

The interaction approach gives weight to visitor, setting, and interaction between the two factors. This approach recognizes that pre-visit agendas, psychological and physiological processes, interests, prior knowledge, and a host of other factors influence the visitor experience. Setting factors are also given their due credit for shaping the visitor experience. The interaction approach considers what the visitor comes to the museum with, how exhibit and architectural design factors influence visitors, and how visitor and setting factors work

together as an inseparable unit. The attention-value model is an example of an approach that recognizes the importance of visitor factors (perceived benefits, interest levels, etc.) and setting factors (time and effort required to extract meaningful information from the exhibition.

There are difficulties in taking a visitor or a setting perspective without considering how they interact. You are unlikely to find something if you're not looking for it. You may overlook important influences if you are exclusively focused on either the visitor or the setting. Unfortunately, the notion of "interaction" is often ignored or misunderstood.

An example of a popular myth: the right-turn bias

One of the dangers of not collecting enough data and not thinking clearly about the implications of research findings is that invalid conclusions may result. The myth of right turning at intersections is an example. The notion of a right-turning pattern at intersections seems to have arose from Melton's work, even though he did not find right turning in all of his studies. The evidence for and against a right-turning pattern was reviewed in my *Curator* article (Bitgood, 2006) and I will not repeat this review. However, we can summarize the evidence as follows:

- Pedestrians do not always turn right at intersections; but, in some cases there is a strong right-turn pattern (e.g., Bitgood, 2006; Melton, 1935).
- People tend to turn right or go straight ahead at intersections when they are walking on the right side

of a pathway (Bitgood & Dukes, 2006; Bitgood, Davey, Huang, & Fung, 2010; Spilkova & Hochel, 2009). If they know they wish to take a left, they move to the left side of the pathway.

Fig. 1 summarizes the intersection choice data from several studies. These data were taken in shopping malls from three countries: USA, China, and the Czech and Slovak Republics. While these studies did not take place in museums, we believe they illustrate general movement patterns in all public spaces. Each study contained in Fig. 1 was comprised of multiple samples with each containing a minimum of 100 pedestrians who were observed as they approached and moved through intersections. The observers recorded which choice pedestrians made (turn right or left or continue straight ahead) and which side the pedestrians were walking (right or left). In the Table, "efficient" choices involved fewer steps and included right side of path making a right turn (R-R), right side of the path continuing straight ahead (R-C, or right-center), walking on the left side and turning left (L-L), or walking on the left side and continuing straight ahead (L-C). "Non-efficient: choices include make a left turn from the right side of the path (R-L) and making a right turn from the left side of the path (L-R). As indicated by Fig. 1, the "non-efficient choices (R-L and L-R) were rarely made. Clearly, pedestrians make the movement choice at intersections that involve the fewest number of steps, even though the difference in number of steps is quite small in most cases. Walking on the right side of the pathway tended to

| Study | Sample | Choice at intersections | | Walk on... | |
		Efficient	Non-efficient	Right	Left
Bitgood & Dukes (2006)	1	97	3	88	12
	2	100	0	85	15
	3	95	6	91	14
	4	93	7	53	47
	5	98	2	54	49
Spilkova & Hochel (2009)	1 & 2	170	30	56	144
	3 & 4	130	70	133	67
	5 & 6	171	19	102	98
Bitgood, Davey, Huang, & Fung (2010) USA samples	1 & 2	190	12	126	76
	3 & 4	188	12	126	74
	5 & 6	177	23	141	59
Bitgood, et al (2010) Chinese samples	1	99	1	81	23
	2	90	12	57	45
	3	98	11	79	30
	4	98	4	72	30
	5	96	4	62	38

Figure 1: Walking patterns in shopping malls.

be a more common pattern than walking on the left side, but other factors such as destination and attractiveness of stores, etc. seemed to play a more powerful role than the tendency to walk on the right.

Papers on orientation and circulation in this section

The chapters in this section of the book combine data-oriented papers with general principles that derive from research. The progression in chapters is chronological and I believe the changes in our thinking about orientation and circulation can

be seen in this chronological presentation of writings. Of the many conclusions we could make based on the literature, a few should be noted:

1. Orientation and circulation is important to all museums, even the smaller ones (Bitgood & Patterson, 1987).

2. Redundancy and variety of orientation cues are, at the very least, helpful to visitors. Some visitors look for help in some places and not others, or they may miss important wayfinding information in one place and are able to use it in another.

3. Both visitor input (visitor evaluation) and the visitor studies literature can and should be used to assist in the design of an effective orientation-circulation system.

4. Visitor guides with a map of the facility should be a fundamental part of any orientation system.

5. The processes of attention (factors in capturing, focusing, and engaging attention) must be understood and applied in an effective orientation-circulation system.

6. The value ratio (utility or benefit divided by costs) is an important key to understanding the choices visitors make in where they go, what they see, and what they do during their visit. Orientation-circulation systems need to be designed with the value ratio in mind.

7. The location of orientation-circulation information is critical. It needs to be placed in locations where visitors are making choices, where visitors are attempting to understand what there is to see and do, and how to plan their visit.

8. While all locations are important, information provided in the entrance lobby is particularly important since it can have an impact on overall visitor satisfaction as well as how effectively people plan their visit.

References

Bitgood, S. (2006). An analysis of visitor circulation: Movement patterns and the general value principle. *Curator*, 49(4), 463-475.

Bitgood, S., & Dukes, S. (2006). Not another step! Economy of movement and pedestrian choice point behavior in shopping malls. *Environment & Behavior*, 38(4),

Bitgood, S., Davey, G., Huang, X., & Fung, H. (2010). Pedestrian choice behavior at shopping mall intersections in China and U.S. Submitted to *Environment & Behavior*.

Briseno-Garzon, A., Anderson, D., & Anderson, A. (2007). Entry and emergent agendas of adult visiting in aquarium in family groups. *Visitor Studies*, 10(1), 73-89.

Conway, W. (1968). How to exhibit a bullfrog: A bed-time story for zoo men. *Curator*, 2(4), 310-318.

Falk, J., (1993). Assessing the impact of exhibit arrangement on visitor behavior and learning. *Curator*, 36(2), 133-146.

Falk, J., Moussouri, T., & Coulson, D. (1998). The effect of visitor agendas on museum learning. *Curator*, 41(2), 107-119.

Hillier, B., & Hanson, J. (1984). *The social logic of space*. Cambridge: Cambridge University Press.

Hillier, B., & Tzortzi, K. (2006). Space syntax: The language of museum space. In S. Macdonald (ed.), *A companion to museum studies*. Malden, MA: Blackwell Publishing.

Melton, A. (1935). *Problems of installation in museums of art*. American Association of Museums Monograph New Series No. 14. Washington, DC: American Association of Museums.

Spilkova, J., & Hochel, M. (2009). Toward an economy of pedestrian movement in Czech and Slovak shopping malls. *Environment & Behavior*, 41(3), 443-455.

Shettel, H. (2005). Interacting with interactive. *Curator*, 48(2), 210-212.

19

Principles of Orientation and Circulation

STEPHEN BITGOOD & DON PATTERSON

Update: The following article represents our first attempt to formulate general principles of orientation and circulation. It was a good start, but was both incomplete and not entirely accurate from our present perspective. The evolution of our thinking about orientation and circulation should be apparent as the reader examines the papers that follow this one. For example, it was several years before we seriously questioned the "right-turn bias" notion.

Below are some tentative principles of visitor orientation and circulation. Some of these principles are based on results that have been replicated by several researchers. Others are tentative and need additional empirical confirmation.

Entering the environment

1. Advance organizers. Informing visitors what exhibits will be displayed before entering the exhibit area facilitates both conceptual and geographic orientation (e.g., Griggs, 1983; Screven, 1986). Screven (1986) describes three types of advance organizers: conceptual preorganizers (brief information about exhibits); topographic organizers (simplified maps); and overviews (what can be seen and done; what can be learned). In addition to their role in orientation and circulation, advance organizers can aid in visitor learning.

2. Redundant orientation cues. Providing multiple and variable orientation cues aids orientation. Several studies suggest that visitors use more than one cue when they

attempt to orient themselves in a new environment. In addition, there is no one device that is preferred by the vast majority of visitors. Some visitors prefer direction arrows; others, board maps; others, hand-held maps; and others, asking directions from staff.

Within the environment

Path turning at choice points

- *Right-turn bias*: In the absence of more powerful cues, visitors appear to have a tendency to turn right at choice points (Melton, 1933). However, other factors, such as the attracting power of an exhibit can easily alter this pattern (e.g., Yoshioka, 1943).

- *Proximity*: Visitors tend to turn in the direction of the closest visible exhibit (e.g., Yoshioka, 1943). This principle applies only if a more attractive exhibit is not visible in another direction.

- *Orientation devices*: Devices such as maps, arrows, and directional signs can exert considerable control over visitor behavior if they are effectively designed and placed. For example, "Entrance" and "Exit" signs were found to be more than 99 percent effective in one study (Bitgood, et. al, 1985).

- *Attracting power of exhibits*: Viewing an attractive exhibit in the distance can influence path turning behavior. In addition, knowing what exhibits are displayed in an exhibit area can increase or decrease visitors' tendency to travel a particular path.

Landmarks as orientation and circulation cues

- Location. Exhibits that are on the periphery of an exhibit hall or of the park grounds are less likely to be viewed than those in the center of a facility (e.g., Bitgood & Richardson, 1986).

- Distinctiveness. Landmarks or exhibits that are more distinctive in terms of size, shape, movement, color, etc. serve as better orientation cues than less distinctive landmarks.

Social influence

- Pressure to conform. People often conform their speed of walking to that of people around them (Preiser, 1973). When crowded, people also tend to be more organized (e.g., walk on the right side) in their movement patterns in order to minimize physical conflict with others.

- Friction. Larger crowds move more slowly than smaller crowds; or stated another way, people tend to walk faster in the absence of crowds (Preiser, 1973).

- Attracting and repelling power of crowds. Under some conditions a crowd will attract other people to an exhibit (Parsons & Loomis, 1973). Under other conditions, people tend to detour around crowds. It is not clear the precise conditions which give the crowd attracting or repelling qualities. Perhaps the size of the crowd is a factor. Also, it is likely that the perception of how rewarding the experience might be plays an

important role. This perceived reward notion would account for why people will wait in line for hours at places like Disneyland.

Other cues
- Floor texture. People walk slower on carpeting than on bare floors (Preiser, 1973).
- Background music. To some extent, people match their speed of walking to the pace of the background music (Preiser, 1973).
- Information overload. Clustering many orientation signs together decreases the effectiveness of orientation information (Pollet, 1976).

Exiting the environment
- Exit gradient. Objects located along the shortest route between the entrance and the exit receive the greatest amount of viewing (e.g., Melton, 1933).
- Exit attraction. Exits appear to exert a pulling force on visitors as evidenced by the tendency of visitors to leave by the first exit they encounter (e.g., Melton, 1933; Yoshioka, 1943).

Originally published in Visitor Behavior (1987) 1(4), 4-5.

References

Bitgood, et at (1985). Zoo Visitors: Can We Make Them Behave? *1985 AAZPA Proceedings*. Columbus, OH.

Bitgood &Richardson (1987). Wayfinding at the Birmingham Zoo. *Visitor Behavior.* 1(4), 9.

Griggs (1983). Orienting visitors within a Thematic Display. *International Journal of Museum Management and Curatorship*, 2, 119-134.

Melton (1933). Studies of Installation at the Pennsylvania Museum of Art. *Museum News*, 10(15), 5-8.

Parsons & Loomis (1973). *Visitor Traffic Patterns: Then and Now*. Smithsonian Institution.

Pollet (1976) *You Can Get There From Here*. Wilson Library Bulletin , 456-462.

Preiser (1973). *Analysis of Pedestrian Velocity and Stationary Behavior in a Shopping Mall*. Unpublished, Blacksburg, VA.

Screven (1986). Exhibitions and Information Centers: Some Principles and Approaches. *Curator*, 29(2), 109-137.

Yoshioka (1942). A Direction-orientation Study with Visitors at the New York World's Fair. *Journal of General Psychology*, 27, 3-33.

20

When is a Zoo Like a City?

Aquariums, museums, parks, and zoos can be thought of as geographic environments similar in many ways to entire cities. It may be useful to visualize your facility as analogous to a small city. Lynch (1960) divided cities into five key features: landmarks, paths, path intersections, districts, and boundaries. These features apply equally well to aquariums, museums, parks, or zoos, as they do to cities. In fact, an awareness of these five features can help improve visitor orientation and circulation through your facility. Each of these features as well as some of its implications are described below.

Features of an environment

Landmarks: Landmarks are objects easily visible from a distance. They are features such as prominent exhibits, buildings, something with a unique shape and/or size, etc. that can be used as a means of identifying one's location within the setting. When we give directions, we usually give landmarks as reference points (e.g., "Turn right at the monkey house, go straight until you reach the sea lion exhibit and then turn left"). Direction signs usually identify landmarks by telling the visitor which way to go to find particular exhibits. A good map will emphasize the most prominent landmarks, thus making it easier for visitors to find their way. Are you making the most of your facility's landmarks in the orientation devices used?

Pathways: Paths are any routes that can be followed. Paths are usually concrete walkways or corridors through exhibit halls. They are often marked off with ropes, chains, directional arrows, etc. to control the direction in which visitors travel.

If paths are not carefully delineated, visitors will often spontaneously determine them (e.g., walking across the grass to save time). As a general rule, visitors tend to take the shortest path unless there is something particularly attractive to lure them from this route or some obstacle to prevent them from taking the shortest path.

Intersections (nodes): These are major points of focus or places where paths cross. The most useful intersections from an orientation perspective are those that are clearly marked such as in the case of traffic squares or circles. Intersections often cause problems for visitors, particularly if it is not clear which direction to turn. Too many intersections may be confusing to visitors. It is wise to minimize the number of intersections in order to reduce visitor disorientation that often occurs.

Districts: Districts are medium-sized subsections of the setting that have a common characteristic. In zoos, a district is often a theme area (e.g., geographic area such as "African animals", or biological theme such as "small mammals"); in museums the district may be a museum wing or exhibit hall; in a park the district may encompass a picnic area or a swimming area. Clearly defined districts aid the visitor in both physical orientation (geographic location) and conceptual orientation (theme or subject identification).

Boundaries (edges): Boundaries are the edges or perimeters of the landmarks, districts, or the entire setting. They do not include paths. Clearly defined boundaries can aid in orientation. When visitors can clearly see when they pass a

boundary from one exhibit area to another, they are more likely to know where they are and how to find their way.

Conclusion

If you design your orientation devices (maps, direction signs, etc.) so that these five features are accentuated, visitors should find their way easier. The uses of landmarks in wayfinding is obvious. Less apparent is the importance of designing clearly marked paths that improve orientation rather than cause disorientation among visitors. Fewer intersections and well-defined districts and boundaries may also play an important role in visitor orientation. See other articles in this issue for more specific suggestions on how to use environmental features to aid visitor orientation.

Originally published in Visitor Behavior, (1987), 1(4),5.

Reference

Lynch, (1960). *The image of the city.* Cambridge, MA: MIT. Press.

Update: Lynch's terminology provides a useful vocabulary to describe important characteristics of an environment that must be navigated, explored, and used to extract something of value. Lynch's five features of an environment are now commonly used in the fields of environmental psychology, geography, and urban studies.

21

Orientation and Wayfinding in a Small Museum

STEPHEN BITGOOD & DON PATTERSON

A visitor orientation and circulation study was completed at the Anniston Museum of Natural History in Alabama. This museum is a moderately small (50,00 sq. ft.) facility with a simple circulation pattern. The visitor is confronted with only a few intersections (choice points for turning right or left).

Direct observation

A sample of 20 visitors were tracked through the museum and the circulation patterns carefully analyzed. In addition, turning behavior at the entrance of the Exhibit Hall was obtained for 150 visitors. The tracking data indicated that most visitors circulated in a similar pattern except in the bird exhibit area in which 35 percent did not circulate through. At the hall entrance over 80 percent turned left, as suggested by direction signs.

Conceptual orientation

Visitors were asked to classify each of 20 exhibits into one of seven museum theme areas. Only four exhibits (cave, snake, volcanic ash, Egyptian mummy) could be accurately classified into the correct theme area by 60 percent or more of the respondents. The average percentage accuracy for the remaining 16 exhibits was less than 40 percent correct. This result suggests that the conceptual themes of the museum were not clearly defined in the minds of the visitors.

Physical orientation

Pre-visit survey: The results of the survey before visitors entered

the exhibit hall are summarized below:

- Did you know the location of the exhibit hall when you entered the lobby? [20 percent said "Yes"]
- Could you locate the rest rooms after entering the lobby? [48 percent said "Yes"]
- Which method would best help you find your way around the museum?
 - Hand-held maps 20%
 - Wall maps 24%
 - Direction signs 40%
 - Information desk 12%
 - Exploring by self 16%
 - Guided tour 12%

Post-visit survey: Below are the results of the survey administered to a group of visitors after they exited the exhibit hall.

- Did you see any maps in the museum? [23 percent said "Yes"]
- Do you think you saw all of the exhibits? [91 percent said "Yes"]
- Did you have trouble finding any exhibits? [5 percent said "Yes"]
- Did you ask directions at the desk? [14 percent said "Yes"]
- Which method would best help you find your way around the museum?
 - Hand-held maps 18 %

- Wall maps 23 %
- Direction signs 27%
- Information desk 5 %
- Exploring by self 32%
- Guided tour 18 %

Conclusions

Results of this study showed that even in a small museum with pathways that have few intersections, conceptual and physical disorientation can occur. It was clear that visitors did not understand the conceptual divisions of the museum. It is also obvious that visitors had difficulty with basic wayfinding goals such as locating rest rooms and detecting stationary board maps inside the exhibit hall. Also of interest in this study was the differences between pre- and post-visit results in terms of preferred orientation devices. Post-visit responders were twice as likely to choose "Exploring by self" than pre-visit responders. On the other hand, post-visit responders were less likely to prefer "Direction signs." Since this museum had a simple traffic pattern, the results may not be applicable to larger facilities with complex circulation patterns.

Originally published in Visitor Behavior, (1987), 1(4),6.

22

Wayfinding at the Birmingham Zoo

STEPHEN BITGOOD
& KATHERINE RICHARDSON

This study analyzed visitors' orientation and circulation at the Birmingham Zoo. Visitors were unobtrusively tracked through the zoo and then stopped for an interview before exiting. Four aspects of this study are summarized below.

Effects of maps

A group of visitors were given hand-held maps at the zoo's entrance and their behavior and self-reports were compared with visitors who did not have maps. The following results were found:

1. Visitors with maps viewed a larger number of exhibits than those without maps (visitors with maps averaged 86 percent of the total exhibits; visitors without maps averaged 78 percent).

2. Of those visitors given maps, 77 percent actually used them.

3. Ninety-four percent of those with maps could locate specific exhibits on the map.

4. Most of the visitors with maps (65 percent) said they missed one or more exhibits, but most of them said that they intentionally did not view at least one of these exhibits. Thus, maps may have assisted visitors in selecting which exhibits to see or which to avoid.

Choice of orientation device

The following percentages reflected the percentage of visitors who ranked the respective device either first or second:

- Hand-held maps: 75 percent

- · Guided tours: 35 percent
- · Wall-maps: 25 percent
- · Self-exploring: 25 percent
- · Directional signs: 20 percent
- · Information desk: 15 percent

Circulation routes

1. *Entrance choice:* Visitors have a choice of four major paths when they enter the zoo. The overwhelming majority chose the center two paths rather than the right or left path.
2. *Routes through the Zoo:* There was no consistent pattern of circulation once visitors entered the zoo.
3. *Frequently missed exhibits:* Several exhibits were frequently missed. The Reptile and Bird House were visited by only 38 percent of visitors. Three other areas were visited by about 75 percent of the visitors (Outdoor bird area, sea lion exhibit, and hoofed animal area). These areas were all on the periphery of the zoo grounds.
4. *Use of auxiliary services:* About 50 percent of visitors rode the train; 35 percent used the food concessions; and 18 percent entered the gift shop.

Accuracy of self-reports

Visitors were asked to retrace their path through the Zoo on a map and estimate the total amount of time they spent in the zoo. These figures were compared with the visitors actual behavior obtained by unobtrusive recording. In both

cases, visitors were somewhat inaccurate. They consistently overestimated the amount of time they spent in the zoo. In addition, visitors tended to be only moderately accurate (60 percent correct) in attempting to retrace their path. These results suggest that one should be cautious about using self-reports for path retracing and for time estimations.

Originally published in Visitor Behavior (1987), 1(4), 9.

23

Visitor Orientation and Circulation: Some General Principles

Update: This article represented an improvement over the 1987 one, but it still entertained the "right-turning bias" principle, although in a weaker form than previously. We also did not make explicit the influence of the value principle (benefit/costs) as a motivating force in determining the direction of pedestrian movement. This was corrected later in a review article on visitor circulation [Bitgood, (2006). *Curator*, 49(4),463-475].

It has been several years since we published a special issue of *Visitor Behavior* on visitor orientation and circulation [*Visitor Behavior*, 1(4),1987]. The current article is an update on this topic. Unfortunately, exhibition centers do not always pay enough attention to these areas. Visitors, on the other hand, can be painfully aware of this lack of attention. People are more likely to return or spread positive word-of-mouth about their visit if orientation and circulation factors facilitate, rather than hinder a successful visit. General principles will be divided into three major areas: conceptual orientation, visitor circulation, and wayfinding. While the principles which follow are not meant to be exhaustive, research and experience suggest they include many of the important considerations from the visitor perspective.

Principles of conceptual orientation
1. Visitors tend to have a more satisfying experience and acquire more knowledge when they are given information about where to go, what to expect, how long it might take

to visit, where to find rest rooms, etc. [e.g., Bitgood & Benefield,'1989; Shettel-Neuber & O'Reilly, 1981].

2. Advance organizers that give pre-knowledge about the theme and content of the exhibit before entering the exhibit area are preferred by visitors and will usually facilitate understanding of the messages. However, these must be carefully designed and placed if they are to be effective. [e.g., Griggs, 1983; Screven, 1986].

3. The only sure way to determine if visitors are adequately conceptually oriented is to obtain systematic input from a visitor study.

Principles of visitor circulation

Explicit cues: Some stimuli that influence visitor circulation patterns are explicit. The following principles relate to such cues:

1. People tend to approach landmarks, moving objects or animals, sound, and large objects. Thus, such factors can be used to attract visitors in the direction you wish to lead them; or they may function to distract visitors and lead them in directions you do not wish them to go.

2. Visitors tend to turn in the direction of the closest visible exhibit, all other factors being equal (e.g., Yoshioka, 1943).

3. Spatial arrangements involving exhibit islands create pockets of low attention (apparently because the traffic flow does not place each object within the visitors line-of-sight or because of no systematic way to see all of the exhibit objects in the space).[Bitgood, et al., 1991; Miles, et al., 1982; Shettel, 1976.]

4. People tend to approach an area containing other people, unless it is too congested in which case a crowd may have a repelling effect.

5. People tend to approach and exit a room when they encounter an open doorway even if they have not viewed all of the exhibits or objects in the room. (See Melton, 1935.)

6. Exhibits that are on the periphery of exhibition areas are less likely to be viewed than those in the center or along the main path (e.g., Bitgood & Richardson,1987 – see Chapter 22).

Implicit cues: Circulation patterns are also influenced by more subtle cues:

1. People tend to remain on the same type of floor surface (carpet, wood) unless other forces draw them to another surface.

2. People tend to prefer the security of a main pathway and are reluctant to circulate off this pathway to areas on the periphery of the environment.

Internal cues: There are several internal cues that seem to influence circulation behavior:

1. There is a tendency for people to continue walking in a straight line unless some force pulls them in another direction or stops them (the principle of inertia).

2. In the absence of explicit or implicit cues or inertia, visitors (when entering a room) tend to turn right (Melton,

1935). This is referred to as the "right-turn bias."

3. Objects/displays located along the shortest route between the entrance and exit receive the greatest amount of viewing (e.g., Melton, 1935).

4. If visitors are looking for some specific objects or areas, goal seeking behavior may overpower any of the other factors described above.

Principles of wayfinding

Placement of information: The following may apply:

1. Wayfinding information should be placed where it is needed – at critical choice points.

2. Wayfinding information should be placed so that it is not in competition with other stimuli.

3. Wayfinding information should be salient or easily noticed.

Simplified patterns that are congruent with the way people form cognitive maps include:

1. Environments should be designed with a minimum number of choice points.

2. The easiest circulation patterns for people to form a cognitive map are simple geometric forms such as circle, square or cloverleaf. Intersections with angles other than 90 degrees make it more difficult to form a cognitive map. Therefore, pathways that form right angles should be preferred.

You-are-here maps: Following Levine's (1982) principles will make fixed maps more useful:

1. Up on the map should be associated with forward in the environment; right on the map should be right in the environment, etc.
2. A "you-are-here" mark should be provided on the map to let people know where they are.
3. Landmarks that are visible from the position of the map should be marked on the map so that the viewer can see where he/she is in relation to environmental features.

Hand-held maps: Hand-carried maps are preferred by visitors (e.g., Bitgood & Richardson, 1987) and are most effective if they consider the following:

1. Features on the map should be simplified as much as much possible. Too much detail causes confusion.
2. The map should include easily identified landmarks in the environment.
3. As with other visitor aides, hand-held maps should be evaluated with actual visitors.

Other principles

1. Provide redundant wayfinding cues. Some visitors prefer to ask for directions, some prefer to get it on their own. Having redundant cues will increase the chance that visitors will notice cues and give him/her a choice. Recurring cues also give a feeling of security to the visitor.
2. Give people choices (information desk, maps, direction

signs, etc.)

3. The use of symbols (such as animal silhouettes) to indicate directions can be confusing if used without words and if the symbols are not easily recognized. [Serrell & Jennings, 1985].

Originally published in Visitor Behavior (1992). 7(3), 15-16.

References

Bitgood, S. (1988). Problems in visitor orientation and circulation. In S. Bitgood, J. Roper, & A. Benefield (Eds.), *Visitor studies - 1988: Theory, research, and practice.* Jacksonville, AL: Center for Social Design. PP. 155-170.

Bitgood, S., & Benefield, A. (1989). *Evaluation of Visitor Orientation at the Space & Rocket Center.* Unpublished Report. Jacksonville, AL: Center for Social Design.

Bitgood, S., Hines, J., Hamberger, W., & Ford, W. (1991). Visitor circulation through a changing exhibits gallery. In A. Benefield, S. Bitgood, & H. Shettel (Eds.), *Visitor Studies: Theory, Research, and Practice, Volume 4.* Jacksonville, AL: Center for Social Design. Pp. 103- 114.

Bitgood, S., & Patterson, D. (1987). Principles of orientation and circulation. *Visitor Behavior,* 1(4), 4.

Bitgood, S., & Richardson, K. (1987). Wayfinding at the Birmingham Zoo. *Visitor Behavior,* 1(4), 9.

Griggs, S. (1983). Orienting visitors within a thematic display. *International Journal of Museum Management and Curatorship,* 2, 119-134.

Levine, M. (1982). You-are-here maps: Psychological considerations. *Environment and Behavior*, 14(2), 221- 237.

Melton, A. (1935). *Problems of installation in museums of art*. New Series No. 14. Washington, DC: American Association of Museums.

Miles, R., Aft, M., Gosling, D., Lewis, B., & Tout, A. (1982). *The design of educational exhibits*. London: Allen & Unwin.

Screven, C. (1986). Exhibitions and information centers: Some principles and approaches. *Curator*, 29(2), 109- 137.

Serrell, B., & Jennings, H. (1985). We are here. In 1985 *Proceedings of the AAZPA*. Columbus, OH: American Association of Zoological Parks & Aquariums.

Shettel, H. (1976). *An evaluation of visitor response to "Man in His Environment."* Technical Report No. 90- 10. Jacksonville, AL: Center for Social Design.

Shettel-Neuber, J., & O'Reilly, J. (1981). *Now where?: A study of visitor orientation and circulation at the Arizona-Sonora Desert Museum*. Techical Report No. 87-25. Jacksonville, AL.

24

Visitor Turning and Exiting in Museum Galleries

Melton[1] described a series of studies that demonstrated two important factors that exert strong control over the behavior of visitors. The first is the tendency for visitors to turn right when entering a museum gallery. The second is the strong attraction of exits. The results of several studies provide convincing evidence of the power of these factors.

Study #1

This study examined visitor behavior in a simple gallery with one entrance and two exits (Fig. 1)

For purposes of reporting results the gallery is divided into seven sections. Melton found that visitors were more likely to stop to view paintings in the first three sections than any other. The circulation patterns are shown below in Figure 2.

From these results, Melton made the following conclusions:

1. Visitors have a strong tendency to turn right when entering a gallery . Over 70% of the visitors turned right in this study. Other studies revealed a similar trend for visitors to turn right as they enter a gallery.

2. Visitors are strongly attracted by exits. According to

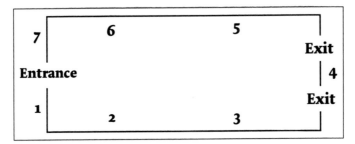

Figure 1: Study 1, a simple gallery.

Figure 2: Visitor circulation patterns.

Melton, exits compete with the exhibit objects. Exits function very much like exhibits for the attention of visitors. The closer one is to an exit, the stronger its attracting value. Thus, the closer visitors are to an exit, the less likely they will attend to an exhibit object since they are drawn to the exit.

Study #2

This study examined the effect of opening a second exit in a gallery. The left side of Figure 3 below shows the circulation pattern before a second exit door was open and the right side of the Figure shows the circulation pattern after opening the second door.

In this gallery about 80% of visitors turned right. Most of them left (62.6%) left when they reached the exit instead of first

Figure 3: The effect of opening a second exit.

circulating around the gallery. The left turners were also likely to exit when they reached the first exit. In terms of frequency of stops to look at paintings, Section A had the highest stopping rate. Frequency of stops decreased as one circulates from Section A to the left-hand wall.

After Exit 2 was opened the circulation patterns changed. Although about 80% of visitors still turned right, the number who went out when they encountered the first exit decreased from 62.6 to 43.5. After Exit 2 was opened, left turners were less likely to view any area except the left wall since 13.4 of the 20.7 exited when they reached Exit 2. In terms of the frequencies of stops by visitors, the far wall (between the two exits) was hurt the most when Exit 2 was opened. Visitors were less likely to stop at paintings in this area, presumably because of the attracting force of the exits.

Study #3

Another study was conducted in the Highway Transportation

Figure 4: Visitor circulation before and after closing an exit.

gallery at the New York Museum of Science and Industry. This gallery was more complex than studied previously and involved a science museum rather than an art museum. In addition, the gallery initially had two exits and during the study one of the exits was closed. Melton measured the circulation patterns of visitors before closing one of the exits and again after the exit was closed. As with-previous studies, Melton tracked visitors from the time they entered the gallery until they exited. The changes in visitor circulation patterns are shown in Fig. 4.

Not only did the circulation patterns change dramatically when the second exit was closed, but the average time in the gallery increased from 134.1 to 230.7 seconds!

Study #4

There are times when the circulation pattern is arranged for the

visitor to precede from left to right. Such a gallery was studied in the Buffalo Museum of Science. Since it was too costly to change all of the exhibits to accommodate the right turning bias, Melton attempted to influence visitors' direction-turning behavior by the use of a direction sign. The sign had an arrow with the words, "Please go to the left [or right]." The gallery was about 50 feet long with the entrance also serving as the exit. Initially, it was found that 70% of visitors turned right as they entered the gallery, even though the gallery was set up for visitors to see the left side first. Melton varied the sign (directions to turn right vs. directions to turn left) and the distance of the sign from the entrance. The following results were found when the sign was placed 0, 2, 4, and 6 feet from the entrance.

Percent visitors turning right when the sign said to turn right:
0 ft: 99.5%
2 ft: 98.0%
4 ft: 92.0%
6 ft: 89.3%

Percent visitors turning left when the sign said turn left:
0 ft: 90.0%
2 ft: 85.0%
4 ft: 77.0%
6 ft: 65.8%

Clearly, the right turning bias was not completely overcome with the direction sign. It was easier to increase right-turning

than left-turning behavior.

Study #5

This study examined the effects of opening a second door in a gallery in the Pennsylvania Museum of Art. Before the second door was opened, the entrance also served as the exit.

Before opening the second door, visitors averaged 73.3 seconds in the gallery. After opening the second door, visitors averaged 22.7 seconds if they entered the original entrance and 34.9 seconds if they entered the second door. Time viewing the paintings and furniture both dramatically decreased when the second door was opened. Melton argued that the exhibition value of the gallery was reduced to a minimum as a result of this second door.

Conclusions

Taken together these five studies by Melton demonstrate persuasively that exhibit designers cannot ignore the right-turning bias of visitors nor the tremendous attracting power of exits.

Update: Melton's studies are important for at least two reasons: they show consistent patterns of movement in exhibition galleries; and they demonstrate that these visitor movement patterns are influenced by changes in the exhibit environment. We now believe, based on current data, that visitors turn right if they are walking on the right side of a pathway when entering a gallery and if a strong

attracting force (e.g., landmark object) doesn't pull then in a different direction. If there really is a right-turning bias, we believe it to be weak (Bitgood & Dukes, 2006; Bitgood, 2006). The value ratio (benefits or utility divided by cost) appears to be the major motivation for circulation as well as engaged attention to exhibit objects.

Originally published in Visitor Behavior (1988), 3(1), 6-8.

Notes

1. A. W. Melton (1935), Problems of Installation in Museums of Art. American Association of Museums Monograph New Series No. 1

25

Visitor Circulation through a Changing Exhibits Gallery

STEPHEN BITGOOD, JOE HINES,
WAYNE HAMBERGER & WILLIAM FORD

How visitors circulate through exhibition spaces has been studied by many investigators (e.g., Bitgood & Richardson, 1987; Melton, 1935; Parsons & Loomis, 1973; Shettel-Neuber & O'Reilly, 1987; Yoshioka, 1942). Melton (1935) demonstrated that an open door exerted a strong attracting force on visitors as evidenced by their tendency to leave the gallery when an open exit door is encountered whether or not they have explored a significant portion of the gallery. When a open door was closed so that visitors could not exit, visitors circulated through a larger portion of the gallery. Melton also found that, in the absence of more powerful cues, visitors had a tendency to turn right as they entered a gallery. For more on visitor circulation, see Bitgood (1988), Bitgood & Patterson (1987), and Loomis (1987).

Miles, Alt, Gosling, Lewis, and Tout (1982) provide a detailed discussion of considerations for visitor circulation based on the experience of the British Museum (Natural History). In the course of their discussion, these authors caution against the use of island displays in exhibit galleries because of the impact on visitor circulation. They point out that island displays generally reduce the width of the path, create increased crowd congestion, and make systematic viewing of exhibits confusing. However, no supporting data was provided in their book.

The current study consisted of visitor tracking through five travelling exhibits at the Anniston Museum of Natural History. By using the same exhibit space with a variety of layouts for exhibit objects, it was hoped that the results would help

answer three questions:

1. How much influence does the spatial arrangement of objects within a gallery have on the behavior of visitors?
2. How much do the characteristics of exhibit objects influence visitor behavior?
3. How effective are techniques for increasing visitation to a changing exhibit hall?

Exhibitions evaluation

Treasures from the Collection: The Museum dusted off objects from its storeroom for this very popular exhibition. It included a variety of objects such as mounted animals, paintings, and cultural artifacts (e.g., Native American head dress, aphrodisiac pills made from rhino horns). The spatial arrangement of objects and displays for this exhibition can be seen in the diagram of Fig. 1.

The Dinosaur Show: This was a travelling exhibition organized by the Boston Museum of Science. It consisted of dinosaur images that ranged from paintings to models to videotapes. There were no mechanical moving creatures as in the very popular *Dinomation* show. Fig. 2 illustrates the spatial arrangement of this exhibition.

Seeing the Unseen (Edgerton): This exhibition consisted of photographs by Harold Edgerton who used the stroboscope to make stop-action photographs. On exhibit were many of the photographs that were televised on a recent NOVA show. To illustrate stroboscopic photography, one photograph showed a bullet just after it passed through an apple, Fig. 3 shows the

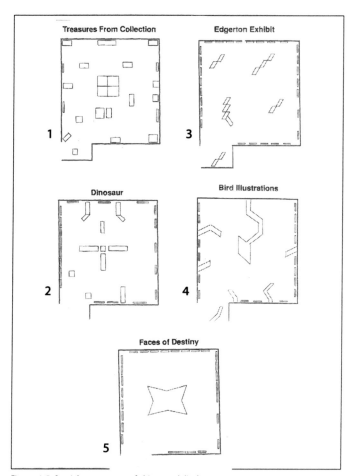

Figures 1-5: Spacial arrangement of objects and displays

spatial arrangement of this exhibition.

Pioneers of Bird Illustration: This exhibition consisted of a collection of bird illustrations organized by the Bell Museum of Natural History at the University of Minnesota. It included works by John James Audubon, Thomas Bewick, Mark Catesby,

and Alexander Wilson. See Fig. 4 for the spatial arrangement of this exhibition. Note that this "peninsula" arrangement differs from the "island" arrangement found in the other exhibitions.

Faces of Destiny: The exhibition contained photographs of Native Americans taken at the 1898 Indian Congress. It was organized by Spencer Museum of Art from the collections of Haskell Indian Junior College in Lawrence, Kansas. Fig. 5 shows the spatial arrangement of this exhibition.

Method

This paper reports only the observational tracking data collected during our study of these temporary exhibitions. Visitors were unobtrusively observed as they walked around the changing exhibition hall and their circulation path and each stop was recorded on a map of the gallery. Gender and age were recorded as well as other factors deemed important by the observer.

Visitor traffic flow and stopping patterns were analyzed as a function of: general spatial arrangement of the displays; specific placement of objects; size of objects; color versus black-and-white photos; and techniques for attracting visitors to the Gallery.

General spatial arrangement differed on the basis of whether objects were placed on displays that formed islands in the gallery, or on displays next to the wall, or on peninsulas of displays jutting out from the wall (see *Pioneers of Bird Illustration* in Figure 4 for an example of the peninsula spatial arrangement).

Size of objects and color versus black-and-white were examined in the Edgerton (*Seeing the Unseen*) exhibition since the photos differed in size and some of the photos were in color.

The percentage of visitors who entered the changing exhibition gallery was also determined in an effort to assess whether any of three techniques assisted in attracting visitors into the gallery. These techniques were:

- The use of music or sound to attract visitors into the gallery
- The placement of exhibit objects in the hallway leading to the gallery.
- The use of a strobe light to attract people into the gallery.

Results and discussion

Spatial arrangement and visitor traffic flow

The arrangement of objects in these exhibitions had a strong influence on visitor behavior. Therefore, it is important that the reader keep in mind the spatial arrangements of objects in these exhibitions shown in Figs. 1-5. Note that *Treasures from the Collection*, *Dinosaurs*, and *Edgerton*, had a number of islands spread throughout the Gallery. *Faces of Destiny* had a single island in the center of the room, but this island contained one label and no photographs. It also had colored lights coming out of corners formed at the center structure. The *Pioneers of Bird Illustration* exhibition is the only one with no islands; it has peninsulas which were physically connected to the wall

and encouraged a linear flow around the Gallery.

Gallery entry patterns

As indicated by Fig. 6, the spatial arrangement of displays and objects appeared to influence whether visitors walked into the gallery along the left wall, toward the center, or along the right wall.

In *Treasures*, less than one-third entered the exhibition hall along the left wall, about one-third entered along the right wall, and the remaining one-third entered into the center of the Gallery. Objects displayed on islands appeared to pull many visitors away from the wall and more toward the center.

In the *Dinosaur* exhibition, over three-fourths of visitors entered along the left wall, about 12% along the right wall, and about 12% moved toward the center as they entered. The *Tyranosaurus Rex* model near the left wall appeared to pull visitors into this direction. This observation is consistent with the notion that landmark exhibits have a large influence on circulation flow (Melton, 1935; Yoshioka, 1942).

In the *Edgerton* Exhibition (*Seeing the Unseen*), 60% of visitors entered along the left wall, 12% along the right wall, and over 27% entered to the center of the Gallery. The spatial arrangement appeared to pull visitors slightly more to the center than found in the *Dinosaur* or *Bird Illustra*tion exhibition. The presence of attractive objects on islands toward the center of the gallery probably accounted for this effect.

In the *Pioneers of Bird Illustration*, over 70% entered along the left wall, about 12% along the right wall, and the remaining 18%

Entry pattern (%)				Circulation direction (%)	
Exhibition	Left wall	Right wall	Center	Clockwise	C/clockwise
Treasures	30.3	32.6	37.1	28.1	27
Dinosaur	76.22	11.9	11.9	66.7	7.1
Edgerton	60.1	11.9	11.9	66.7	7.1
Birds	71.2	12.4	16.5	70.9	17
Destiny	56.5	30.4	13.1	56.5	43.5

Figure 6: Visitor entry and circulation patterns.

moved toward the center. The peninsula display arrangement of the gallery was designed to create a linear flow beginning with the left wall and the design appeared to work fairly well.

Finally, in *Faces of Destiny*, over 56% followed the left wall, while about 30% turned right when entering the gallery, and 13% toward the center. This pattern seems to reflect a natural pattern for a gallery of this type in which entry is along the left wall and there are no strong landmarks to draw visitors away from the wall. For example, Melton (1935) found over 50% of visitors walked along the left wall in a similar exhibit gallery.

Circulation through the gallery

In addition to the entry behavior, the arrangement of objects within the Gallery also influenced the pattern of circulation after entering the Gallery. Three of the exhibitions generated a high probability of clockwise circulation (*Dinosaur, Edgerton,* and *Bird Illustration*); *Faces of Destiny* resulted in over half of the visitors circulating clockwise; and Treasures resulted in only about one-fourth of visitors circulating clockwise. The Treasures exhibition (with the lowest clockwise circulation)

Treasures from the Collection		
	Number of displays	
Range of stopping	Island	Wall
Less than 30%	2	2
30-50%	4	4
50-70%	4	2
Over 70%	0	3
Egerton (Seeing the Unseen)		
	Number of displays	
Range of stopping	Island	Wall
Less than 30%	2	0
30-50%	6	2
50-70%	4	9
Over 70%	2	2

Figure 7: Stops at island versus wall placements.

also had the highest percentage of idiosyncratic traffic flow patterns through the Gallery, ostensible because of a large number of direction choice points created by the display islands. The Circulation Direction data from Fig. 6 summarize these differences.

Spatial arrangement and visitor stopping

Wall vs. island location: Objects located on islands in the middle of the room tended to receive less attention than objects along the wall. As shown in Fig.7, this effect was stronger in the *Edgerton* than in the *Treasures* exhibition. Note that in *Treasures*, the three objects receiving the highest level of

	Percent stops	
Exhibition	First	Last
Edgerton	64.4%	53.3%
Bird Illustration	68.2%	40.0%

Figure 8: Percentage of stops at first and last objects.

attraction (over 70%) stopping) were placed next to the wall. In *Edgerton*, 11 of 13 wall objects received over 50% stopping while only 6 of 14 island objects received this much attention. While the precise location with respect to traffic flow and the inherent interest level of the object were important, it seems that the island arrangement is more likely to result in some objects receiving lower levels of attention than if placed by the wall.

Island vs. peninsula arrangement: As noted previously, the *Bird Illustration* exhibition was configured with peninsulas jutting from the fixed walls. There was a smaller range of differences in visitor stopping among these *Bird Illustrations* objects than in the island exhibitions. That is, the percent of stops for *Treasures* ranged from 18.7 to 79.1%; for Edgerton, 9.1 to 81.8%; and for *Bird Illustration* (the only peninsula arrangement), 31.7 to 81.8%. It may be that the peninsula arrangement give all objects a better chance of receiving attention since more objects are likely to fall within the visitor's line-of-sight.

Beginning vs. end of visit: In general, items viewed at the beginning of the gallery visit received more attention than objects viewed last. Fig. 8 shows visitor stopping at first and last objects in two of the exhibitions.

Size	Square inches	Mean stops	Size of N
Small	525	18.1	20
Medium	775	17.6	19
Large	1148-1271	18.8	8
Extra large	1813	23.7	3

Figure 9: Relation between size of photo and visitor stops.

Size of object: Photographs from the Edgerton Exhibition were divided into four sizes and mean stops were computed in order to assess the possible role of size on visitor attention. Fig. 9 summarizes the results. The average number of stops does not differ appreciably among the small, medium and large photos. The extra large photos, however, result in more average stops; unfortunately, there was only three extra large photos, thus it is difficult to draw any conclusions about this difference.

Color versus black-and-white photography: The difference between color versus black-and-white photographs were also assessed in the *Edgerton* exhibition. Comparing only the small photos, the average number of stops for color was 19.7 and for black-and-white, 18.2. This difference is not large and suggests that in the case of the current exhibition, color did not play a critical role.

Relation of exhibit content to visitor behavior: Occasionally, landmark exhibit objects resulted in an increased amount of visitor attention. For example, the *Tyranosaurus Rex* in the *Dinosaur* Exhibition, and the snapping turtle in the *Treasures* exhibition received more than expected attention. Intrinsic

interest appeared to be a factor in such cases. Otherwise, size of object and color (vs. black-and-white) did not seem to have a large influence.

Techniques for attracting visitors to the changing exhibit gallery: While three methods of attracting visitors to the gallery were tested, only two of them were successful:

- Placing exhibits along the hallway leading to the gallery increased visitation in the gallery by about 20% (from 60% to 80% for all exhibits in the study).
- Music in the gallery appeared to attract an additional visitation of 10% (from 60 to 70%).
- Strobe light. There was no difference in the percentage of visitors entering the gallery when the strobe light was on vs. when it was off.

What lessons can we learn from the results?

The current results are consistent with the observations of others with respect to visitor circulation. The following conclusions are suggested by the current results:

1. Linear traffic flow, such as was generated in the peninsula display arrangement, appears to increase the chance that all exhibit objects will fall within the visitor's line-of-sight; non-linear patterns, on the other hand, as created with the island display arrangement, appear to produce greater visitor confusion, back tracking, and missed viewing opportunities. As evidenced in this study, linear does not mean that the arrangement has to be boring and unaesthetic. The *Bird Illustration* arrangement was

aesthetically pleasing as well as effective in creating a desirable traffic flow in terms of all objects receiving visitor attention.

2. Attractive exhibit objects influence how visitors circulate through the gallery. An attractive, landmark object pulls visitors in one direction or another. As a result, object placement should be carefully planned with this effect in mind.

3. Spatial arrangements involving exhibit islands create pockets of low attention (apparently because the traffic flow does not place each object within the visitor's line-of-sight). (See also Shettel, 1976, "An Evaluation of Visitor Response to Man in His Environment"). The advice of Miles, et al (1982) seems to be sound. Unless there is a good reason to include islands, they should probably be avoided. If display islands are used, other devices might be used to guide traffic flow. For example, numbering exhibits might encourage visitors to view more exhibits if they wish to see exhibit objects in an orderly manner.

4. At least two methods were found to increase visitation in the Gallery; placing exhibit objects along the hallway leading to the Gallery; and playing music in the hall leading to the Gallery. The flashing strobe light was not effective. Placing objects along the hallway leading to the Gallery appeared to be particularly effective in overcoming the tendency of visitors to avoid walking off the main circulation pathway.

Originally published in A. Benefield, S. Bitgood, & H. Shettel (Eds.),
Visitor studies: Theory, research, and practice, Vol. 4. Jacksonville,
AL: Center for Social Design. Pp. 103-114.

References

Bitgood, S. (1988). Problems in visitor orientation and circulation. In S. Bitgood, J. Roper, & A. Benefield (eds.), *Visitor studies - 1988: Theory, research, and practice.* Jacksonville, AL: Center for Social Design. P. 155-170.

Bitgood, S., & Patterson, D. (1986). Principles of orientation and circulation. *Visitor Behavior, 1*(4), 4.

Bitgood, S., & Richardson, K. (1987). Wayfinding at the Birmingham Zoo. *Visitor Behavior, 1*(4), 9.

Melton, A. (1935). *Problems of installation in museums of art.* New Series No. 14. Washington, DC: American Association of Museums.

Melton, A. (1972). Visitor behavior in museums: Some early research in environmental design. *Human Factors, 14*(5), 393-403.

Miles, R., Alt, M., Gosling, D., Lewis, B., & Tout, A. (1982). The design of educational exhibits. London: Allen & Unwin.

Parsons, M., & Loomis, R. (1973). *Visitor traffic patterns: Then and now.* Washington, DC: Office of Museum Programs, Smithsonian Institution.

Shettel, H. (1976). *An evaluation of visitor response to Man in His Environment.* AIR-43200-7/76 Final Report. Washington, DC: American Institutes for Research.

Shettel-Neuber, J. & O'Reilly, J. (1987). *"Now Where?" A Study*

of Visitor Orientation and Circulation at the Arizona-Sonora Desert Museum. Technical Report No. 87-25. Jacksonville, AL: Center for Social Design.

Yoshioka, J. G. (1942). A direction-oriented study with visitors at the New World's Fair. *Journal of General Psychology, 27,* 3-33.

26

Visitor Circulation:
Is There Really a Right-Turn Bias?

Update: The following brief article proposes a hierarchy of factors that influence turning choices at intersections and suggests that "right turning" is one of the least powerful phenomena of visitor circulation occurring only in the absence of other factors. As it turns out, I was wrong in accepting that it is a visitor circulation phenomenon at all! We now have evidence that it is an artifact of a more important phenomenon – the tendency to save steps (Bitgood, 2006; Bitgood & Dukes, 2006). People turn right at intersections if, and only if, it requires the least effort. If a visitor is walking on the right side of a path way, turning right takes fewer steps than turning left. In addition, when crowded, turning left against oncoming traffic is more difficult than turning right since, especially under crowded condition, people tend to walk on the right side of a pathway.

Since Melton's (1935) publication describing circulation patterns of visitors in museums, the belief that visitors turn right when entering a museum gallery has been frequently cited. Of course, there is substance to this belief. In a variety of museum galleries, Melton found that 70-80 percent of visitors turned right and followed the right-hand wall as they circulated through the gallery. This tendency to turn right has been found by many other investigators and in other types of public settings. For example, we found a similar right-turn bias in shopping mall user circulation. However, others have found that people do not always show the right-turn bias (e.g., Bitgood, Hines, Hamberger, & Ford, 1991; Yoshioka, 1942).

Yoshioka found that visitors at the 1939 New York World's Fair exhibit halls tended to turn toward landmark exhibits. Bitgood, et al found that visitor circulation through a changing exhibit gallery at the Anniston Museum of Natural History was dependent upon the layout of exhibits and partitions as well as a tendency to continue in the same direction in the absence of landmark exhibits. Thus, the right-turn bias seems to be only one of the mechanisms that influence visitor circulation.

Based on empirical studies, it appears that there is a hierarchy of forces that influence visitor turning at choice points. At this point the hierarchy I am proposing is somewhat speculative and needs empirical comparisons. Given this caution, here is my best guess as to the forces that influence circulation.

The hierarchy for visitor turning at choice points
1. *Goal-directed circulation:* When visitors have a particular destination in mind, this will have the strongest effect on turning at choice points.
2. *Attraction of landmark objects/exhibits:* The second most powerful force influencing visitors appears to be the attraction of large objects (landmarks). Evidence for the force of this factor has been provided by studies such as Bitgood, et al (1991) and Yoshioka (1942).
3. *Attraction to an open door:* Melton (1933) found that an open door (or exit) has its own attracting power over visitor circulation. A large proportion of visitors exit a gallery by the first open door they encounter.
4. *Inertia:* In the absence of any of the above factors to

attract visitors, people tend to walk in the same direction (straight line). Thus, if a visitor enters a gallery along the left-hand wall, he/she continues walking along this wall (unless a force higher on the hierarchy is operating).

5. *Right-turn bias*: Finally, in the absence of any of the stronger forces described above, visitors tend to turn right when entering a gallery.

Other factors may also play a role in circulation, but in the absence of careful studies, it is difficult to assess their importance. Three other possible factors are: tendency to approach other people, tendency to remain on the same floor surface, tendency to remain on a main pathway rather than select a secondary one.

Originally published in Visitor Behavior, 10(1)5.

References

Bitgood, S., Hines, J., Hamberger, W., & Ford, W. (1991). A study of visitor circulation through five changing exhibitions. In A. Benefield, S. Bitgood, & H. Shettel (eds.), *Visitor Studies: Theory, research and practice, vol. 4*. Jacksonville, AL: Center for Social Design. Pp. 103-114.

Melton, A. (1933). Studies of installation at the Pennsylvania Museum of Art. *Museum News*, 10(15), 5-8.

Yoshioka, J. (1942). A direction-orientation study with visitors at the New York World's Fair. *Journal of General Psychology*, 27, 3-33.

27

Museum Orientation and Circulation

STEPHEN BITGOOD & SHERRI LANKFORD

Update: This article came from a special issue of Visitor Behavior on orientation and circulation. A check list is provided after each section to aid the practitioner and/or evaluator who wishes to apply these suggestions to a museum project. We hope that the reader takes a global approach to orientation-circulation, considering both the chronological sequence (pre-visit orientation to leaving the museum) and all three major elements (conceptual orientation, wayfinding, and circulation.

Orientation can be divided into conceptual (thematic) and physical (wayfinding). Conceptual orientation refers to knowledge of the themes and activities available in a setting. Wayfinding deals with the ability of a user to find his/her way to/from and within a setting. A final concept associated with these terms is circulation or the way people move through a space.

Pre-visit orientation

Orientation does not begin at the entrance of the exhibition center. Visitors acquire critical knowledge long before they actually visit. Pre-visit knowledge has important implications for visitation. For example, we might expect that visitors will be able to concentrate more on the interpretative or educational messages if they have pre-visit knowledge about the exhibition center. Even more importantly, pre-visit knowledge can determine whether or not visitors can find a museum!

Conceptual orientation: Why is conceptual orientation important? First, expectations can determine whether or not people visit a facility. Second, visitor expectations can influence both the experience and how information is interpreted. Obviously, if the subject matter of the exhibition center does not sound inviting to potential visitors, they are unlikely to make a visit. With respect to the second point, Hayward & Brydon-Miller (1984) found that visitors often entered Sturbridge Village with misconceptions concerning the historical period described in the museum; as a result, they misinterpreted their exhibit experiences. Suggestions:

- Provide visitors with sufficient and accurate information about what the museum is all about.
- Information should include exhibition themes, programs, other activities, time budgeting information, etc.
- Include adequate conceptual orientation in visitor brochures, billboards, publicity, etc.

Wayfinding; An effective wayfinding system is important so that visitors can move through the museum in an efficient manner, so that visitors do not fatigue easily, and so that visitors may concentrate on enjoying their experience rather than spending unnecessary time and energy finding their way.

Ensure that phone-book listings, airport displays, pamphlets, travel guides, direction signs and other information in the community about the facility contains adequate wayfinding information (Loomis, 1987).

Evaluation checklist: pre-visit:

- Where did visitors learn about the facility? How accurate is this information?
- Do visitors understand the major themes, activities, and how long it will take to visit?
- Was it difficult or confusing attempting to find the museum? If so, what were the reasons for this problem?
- Are path finding road signs distinct from other highway signs?
- Does vegetation (trees, bushes) obstruct the view of the entrance and/or direction signs?
- Are letters on signs legible in terms of size, contrast with background, and font size?

Arrival and entrance orientation

Once visitors arrive, they are confronted with new potential problems. Can they find a place to park? Is the visitor entrance clearly marked? Several guidelines may help ensure adequate arrival orientation:

- The purpose of the facility should be clearly indicated on the outside of the building.
- Special exhibitions should be noted either with special signs or banners before entering the building or site.
- Direction signs should clearly identify parking lots and the visitor entrance.
- Wayfinding from public transportation should be provided.

Lobby orientation

Once in the exhibition center, visitors must make decisions about whether or not they are willing to pay the entrance fee, where to go to get tickets, where to find the rest rooms, how to plan their visit, etc. Lobby orientation is critical because this is where visitors make important decisions: Is it worth paying the entrance fee? Do I have enough time to visit the museum? Which exhibitions do I want to see and in which programs do I want to participate? Should I eat in the cafeteria/restaurant? Museum lobbies are usually filled with visual stimuli and sometimes crowded. How, where, and what information is presented sets the tone for the entire visit.

Customer relations is critical in this area – friendly people greeting visitors, answering questions, and dealing with problems is critical.

Conceptual orientation:
- Provide information about what can be seen and done
- Give clear directions to restrooms, exhibits, gift shop, food
- Give adequate information to allow time budgeting
- Provide easy-to-see information on guided tours and/ or self-guided tours

Wayfinding:
- Ensure that the ticket desk/booth is clearly marked
- Provide clear directions for amenities such as rest rooms, food, and gift shop

- Make sure the reception desk attracts visitors by providing an effective location and eye-catching labeling
- Design visitor guides with a readable map
- Provide good customer relations with friendly greeters at the entrance (ticket counter, information booths, etc.)

Evaluation checklist:
- Does lobby orientation provide adequate information about what there is to do, how long it will take, etc?
- Can visitors easily find ticketing, restrooms, gift shop, and other information?
- Is there an information booth? Is it clearly marked and in the best location?
- Are there topographical organizers showing layout of the museum?
- Are there suggested routes through the museum according to time constraints and interests?
- Are front-line staff friendly and informed; do they handle problems in a way that maintains good customer relations?

During-visit orientation

The visitor now has his/her ticket, has visited the rest room, has planned his/her visit in terms of which areas and activities to see and do. The adventure begins. And a whole new set of potential problems must be confronted. Where are the

exhibition halls? Which way do I go? Will I find all of the exhibit displays that I want to see? Will I miss any exhibits? Do I really understand the exhibit themes? Will I be able to find the restroom? Will I be close to the cafeteria when I get hungry?

Conceptual orientation:
- Exhibition themes should be clearly stated without having to enter exhibition areas.
- Slide or film orientation can be effective if all (or most) visitors are encouraged to see it.
- [See the next chapter for additional guidelines for orientation and wayfinding within an exhibition area.]

Wayfinding:
- Place information where it is needed, especially at choice points
- Provide redundant wayfinding information
- Make sure names of exhibits, exhibit areas, and other locations are consistent. An exhibit area or display or location should not have two different names.
- Identifiers for exhibitions should be informative. For example, the Robert Smith Hall does not provide the visitor with information about the theme of the hall.
- Security personnel should be trained to answer orientation questions and give wayfinding directions (Loomis, 1987).
- You-are-here maps should adhere to three principles:

up on the map is forward in the environment; you-are-here symbol is needed to orient location at the moment; and a salient feature (landmark) should be identified on the map and be visible in the environment.

- Hand-held maps should have only the essential information and features portrayed should be easily identified.

- Directional signs should be placed where they will be noticed, where they are needed, and should be consistent with other wayfinding devices.

Circulation pathway:

There are consistent patterns people use to move through public spaces. If exhibition center spaces are designed with this knowledge, they should be more successful in providing visitors with a satisfying experience. As a general rule, visitors like to keep in visual contact with a familiar place such as the entrance lobby or a main pathway. Pathways that deviate too much from the security of a main path are less likely to be used. Other important factors that influence visitor circulation include:

- Landmarks have the strongest influence on visitor circulation. Place a large, attractive object in the middle of a gallery and people will walk toward it.

- Inertia is another factor that influences circulation. People tend to continue on the same path or in the same direction unless there is something (attractive object) else to pull them one way or another.

- In the absence of the above two principles, there appears to be a right-turn bias; that is, people tend to turn right when coming to a choice point if there are no other forces stronger at the moment.
- An open door in a hall or gallery has an attracting force all to itself. Visitors tend to walk out the first open door they encounter.
- Finally, at times, people simply follow others when moving through an environment.

Evaluation checklist: during the visit:
- Can visitors find their way to exhibitions, restrooms, food, gift shops, telephone, etc. no matter where they are during their visit?
- Are visitors able to use maps and other orientation devices to find their way?
- Are exhibition themes and direction signs clearly marked so visitors can find them?
- Are exhibitions designed with knowledge of how visitors circulate through such spaces?

Exiting orientation

Even when the visit is ending and visitors are ready to leave, problems of orientation have not ended. Can I find the exit? Will I be able to find my car in the sea of automobiles? Can I find a restaurant for lunch or dinner? Is there lodging information in the lobby? Suggested guidelines include:
- Exits should be clearly marked.

- Provide wayfinding directions to main highways.
- Give information on public transportation including schedule, stops, routes.
- Make sure visitors are able to find their car in the parking lot.
- Ensure that information about restaurants, lodging, or other tourist centers is available at visitors' exit.

Originally published in Visitor Behavior (1995). 10(2), 4-6.

28

Principles of Orientation and Circulation within Exhibitions

STEPHEN BITGOOD & AMY COTA

Update: This article also came from the special issue on orientation and circulation. While the first article (with Sherri Lankford) focuses on museum-wide orientation and circulation, this article targets considerations within exhibitions. Three sources [Miles, et al, 1982; Griggs (1983), Loomis' (1987) chapter on orientation] are responsible for many of the ideas presented in this article.

Exhibition design is likely to be more successful if principles of orientation and circulation within exhibits are applied to the design process. Visitors learn more and are more satisfied when they are properly oriented to an exhibition and when the exhibition is designed with an understanding of the factors that determine circulation behavior.

Orientation includes both conceptual or thematic knowledge and the ability to wayfind. Circulation describes how visitors move through spaces. These concepts are discussed more generally in the last chapter. Here the discussion is limited to orientation and circulation within an exhibition.

Listed below are selected principles of visitor orientation and circulation that pertain specifically to an exhibition space, rather than an entire facility. These principles are tentative; although most are based on visitor research evidence, additional empirical confirmation is needed to determine more precise patterns and to assess the generality of findings. Note that some of these principles overlap with principles for an entire museum (previous chapter).

General principles

1. If possible, orientation should be integrated into the exhibit develop process rather than added after the fact (Griggs, 1983). Orientation considerations should be an important part of the exhibition design and be part of the plan beginning with the planning stage and continuing through installation.

2. Both conceptual orientation and wayfinding (if it is a large exhibition) should be provided at the beginning or entrance of the exhibition.

3. Conceptual orientation and wayfinding aides should be continued through the exhibition where it is needed or where it would be helpful to visitors.

4. Orientation devices should be defined by visitors (Griggs, 1983). This means that orientation devices should be developed with visitor input, not exclusively by museum professionals who may not be able to predict the impact of these devices on visitors.

5. Visitors should be explicitly informed of the intended sequence of an exhibition (Griggs, 1983). The sequence can be indicated by numbers on the exhibits, banners, etc. If the sequence is important, it is crucial that the visitor is informed on how the exhibition is marked and that the exhibition is organized in a sensible fashion. You cannot assume that visitors will follow subtle clues.

6. Conceptual orientation should be considered independently of wayfinding plans (Griggs, 1983).

Each type of orientation usually needs its own devices to convey its messages.

7. Visitor circulation should be planned from the beginning. Consider how visitors will circulate and what visual attracting forces will influence how they move through the exhibition. Visual sight lines need to be considered.

8. The use of display islands should be avoided if possible since they create a chaotic circulation flow, often resulting in visitors unintentionally missing exhibits (Bitgood, et al, 1993; Miles, et al, 1982).

9. Orientation and circulation should be assessed following installation of an exhibition. Even if orientation and circulation are carefully integrated into the design process, there may still be unanticipated problems. Tracking visitors through the exhibition space can often identify problems that can be easily corrected through inexpensive alterations (e.g., moving a label, adding a more salient title, adding directional arrows, etc.).

Conceptual orientation

Conceptual orientation provides information to the visitor about where to go, what to expect, and how long it might take to visit a particular exhibition. It aids visitors in making informed decisions about viewing an exhibition. What kind of information will help visitors cognitively process exhibit messages?

1. Conceptual orientation provides pre-organizers to an exhibition and tells how it is organized conceptually (Griggs, 1983). This means that essential information is clearly conveyed: the title of the exhibit with an elaborating sentence if necessary; organizing the exhibit in an easy-to-understand fashion that is explicitly communicated to the visitor; and a brief overview of the major components and how they interrelate to one another to form a coherent theme.

2. In order to achieve effective conceptual orientation, attracting and holding visitors' attention to the necessary information and communicating this information to visitors must be accomplished (Griggs, 1983).

3. Conceptual orientation should be provided at the beginning of an exhibition. Plan an entrance orientation area. Loomis (1987) suggests using large orientation labels, gallery wall maps, barriers, lighting, etc. to suggest direction of movement. Through the use of advanced organizers (aids that provide a framework for viewing an exhibition (Griggs, 1983; Screven, 1986), exhibit messages or themes can be introduced. Screven (1986) describes three types of advanced organizers: conceptual pre-organizers (brief information regarding the main exhibit elements), overview (what can be seen, done, and learned from the exhibit), and topographic organizers (simplified maps which orient visitors to the layout of the exhibit hall).

4. Conceptual orientation should be repeated throughout

the exhibition (Griggs, 1983). By starting each section with one or two key questions or statements, the theme of the gallery can be reinforced. The Origin of Species Exhibition at the Natural History Museum (London) used lolly-pop-style, free standing, numbered signs to signify the suggested order of viewing and to briefly describe what the area is all about.

Wayfinding

1. Wayfinding systems should indicate to visitors the overall physical arrangement of the display and the intended route (if there is one) through the display (Griggs, 1983).

2. Wayfinding information at the beginning of an exhibition reduces the anxiety associated with a new environment and helps to provide initial directional cues. At the entrance to a display, wayfinding information can be provided by a floor-plan or map (Griggs, 1983). The map should be simple enough to obtain the necessary information at a glance.

3. Wayfinding information needs to be repeated throughout the exhibition (Griggs, 1983). Each exhibit display section should be clearly marked.

4. Information should be placed where it is needed, that is, at critical choice points and where it is not in competition with other objects.

5. Hand-held maps should be designed with simplified features, they should include easily identified

landmarks in the environment, and they should be evaluated with visitors to determine ease of use.

Circulation

People follow general patterns as they move through exhibition spaces. Some of the important factors that influence this movement are listed below:

1. People tend to approach landmarks, moving objects/ animals, sounds, and large objects. These visual attractors exert a strong influence over circulation patterns (Bitgood, et al, 1993).

2. People tend to approach an area containing other people unless it is too congested, in which case a crowd may have a repelling effect.

3. Visitors tend to exit a room when they encounter an open doorway even if they have not viewed all of the exhibits or objects in the room (Melton, 1935; 1972).

4. Visitors tend to remain on the same type of floor surface (carpet, wood) unless other forces impinge upon them.

5. Visitors tend to prefer the security of the main pathway and are reluctant to circulate off this pathway to areas on the periphery of the setting. Two techniques have been found to attract visitors off the main pathway; the placement of exhibits along the hallway leading to the gallery and playing music in the gallery (Bitgood, Hines, Hamberger, & Ford, 1991).

6. Human inertia influences circulation. This is the

tendency for visitors to continue walking in the same direction or along one wall in a gallery unless some other force pulls them in another direction.

7. Right-turn bias. When visitors enter a gallery with exhibit objects on both walls, they tend to turn right in the absence of other stronger attracting cues.

8. At times, visitors may look for specific objects or exhibitions in a museum. This, of course, will influence circulation pattern. Adequate wayfinding must be provided, however, if visitors are to be successful in finding their goal.

9. Griggs (1983) recommends that choice points be identified and orientation planned during the development of the exhibition. The environment should suggest the intended sequence in addition to having obvious signs.

10. Breaks in the sequence of an exhibition should be identified to visitors (Griggs, 1983). Placing a large exhibition in a pre-ordained space can create problems. Designers are often forced to compromise on the layout of exhibit displays, which can create confusion to visitors. The orientation system should provide appropriate indications when such problems occur.

Conclusions

To design an effective exhibition, designers must seriously consider visitor orientation and circulation. It is not enough to

simply select appropriate exhibit objects and design effective communication devices. The way visitors move through space in the exhibition must be factored into the equation. The principles described in this article, if applied, should help the visitor in the exhibition equation.

Originally published in Visitor Behavior (1995). 10(2), 7-8.

29

Suggested Guidelines
for Orientation Signage

Orientation and wayfinding signage should follow the same principles as any other type of signage (e.g., Bitgood, 1989; 1990; 1993). As with any written message, orientation messages should be easily noticed and appealing enough to hold attention. They must also communicate their purpose. While the following list of principles does not include all that are possibly important, it offers a starting point for someone who wishes to construct a checklist.

1. Place signage where it is needed and where it will be noticed. It is especially important at the beginning of a visit and at critical choice points along the way.

2. Signage and letters on the signage must be sufficiently large to afford easy reading and to attract attention even when there are many other competing visual stimuli.

3. Signage must fall easily within visitors' line of sight as they walk through the setting. It is useful to walk through the space and see whether or not the orientation signage is well placed in terms of line of sight.

4. Number of words should be kept at a minimum so that visitors can extract information without having to stop.

5. Contrast between lettering and background must be sufficient to create legible text.

6. Contrast between the sign and its environment must be sharp enough to make the sign stand out from its background.

7. Consistent layout and color help identify an orientation sign from exhibit labels and other information signage.

8. Signage should be tested for effectiveness. Orientation signage must attract and hold attention as well as communicate a message. The only way to know for sure that these criteria are met is to test the signs.

9. Terminology must be consistent. The same wording to describe locations should be used throughout the facility. Thus, visitors may be confused if wayfinding signage identifies an exhibition as "Vanishing Wetlands" and the actual exhibit is entitled "The Changing Wetlands."

10. Terminology should make sense to the visitor. An Omnimax theater should indicate that it presents a film instead of calling it *Spacedome* or some other term that doesn't communicate its function.

11. Typeface should be easy to read. Old English or script or other such difficult-to-read typeface will influence how effectively the orientation message is communicated.

Originally published in Visitor Behavior (1995) 10(2), 7.

References

Bitgood, S. (1989). Deadly sins revisited: A review of the exhibit label literature. *Visitor Behavior*, 4(3), 4-11.

Bitgood, S. (1990). The ABCs of label design. In *Visitor Studies: Theory, Research, and Practice, Volume 2*. Jacksonville, AL: Center for Social Design. Pp. 115-129.

Bitgood, S. (1993). Putting the horse before the cart: A conceptual analysis of educational exhibits. In S. Bicknell & G. Farmelo (Eds.), *Museum Visitor Studies in the 90s*. London: Antony Rowe Ltd. Pp. 133-139.

30

Does Lobby Orientation Influence Visitor Satisfaction?

STEPHEN BITGOOD & CAREY TISDAL

It is often argued that effective visitor orientation is critical to the entire museum experience. However, there is a dearth of hard, empirical data to support this argument. The current report describes findings that suggest how important it is to provide adequate visitor orientation as people enter a museum.

Orientation includes two components – wayfinding and conceptual orientation. Wayfinding systems should be designed so that users can navigate through the environment in order to locate destinations with ease. Conceptual orientation systems provide information that allows users to plan their visit. For example, what is available to see and do, and how much time does each activity take? Both of these systems combine to provide visitors with the ability to plan their visit, locate desired destinations, and provide the security of knowing where they are at any moment.

Assessing orientation can be difficult because it includes a complex of elements, because visitors may interpret orientation problems as their fault, and no single measurement (survey or observational) can, by itself, adequately describe the effectiveness (or ineffectiveness) of an orientation system. Some problems (e.g., not receiving a visitor guide) can be directly observed; while other problems (e.g., feeling lost or confused) require survey methods to assess.

Part of a study conducted in the summer of 1996 at the St. Louis Science Center examined the relationship between lobby orientation experience and ratings of overall satisfaction of the visit. If orientation in the lobby is critical, then it should influence the entire visit and should be reflected in ratings of

overall visit satisfaction. Like many large museums, the St. Louis Science Center is a complex environment fraught with orientation difficulties. One problem is that there are two major buildings each with its own entrance lobby. The two buildings (subsequently referred to as the Oakland Avenue and the Forest Park buildings) are connected by a bridge that spans a divided highway. Often, visitors who enter one building are not aware of the other. The Forest Park lobby is particularly troublesome since it tends to be dark, is smaller than the Oakland lobby, and has minimal signage directing visitors.

Another problem is the lack of distant visual orientation cues in some places. The Forest Park building is round and, as a consequence, exhibit spaces tend to be curved and lack a long horizontal view. Such curved spaces make it difficult to use visual cues for orientation. In the Oakland building, a corridor on the second floor is curved to accommodate the shape of the Omnimax theater. Visitors cannot look down the corridor and see the cafeteria at the end. These limited views deprive visitors of one of the most important types of orientation information.

Many science centers share still another orientation problem with St. Louis – the multiple-option ticketing problem. At the St. Louis Science Center visitors can visit the exhibit galleries without purchasing a ticket. However, they must purchase a ticket to see the Omnimax movie, the Planetarium, the Discovery Room, and (occasionally) travelling exhibitions. These various ticketing options often confuse visitors.

Science Center staff have worked hard to overcome some

of the physical limitations of the facility. They have altered wayfinding signage, improved the Visitor Guide, scheduled staff to greet visitors as they enter, and provided a visitor information desk. Despite these changes, orientation problems persist. The visitor orientation project was undertaken because Science Center staff recognized these and other orientation difficulties and because the Science Center sought information for long-range planning.

Method

The visitor orientation project (of which only a small part is reported here) involved several samples of visitors. Two samples of entering visitors (N=210) from the Oakland and Forest Park building lobbies comprised one set of visitor groups. These visitors were observed to determine how long they spent in the lobby and what orientation devices they were exposed to or used. After these visitors left the lobby, they were stopped and interviewed to determine their visit plans (where they will visit, how long they planned to visit, etc.).

Another pair of visitor samples (N=82) were approached in each of the lobbies as they exited the museum. They were asked to complete an interview related to their museum visit (e.g., which orientation devices they used, which destinations they visited) and were asked to retrace their steps through the museum with the aid of a map and the assistance of the interviewer.

Data were collected in the Summer of 1996. This time of year was selected because a higher percentage of first-time

visitors were known to visit in the summer and first-time visitors were assumed to have more difficulties with visitor orientation.

Independent variables in this study included: (1) the use or non-use of the Visitor Guide; (2) frequency of visit (first-time versus repeat visitors); (3) location of the lobby (Oakland versus Forest Park).

Dependent variables were:

1. ratings of overall visit satisfaction;
2. total time in the lobby;
3. total visit time;
4. destinations visited;
5. and self-reported orientation problems.

Results

Ratings of satisfaction: Figs. 1 and 2 summarize the ratings of overall satisfaction as a function of lobby location, frequency of visitation, and use of the Visitor Guide. Use of the Visitor Guide was used because it appears to be critical to orientation (equal percentage of first-time visitors at each lobby).

As shown in Fig. 1, visitors who initially entered the Oakland building were more likely to give an overall satisfaction rating of 9 or 10 than visitors who entered the Forest Park building. Over 65% of Oakland visitors gave a 9 or 10 rating while only 37% of Forest Park visitors gave a similar rating [t(79) = 2.014; p < .05].

Visitor Guide use: The use of the Visitor Guide appeared to be critical to first-time visitors. First time visitors (73 %) were more likely than repeaters (35.6%) to use the Guide [X2(77) =

| | Lobby location | |
	Forest Park	Oakland
Rating of 9 or 10	37.1%	65.2%
Rating of 7 or 8	54.3%	28.3%

Figure 1: Satisfaction Ratings: Percentage of Visitors in Forest Park & Oakland Lobbies.

| | Frequency of visit | |
	First-time	Repeat
Used Visitor Guide	8.5	9.0
Did not use Guide	7.4	8.8

Figure 2: Average satisfaction ratings of first-time and repeat visitors as a function of Visitor Guide Use.

11.389; p < .001]. As indicated in Fig. 2, first-timers who used the Visitor Guide gave an average rating of 8.5, while those who did not use the Guide averaged 7.4. There was little difference, however, between repeat visitors who did (9.0) and repeaters who did not use the Guide (8.8). Both Frequency of Visitation (p < .01) and Use of Visitor Guide (p < .05) were statistically significant in a two-factor Analysis of Variance. First-time visitors who used the Guide had an average visit of 3.7 hours while those who did not use the Guide averaged only 1.1 hours (see Fig. 3). Repeat visitors who used the Guide averaged 2.3 hours and those who did not use the Guide averaged 2.8. Even more dramatic was the difference between Omnimax movie goers who used the Guide and movie goers who did not use the Guide. Guide users who went to the movie averaged 5.4 hours while Non-Guide users who went to the movie averaged only 2.9 hours.

| | Average visit time (hours) | |
	First-time	Repeat
Used Visitor Guide	3.7	2.3
Did not use Guide	1.1	2.8

Figure 3: Average total visit time for first-time and repeat visitors.

Lobby orientation: From the sample of entering visitors, 80% of Oakland first-time visitors received the Visitor Guide, while only 45% of Forest Park visitors received the Guide. First-time Forest Park visitors spent an average of 1.8 minutes in the lobby compared with an average of 3.9 minutes for Oakland visitors. Although it is beyond the scope of this article, it is interesting to note that the vast majority of both first-time and repeat visitors indicated they want a variety of orientation information including what to see and do.

Self-reported problems: The sample of exiting visitors were asked to indicate from a checklist, which orientation problems they experienced during their visit (See Fig. 4). Forest Park visitors (30.6%) were more likely than Oakland visitors (13.0%) to check "Which way to go in the lobby." There was also a difference in terms of awareness of the presence of the cafeteria (41.7% of Forest Park visitors and 13.0% of Oakland visitors checked this as a problem). Forest Park visitors (44.4%) were more likely than Oakland visitors (34.8%) to check that wayfinding during the visit was a problem. Oakland visitors (48.9%), on the other hand, were more likely than Forest Park visitors (27.8%) to report being unaware that the Forest Park building had two levels.

| | Lobby location | |
	Forest Park	Oakland
Which way to go in lobby	30.6%	13%
Finding rest room	19.4	8.7
Finding a destination	11.1	0
Not aware of cafeteria	41.7	13
Wayfinding during visit	44.4	34.8
Not aware of 2nd level in other building	27.8	48.9

Figure 4: Self-reported orientation problems during visit.

Discussion

The findings can be summarized as follows:

1. The concern over orientation problems in the Forest Park lobby was confirmed. Those who begin their visit in the Forest Park lobby rate their overall visit satisfaction lower than those who start in the Oakland lobby. Furthermore, they tend to receive less orientation in the Forest Park lobby than the Oakland lobby as shown by the amount of time they spend in the lobby, whether or not they are greeted by staff, whether or not they receive the Visitor Guide, the number of orientation problems reported during their visit, and the amount of orientation signage in the lobby.

2. The Visitor Guide appears to be a critical orientation device. First-time visitors who do not get the Guide seem to suffer as a result as shown by their ratings of overall satisfaction and the amount of total visit time.

While these results are correlational in nature rather than experimental, they do suggest that orientation in the lobby is a critical part of the visitor experience. Visitors tend to spend less time in the Forest Park lobby and are less likely to receive orientation information while in the lobby. This seems to translate into lower overall satisfaction for their visit.

The Science Center is currently attempting to correct these orientation problems in several ways. First, the use of an Orientation Information Board in the lobby has already received some pretesting using formative evaluation. This device is designed to be visible as visitors enter the lobby and it is composed of three panels. The first panel is titled, "What to do..," the second panel, "Where you are...," and the third panel, "Where to find ..."

The initial results of the Visitor Orientation Board were encouraging, particularly in the Forest Park lobby. Those who used the device reported that they were more confident that they had enough information to plan their visit, while a large percentage of non-users did not feel they had enough information. However, it was clear that placement of this device is critical. One of the placements in the Forest Park lobby received little attention while a second placement was frequently used. The findings of the study are also being used to re-design the Forest park lobby. It is not clear yet exactly how the findings will be used, but staff are strongly motivated to make the best use of the information.

A final word should be made with respect to the methods used in the current study. The study employed several types of measurements to assess orientation problems. It is believed that no single method would have provided a clear picture of the overall problems. The combination of observational data in the lobby and interviews with the visitors who were observed provided an excellent way to study entering visitors. The exit survey that included a variety of items (destinations visited, orientation devices used, orientation problems encountered, and tracing of the pathway through the Science Center gave a fairly complete view of the nature of orientation problems from the perspective of exiting visitors. When combined, these measurements provided a relatively cost-effective way to analyze visitor orientation.

Originally published in Visitor Behavior (1996), 11(3),13-16.

31

Visitor Orientation:
Are Museums Similar to Casinos?

Attending a conference in Las Vegas last year revealed an amazing consistency in design from one casino to another. Of course, I had heard about the lack of clocks and windows so that customers are unaware of time passing. But, I had not realized how much the principles of good orientation are turned upside down to purposely confuse casino customers. Having conducted a number of visitor orientation and circulation studies in museums over the years, I asked myself, "What principles do casinos follow?" Two conclusions were inferred concerning orientation. First, casino design in the huge hotel/casino complexes on the Las Vegas Strip apply effective principles of design, but those principles are turned upside down to confuse people. Second, casino design follows different principles than those of shopping areas within the same complexes (most of these complexes contain shopping malls). To assess the accuracy of these insights, I collected data on many of the casino complexes along the Las Vegas Strip. The data consisted of obtaining a floor plan of the casino-hotel (if available) and making observations related to good facility orientation (presence of wayfinding devices, pathway configuration, etc.). This analysis provides a useful lesson to museums: Don't follow casino design if you want to be friendly to visitors.

Designing for confusion
What makes casinos confusing with respect to orientation?
- *Visual access*: There is a lack of visual access to locations such as hotel registration desk, restaurants, etc.

In general, the only visible features are gambling devices/areas and bars. The ability to see what and where something is in a facility is an important aid to wayfinding in most settings, but missing from the design of casinos.

- *Choice points and pathways*: The unnecessarily large number of choice points and pathways on the casino floor make it difficult to form a cognitive map of the area even after spending a moderate amount of time in the casino.

- *Geometric design*: The geometric design of casinos is always irregular making it confusing when trying to orient oneself. In general, the simpler the pattern, the easier it is to know where you are and find your way. The simplest geometric patterns are usually found in shopping malls and theme parks.

- *Wayfinding devices*: A lack of wayfinding devices such as you-are-here maps and consistent direction signs are the rule in casinos. Of all the casinos visited on the Strip, none had you-are-here maps. Direction signs are often inconsistent, provided at some choice points, but not others.

- *Angle of intersections*: Intersections in casinos rarely (if ever) have 90-degree angles. Intersections that come to a 90-degree angle make it easier to form a mental map of the setting. Many old cities are difficult to navigate because roads were haphazardly formed from cow paths. Far from such unintentional development,

casinos deliberately vary the angles of intersections to increase disorientation.

· *Landmarks* There are few, if any, distinct landmarks (large, salient objects or features) upon which to orient. Finding your way out of a casino is always more difficult than finding your way in!

A double standard

Take a few steps from the casino to the shopping area of one of these complexes and you are faced with a different set of design principles. Visual access down the corridor is provided so that it is easy to see the location of a number of shops. Choice points are kept to a minimum – usually the shopping area has one path, sometimes one or two additional paths with a minimum of choice points. Geometric design is predictable and simple. You-are-here maps and direction signs are used effectively to help you find your way. Intersections are more likely to meet at right angles.

My conclusion: Las Vegas complexes have a double standard – one for casinos and one for shopping areas. They intentionally attempt to confuse people in the casino areas by reversing design principles in an attempt to increase time (and therefore, money) spent. However, the principles of good orientation design are applied in shopping areas in order to facilitate more efficient shopping. It's all about money!

Other public places vary in orientation effectiveness. Shopping malls and theme parks tend to apply the principles effectively. Museums, on the other hand, vary. At times they

Figure 1: Venetian® Casino.

resemble shopping malls or theme parks; at other times, casinos. What's the difference between poor orientation in a casino and a museum? The museum does it without intention!

A few examples

Floor plans will illustrate my point. Floor plans of the Venetian® Casino and Shopping Mall (Figs. 1 and 2) provide the contrasting design principles for casinos and shopping areas noted above.

Note that the casino area is irregularly shaped. When you are on the casino floor, you can see little more than gambling devices and bars. Not shown on the floor plan are the numerous

Figure 2: Venetian shopping mall.

pathways and intersections that wander seemingly aimlessly throughout the casino. The shopping level, however, by comparison, is extremely orderly. There is one main pathway and few choice points. You-are-here maps help visitors to orient themselves. Visual access down the corridor is unobstructed. Landmarks Square provide additional aids to wayfinding.

The next floor plan is from the Riviera Hotel & Casino, also located on the Strip (Fig. 3). Entering from one of the main entrances, one is quickly placed on meandering pathways through the casino. Intersections are never at a 90-degree angle and the casino is irregularly shaped. The "front desk" is anything but in front.

Contrast the casino-hotel design with that of theme parks. The map of Walt Disney World Epcot® (Fig. 4) shows a simple

Figure 3: Riviera Hotel and Casino.

geometric pattern (two circles or a figure 8) with the Nations of the World placed around the lake forming the upper circle and the major attractions (Living Seas, Energy, The Body, etc.) placed around the lower circle.

The geometric design is simple and exhibit galleries are

Figure 4: Walt Disney World Epcot®.

accessed from a main path. Notice that the "front desk," marked Information (circled), is just inside the front entrance. It's relatively easy to find your way and know where you are at any moment.

The final floor plan for comparison is the Metropolitan Museum of Art (Fig. 5).

In many ways, the facility is designed more like a casino than a theme park in terms of orientation. There is a maze of galleries with no clear pathways. Choice points are numerous and landmarks are few once you enter the back galleries.

The lesson

Many museums fail to consider the importance of orientation and allow their facilities to perform more like casinos where users are confused and have difficulty finding their way. What

Figure 5: Metropolitan Museum of Art.

is the impact of poor orientation? Visitors become fatigued quickly – they waste energy by focusing on finding their way rather than on the exhibition experience.

Originally published in Visitor Studies Today (2003), 6(1), 10-12.

32

Orientation and Circulation:
Selected Annotated Bibliography

Update: The following summaries were published in two issues of Visitor Behavior, one in 1987 and the other in 1995. Thanks to the following individuals who assisted in these summaries: Amy Cota, Randi Korn, Pete Conroy, and Michael Pierce

Melton, A. (1935). *Problems of installation in museums of art. New Series No. 14*. Washington, DC: American Association of Museums.

Melton collected the first observational data on how people move through museums. These data is presented in more detail in Chapter 24 so it will not be repeated here. Suffice it to say that Melton set the stage for all subsequent studies on orientation and circulation with his ground-breaking work.

J. Yoshioka, J. (1942). *Visitor circulation at the New York World's Fair. Journal of General Psychology,, 1942,27,3-33.*

Visitors at the 1939 New York World's Fair were studied in two exhibit halls, The Hall of Man and the Hall of Medicine. Major findings included:

First turn at the entrance of the hall: The first turn was determined by exhibits to the right or left of the entrance. An attractive exhibit near the entrance tends to pull the visitors in that direction.

Pathway through the hall: Visitors pathway through the exhibit hall was influenced by three factors: (1) internal motivation to explore; (2) exit gradient (tendency to view exhibits along a direct route from the entrance to the nearest or most convenient exit; (3) presence of attractive exhibits.

Leaving the hall: Leaving an exhibit hall was determined by the attraction of an exit which was influenced by the location of the exit, by external factors such as the placement of exhibits, and internal factors such as exploration.

Parsons, & Loomis, R. (1973). Visitor traffic patterns: Then and Now. Office of Museum Programs, Washington, DC: Smithsonian Institution.

Parsons and Loomis studied visitor circulation through the Hall of Pharmacy at the National Museum of History and Technology. Two samples of visitor behavior were taken, one before and one after the installation of a new exhibit, "Shaving Through the Ages." Many of the major findings of circulation were similar to those of Melton (1935). For example, over 40% of visitors passed along only one wall before leaving the area. About 30% passed along one wall and part of an adjacent wall. In addition, objects located along the shortest route between the entrance and exit of a gallery received the greatest amount of viewing (Melton's exit gradient). When the two visitor samples were compared, several interesting results were evident. First, total time in the Hall was the same, despite the presence of the new exhibit. Secondly, the new exhibit appeared to take away time from other exhibits. Finally, the attracting power of exhibits in the Hall varied; the new exhibit appeared to detract primarily from one other exhibit, 18th Century Pharmacy. In their discussion, Parsons and Loomis point out that "...the actual flow of visitor traffic can only be known by empirical study." (p. 15). They also indicate that

traffic patterns were different on crowded days than on days with fewer people.

Cohen, F. M., Winkel, G., Olsen, R., & Wheeler, F. (1977). Orientation in a museum: An experimental visitor study. Curator, 1977, 20(2), 85-97.

This study examined problems in orientation and circulation by collecting visitor data and then attempted to correct these problems. Observation and surveys during baseline revealed:

- 71% of visitors were unaware of an entire exhibit wing
- 86% had no idea of what hall they were approaching
- 41% were forced to backtrack at some point in the wing
- Most visitors wished there were some orientation assistance available.

After the installation of maps, signs or a combination of the two, it was found that all changes improved orientation, although each type of orientation device appeared to be used in a different way. Signs helped people organize their visits and understand where certain exhibits were located (conceptual orientation). The maps (used by 60% of visitors) were used to find the most interesting exhibits rather than to determine routes. The floor plan was the most useful part of the map.

The study also found that guided tours, information desks, and museum directories were much less popular than maps and signs. The visitors used the entrance information desk more than the directory and when desk personnel were

approached, the questions generally pertained to content rather than orientation. When given the chance, visitors were found to look for a visitor guide with a map, rather than approach an information desk person. In general, it was found that each type of orientation aid "contributes to a different aspect of locating oneself in space..." It was also shown that every effort made to solve the problem of museum disorientation resulted in improvement in orientation.

Levine, M. (1982), You-Are-Here Maps: Guiding Principles. Environment and Behavior, 14(2),221-237.

1. A viewer of a map must have two items of information in order to relate the map to the terrain.
2. A "You-are-here" symbol telling the viewer where he/she is provides one piece of information.
3. Signs and labels are also important orientation cues on a map.
4. Employ redundancy of orientation cues by using several points of correspondence between the map and the terrain.
5. Use asymmetrical structures (distinctive landmarks) as orientation cues on the map.
6. Arrange the map so that it parallels or is aligned with the terrain ("forward-up equivalence").
7. The two-item theorem: Either two pairs of points or one pair of points and a direction need to match in order to produce an overall figure match (produce effective orientation cues).

Levine, M., Marchon, & Hanley, G. (1984). Placement of You-Are-Here Maps. Environment and Behavior, 16(2), 139-157.

This study attempted to provide data to support Levine's (1982) principles of You-Are-Here (YAH) map use: (1) the Alignment Principle – maps should be aligned with the terrain; and (2) Forward-up Equivalence – viewers assume that "up" on a map corresponds to forward, right to right, left to left, etc. One of the experiments took place in a laboratory setting, and the other in the field. The lab study used slides depicting a campus map. Two map conditions were presented: an aligned map (the YAH arrow pointing up); and a misalinged map (YAH arrow pointing to one of the other 3 walls). Subjects responded correctly when the map was aligned, but not when the map was misalinged. In the field setting, two sets of maps were used, each set included an aligned and a contra-aligned map. One of the contra-alined maps was rotated 180 degrees, the other inverted 180 degrees. In a library setting, subjects were asked to study a map and then walk to a specific point in the library that was designated on the map. The subjects were timed as they performed the tasks from start to finish With the aligned map, 80% of subjects found their way, while only 35% were successful using the contra-aligned map.

Shettel-Neuber, J. & Joe O'Reilly, J. (1981). Now Where: A study of visitor orientation and circulation at the Arizona-Sonora Desert Museum. Tucson, AZ: Arizona Sonora Desert Museum.

Visitors of exhibition-type facilities probably ask one question more than any other. "Now Where?" In a 1981 paper

whose title is this very question, Shettel-Neuber and O'Reilly carefully looked at the Arizona-Sonora Desert Museum to find out what visitors decided. Through three primary methods of study, a lot about orientation and circulation at this institution was revealed. Direct observation, photographic recording, and questionnaires were used in this evaluation. Results suggested that there needed to be "a suggested route through the museum." When possible routes are suggested, people don't have to take them but at least they have the choice. The study also indicated that an orientation area near the entrance would be useful. "A short repeating film or a poster display could be used to present this information." Shettel-Neuber and OReilly also suggest that a general concept should be the subject of orientation throughout the entire museum. Devices such as maps should be present to aid the visitors in identifying those exhibits which exemplify the overall theme. Other suggestions included the need for clearer signs indicating "one-way" areas and exhibit entrances.

This paper described a detailed orientation study of a single facility and until others take a similar initiative, confused visitors may continue to ask, "Now where?"

Griggs, S. A. (1983). *Orienting visitors within a thematic display. International Journal of Museum Management and Curatorship*, 2, 119-134.

Griggs studied both topographical orientation and conceptual orientation at the British Museum (Natural History). He used four measures of visitor orientation for three

exhibitions (Hall of Human Biology, Origin of Species, and the Insect Gallery):

- Verbal descriptions: visitors were asked to describe in detail their passage through the exhibition.
- Locating exhibits on a map: visitors were asked to locate objects and particular areas on a ground-plan of the exhibition.
- Reconstructing the story: visitors were given summaries of the 10 parts of the exhibition in random order and asked to reconstruct the sequence of the exhibition.
- Asking for directions: visitors were asked to take the interviewer to different locations within the exhibition.

Topographical orientation

- The routes visitors actually followed varied considerably from the intended sequence.
- It is difficult to produce a particular pattern of flow when visitors are confronted by a number of possible routes.
- Visitors had a good representation of the display's overall physical layout.
- Visitors were able to give descriptions with a great deal of detail.
- Visitors who followed the intended sequence and used the orientation devices had better representations of the display.

Conceptual orientation

- Forty percent of visitors were unaware that the displays were sequential in nature.
- Visitors were frequently unaware of how the intended sequence was indicated (exhibits were numbered).
- From the detail of visitors' stories, it appeared that visitors had a poor conceptual picture of the display; their impressions tended to consist of isolated facts rather than a coherent story.
- The lack of orientation devices impaired the visitors' understanding of the display's conceptual organization.

Griggs offered a number of recommendations for effective orientation:

1. "Orientation should be integrated into the process of developing displays and not tackled as an 'afterthought' once the exhibits have been developed."
2. "Orientation devices should be user-defined."
3. "Design conventions should be made explicit."
4. "Detailed conceptual orientation needs to be tackled independently from topographical orientation."
5. "Topographical orientation should: ...indicate to visitors the overall physical arrangement of the display; and indicate the intended route through the display."
6. "At the entrance to a display topographical orientation can be provided by a ground-plan."
7. "This information needs to be reinforced throughout the display."

8. "Choice points should be identified during the development of the display and treated appropriately."
9. "Any breaks in the sequence of a display should be identified."
10. "Any breaks in the sequence of a display should be identified."
11. "The general aim of conceptual orientation is to produce in visitors the expectation of what the display is about and how it is organized conceptually."
12. "There are two main problems to be surmounted before conceptual orientation can be achieved: how to attract and hold visitors' attention to the necessary information and how to communicate the information to them."
13. "Conceptual orientation should begin at the very start of a display."
14. "Conceptual orientation needs to be reinforced throughout the display."

Talbot, J. F., Kaplan, R.,. Kuo, R. E, & Kaplan, S. (1993). Factors that enhance effectiveness of visitor maps. Environment and Behavior, 25 (3), 743-760. [Visitor Behavior (1995), 10(2), 12]

Wayfinding is an important aspect in a museum visit. The quality of the visitor experience can be altered dramatically based solely on the museum's use of effective wayfinding aids. This is why the museum should consider carefully the planning of useful visitor maps.

"Visitor maps are characteristically a rich source of information, but the very richness often gets in the way of

communicating the basic intent of the map." Museum staff may have no problems understanding these maps, but it is the visitor who finds these information-rich maps confusing. The authors suggest simplifying visitor maps to solve the problem. Three profound advantages result from simplification: "One can take in more without being overwhelmed; one can achieve a hierarchical perspective, or see the bigger picture; and one can make transformations of the material, or manipulate it, to meet a variety of needs."

This research took the theoretically grounded principles on handout maps and focused on the essential role of simplicity. Extensions to the theory were made:

1. Novice visitors are overwhelmed by large amounts of information. It is essential to minimize the amount of information and the degree of detail.

2. Minimize the amount of mental processing required to understand the map; immediate comprehension is important.

3. Handout maps need to facilitate comprehension of spatial relationships. Basic information should be the easiest to find.

The studies

There were two phases to this study. Phase 1, Study 1 involved an entry survey and visitor use of one of three maps (upper floor only) which the visitor rated. In Phase 1, Study 2, the visitor picked one of three maps (same as Phase 1, Study 1) and was given specific map tasks (locating specific destinations

or drawing a route to the parking lot on the handout map). In Phase 2, Study 1, visitors were given an entry survey and rated one of two maps (both floors of museum). In Phase 2, Study 2, visitors were given an exit survey and rated one of two maps (same as Phase 2, Study 1). Phase 1 included 148 visitors and 37 workers (security staff and information desk volunteers) and Phase 2 had over 500 visitor participants.

The five different maps that were used had some features in common. Shading was used to communicate that a common theme linked the works in adjacent galleries. Maps that were directly compared were of the same size and used identical labels to identify the collections. In addition, nonessential architectural details were omitted, office names were dropped and labels for areas were placed directly on those spaces rather than in a separate list on the side.

Results and discussion

Reaction to the simplified maps was positive. Some participants commented that the lack of detail was an advantage. The results of the rating scales used in the survey (5- point scale, 5 = very much) revealed that participants rated the maps as being "interesting," "understandable," and "informative" (the mean range between each study 3.7 and 4.0) and as being not at all "confusing," "overwhelming," or "hard to follow" (means 1.5 - 1.7). Participants also rated that the test maps gave a good sense of where to find things in the museum and most places that were identified were easy to find (means between 4.1 and 4.4). Finding the stairs and the exit were the

only two problems (both means 3.3). The performance tasks also supported the need for simplicity on maps and illustrated the confusion that can be caused by unnecessary detail.

The results of this study indicate the importance of simplicity in handout maps. Visitors who used the handout map indicated that their expectations of the museum visit were enhanced. Forty-one percent said they looked forward more to the visit; 45% felt more comfortable, and 50% said they felt more oriented after looking at the map. This data shows that effective handout maps allow visitors to experience fewer wayfinding difficulties resulting in more satisfying museum experiences.

Klein, H.J. (1993). *Tracking visitor circulation in museum settings. Environment and Behavior, 25 (6), 782-800.*

Various methods have been employed to track visitor locomotion: (1) recording visitor behavior unobtrusively on maps; (2) recording the traces of wear within an environment (ex: use of brochures, turned-over leaflets); (3) recording behavior through the use of video equipment; and (4) the Hodometer method developed by Bechtel (1967). In the Hodometer method, the floor of an exhibit is laid out with a one foot square grid (covered with carpet). The frequency of use is measured by electric contacts on the grid which sense visitor circulation.

In a series of studies conducted by Klein, visitor circulation was recorded by unobtrusively tracking visitors and recording their behavior on floor maps of the exhibit hall. The method

was adopted from Melton's classic study (1935), and slightly modified to indicate the amount of traffic flow. In Melton's study visitors' routes were drawn on room maps in a single line with numbers identifying frequency. Klein's studies used three methods to record the amount of traffic flow: (1) coding the routes by different degrees of thickness in proportion to their frequencies; (2) representing whole routes by shading visitor paths in different colors to represent frequency of use; and (3) shading frequently visited sections and using arrows to show the dominant direction.

Study 1: The first study was two-fold in that it was carried out in the old and renovated Hall of Automobiles at the Deutsches Museum in Munich. The tracking study was done to discover the strengths and weaknesses of the old exhibit hall before renovation was to occur.

The old exhibit hall was set up in a u-shaped circular course going clockwise, with alcoves on the inner side. The results showed that two thirds of the visitors used suggested routes. However, many objects ("old timer" automobiles) on the first third of the tour were given less attention due to their crowded appearance while displays located near the exit received more attention.

The renovated Hall of Automobiles incorporated lessons from the above results into its design. Cars were placed on larger and smaller islands that visitors could walk around, the oldest artifact (1886 Benz) was placed in a prominent place, and a throughway to an added-on room was created for motorcycles and commercial vehicles. The change made to the

1886 Benz produced an increase from 20% to 47% attracting power for visitors. The results also revealed that the most frequently travelled zones do not necessarily coincide with the locations of the objects with the highest attracting power.

Study 2: The second study was conducted in a special exhibit titled "1949" (on the 40-year founding of the Federal Republic of Germany) at the Museum of the History of the Federal Republic of Germany in Bonn. Tracking and follow-up interviews were used to study the competition phenomenon between the two sides of the corridor-shaped gallery. It was found that as visitors entered the "1949" exhibit a decision was made for one of the two walls or to cross over from one side to the other. Two thirds of the visitors attempted to see everything by crossing over several times. A critical point in the gallery forced visitors to decide which path to take; one forth of the visitors went left and the remainder followed to the right to the lively colored thematic installations. The disadvantage to this choice point was that not one visitor backtracked to see the parts of the exhibit they had missed.

Study 3: The final study was done on an existing exhibition, at the Museum of Cultural History in the castle of Rastatt, which was undergoing a formative evaluation. Tracking was conducted on the existing exhibition (Phase 1) and after four didactic aids (an advance organizer, a flip chart, a text graphic unit, and a demonstration of loading old guns) were installed (Phase 2). During Phase 1 visitors spent an average of 2 minutes, 15 seconds. One fourth of the visitors walked from one door to the next, only viewing cases one and three. "One third went to

the right at the door, and a few more browsed between cases one and three." In Phase 2 the use of the four didactic aids gave information linking the artifacts to one another. The average time in the exhibition increased to 3 and one-half minutes and the use of the aids reorganized the walking routes. Almost three quarters of the visitors turned right at the entrance and the space between the cases was more frequented.

About The Author

After several years of work in experimental, clinical, and educational psychology, Steve Bitgood began studying visitors in museums, parks, and zoos in 1984. Over the years, he has travelled the USA, Canada, and Europe conducting research with visitors, evaluating exhibitions, conducting workshops for professionals, and presenting conference papers. His work has stubbornly focused on applying a scientific, psychological approach to the study of visitors.

After obtaining a Ph.D in experimental learning psychology at the University of Iowa, Steve served as a post-doctoral research associate at McMaster University in Hamilton, Ontario, Canada. His next assignment was as an Assistant Professor at Drake University in Des Moines, Iowa. Following the cold winter of 1973-74, he accepted a position as Associate Professor at Jacksonville State University in Alabama where he has remained and avoided the cold winters of the North. In 2008, Steve retired from teaching, was appointed Professor Emeritus, and continues to conduct research on visitors, consult, and write.

Steve's publications in visitor studies have included a number of topics and a wide range of publications. Included are a chapter in the *Handbook of Environmental Psychology* (Bechtel & Churchman, 2002), articles in *Visitor Studies, Visitor Studies Today, Curator, Journal of Interpretation Research, Journal of Museum Education*, as well as publications in Germany and France. Other publications can be found in several volumes of *Visitor Studies: Theory, Research, & Practice* (conference proceedings of the Visitor Studies Conference) and *Informal*

Science Learning: What the Resesarch Says About Television, Science Museums, and Community-Based Projects (Valerie Crane, Heather Nicholson, Milton Chen, & Stephen Bitgood), National Science Foundation, 1994.

In his recent work, he has outlined a model of attention and value applied to museum visitors. The model is based on the visitor literature and the psychology of attention. Recent papers include a monograph published by the Center for the Advancement of Informal Science and three publications on "museum fatigue" and associated phenomena.

In addition to his professional writing, Steve has been a leader in establishing and furthering the field of visitor studies. His activities have included:

- Publishing and editing *Visitor Behavior* in 1986 through 1996.
- Organizing the first Visitor Studies Conference in 1988.
- Editing conference proceedings from the Visitor Studies Conference for several years.
- Conducting workshops for professionals.
- Founding the Visitor Studies Association with several others in 1991.

Other activities include 25 years of consulting with zoological parks, museums, science centers, parks, historic sites, botanical gardens, and similar organizations that have educational exhibitions.

Steve's major concerns have been and continue to be:

- Developing sound theories of the visitor experience.

- Clear communication among professionals in visitor-type institutions.
- Closing the applicability gap between what we know and what we practice.
- Development of visitor studies as a profession.

Stephen Bitgood, Ph.D
Professor Emeritus of Psychology
Jacksonville State University
E: steveb@jsu.edu
T. 256-591-1325

Index

Also from MuseumsEtc

Interpretive Master Planning (Two Volumes)

Author: John A Veverka

ISBN: 978-1-907697-23-4
and 978-1-907697-25-8 [paperback]
ISBN: 978-1-907697-24-1
and 978-1-907697-26-5 [hardback]

Order online from www.museumsetc.com

Author John A Veverka is one of the world's leading consultants in interpretive planning, training and heritage tourism, with experience spanning over 30 years and taking him all over the world.

Interpretive Master Planning presents - in two comprehensive volumes - a wealth of information on how to plan and design interpretive facilities and services.

John Veverka's lively text uses anecdotes, case histories and interactive examples to illustrate all aspects of interpretive planning: from theories of visitor psychology to budgeting, planning strategies and practical, field-tested ideas on everything from scriptwriting to evaluation.

This is the most comprehensive reference book on the subject, an invaluable resource for designing interpretation that really works.

"Here is knowledge based on years of national and international interpretive planning projects with parks, museums, commercial attractions and a variety of other agencies. This is a classic work by an author who does interpretive planning every day." *Gary R Moore, Program Coordinator, MetroParks, Columbus and Franklin County, Ohio.*

Creativity and Technology:
Social Media, Mobiles and Museums

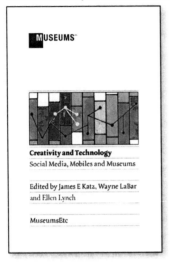

Editors: James E Katz, Wayne LaBar and
Ellen Lynch

ISBN: 978-1-907697-11-1 [paperback]
ISBN: 978-1-907697-12-8 [hardback]

Order online from www.museumsetc.com

This book brings together papers
given at a major conference
organised by the Center for
Mobile Communication Studies
at Rutgers University (the world's
first academic unit to focus
solely on social aspects of mobile
communication) and Liberty
Science Center (the New Jersey-New
York City region's largest education
resource).

Presented by leading thinkers
and museum experts, the papers
provide an incisive, up-to-the-
minute analysis of trends in the
use of mobile devices by museum
audiences, with a special focus on
outreach efforts to under-served
communities.

"This important collection of
essays delves into a complex and
exciting world, and makes a key
contribution to this developing
field." *Dr. Lynda Kelly, Head of Web
and Audience Research, Australian
Museum, Sydney.*

"Mobile technologies have
the potential to revolutionize the
museum experience. This book
shares perspectives and findings
that will help practitioners navigate
this new learning terrain." *Marsha
Semmel, Deputy Director for Museums,
Institute of Museum and Library
Services, Washington DC.*

Museums at Play:
Games, Interaction and Learning

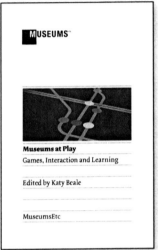

Editor: Katy Beale

ISBN: 978-1-907697-13-5 [paperback]
ISBN: 978-1-907697-14-2 [hardback]

Order online from www.museumsetc.com

Museums are using games in many ways – for interpretation, education, marketing, outreach and events. *Museums at Play* showcases tried and tested examples from the sector and seeks to inspire further informed use of games. It also draws on relevant experience from other sectors, and on the experience of game designers and theorists. It looks at learnings from other disciplines and explores the possibilities of interaction using gaming within museums.

Some 50 contributors include specialists from world-class institutions including: British Museum, Carnegie Museum of Natural History, Children's Discovery Museum of San Jose, Conner Prairie Interactive History Park, Museum of London, New Art Gallery Walsall, Science Museum, SciTech, Smithsonian Institution, Tate, Walker Art Center and specialists from Belgium, Canada, Denmark, Germany, Greece, Iceland, Italy, Mexico, New Zealand, Norway, Portugal, Spain, Turkey, UK and USA.

Colophon

MuseumsEtc Ltd
Hudson House
8 Albany Street
Edinburgh EH1 3QB
United Kingdom

www.museumsetc.com

This edition first published 2011

Edition © 2011 MuseumsEtc Ltd
Texts © Stephen Bitgood

The paper used in printing this book comes from responsibly managed forests
and meets the requirements of the Forest Stewardship Council™ (FSC®) and the
Sustainable Forestry Initiative® (SFI®). It is is acid free and lignin free and meets all
ANSI standards for archival quality paper.

Typeset in Underware Dolly and Adobe Myriad Pro.

ISBN: 978-1-907697-20-3

A CIP catalogue record for this book is available from the British Library.

CPSIA information can be obtained at www.ICGtesting.com
Printed in the USA
LVOW111427161012

303097LV00002B/2/P